THE PRACTICE OF POETRY

The

PRACTICE

of

POETRY

Writing Exercises from Poets Who Teach

Edited by

ROBIN BEHN &

CHASE TWICHELL

wm

WILLIAM MORROW
An Imprint of HarperCollins*Publishers*

wm

WILLIAM MORROW
An Imprint of HarperCollins*Publishers*

A paperback edition of this book was published in 2001 by Quill/HarperResource.

HarperCollins books may be purchased for educational, business, or sales promotional use.
For information, please e-mail the Special Markets Department at SPsales@harpercollins.com.

First Collins Reference edition published in 2005.

Designed by Jessica Shatan

Library of Congress Cataloging-in-Publication Data

The Practice of poetry : writing exercises from poets who teach /
[edited by] Robin Behn & Chase Twichell.
 p. cm.
 Includes index.
 ISBN 0-06-271507-0
 ISBN 0-06-273024-X (pbk.) ISBN 978-0-06-273024-4 (pbk.)
 1. Poetry—Authorship. I. Behn, Robin. II. Twichell, Chase,
1950– .
PN1059.A9P7 1992
808.1—dc20 92-52535

 17 18 19 RRD C 60 59 58 57 56 55 54

CONTENTS

INTRODUCTION

Poetry, like any art, requires practice. It's easy for us to accept the idea of practice when we think of a painter's figure studies or the sounds coming from the hives of practice rooms in a conservatory. But since we consider ourselves already fluent in language, we may imagine that talent is the only requirement for writing poetry. Talent, certainly, is essential, but so are curiosity, determination, and the willingness to learn from others. Writing is solitary work, but most poets would argue, as they have here in exercise after exercise, that the aspiring poet must apprentice him or herself, must master the elements of language, the complexities of form and its relation to subject, the feel of the line, the image, the play of sound, that make it possible to respond in a voice with subtlety and range when he hears that music in his inner ear, or she sees in the world that image that's the spark of a poem.

This book is a compilation of suggestions for practice in the art of poetry. It's for anyone interested in writing poetry, whether alone or in a class. We want to give you the chance to benefit from the knowledge and insight of a wide range of poets who are also teachers of poetry. A source book for writers of all levels, as well as teachers who are looking for fresh approaches, *The Practice of Poetry* is intended to sketch out the contours of apprentice

work, from the "scales" to the large personal and formal questions raised by the act of writing. It's a collection of memorable commentaries by practitioners of the art as well as a "how-to" workbook.

When we first set out to collect these exercises, we had in mind a slender volume that would supplement the many fine texts and anthologies currently available. Most texts, while admirably covering the basics of how to *read* poetry, do not provide specific suggestions for how to *write* it. Therefore, teachers of poetry writing have always designed inventive and challenging ways to help students explore language. *Our* task has been to collect these exercises, these meditations and suggestions for practice, and make them available for the first time in book form. We want to give aspiring poets, whether or not you're actually enrolled in a writing workshop, the chance to listen in on a variety of poets as they teach what they know about how to prepare for that moment in language when the angel comes and taps you on the shoulder.

We asked hundreds of poets to share with us their favorite writing exercises. Although we anticipated a great deal of interest, we were unprepared for the extraordinary range of work we received, both in number (hundreds), and in ingenuity. To our delight, the exercises were as different from one another as is the work of the writers who produced them, and they covered just about every aspect of poetry writing, from how to get started to sophisticated technical problems. The contributors were extremely generous and nonproprietary. The overall feeling was one of a community enterprise—everyone was curious about what others would have to offer, and enthusiastic about the idea of having the material gathered in one place. It soon became clear that *The Practice of Poetry* was going to be much bigger, much

juicier, than we first imagined. We were especially pleased by the commentaries that accompanied the exercises. In them, one can observe the poet's mind at work, inviting the reader to participate in the heat and excitement of the act of writing, and the pleasures, frustrations, and challenges of teaching.

The exercises in this book are extremely various in approach, style, and content, and cover a great deal of territory. Some of them aren't necessarily intended to result in *poems.* A good exercise serves as a scaffold—it eventually falls away, leaving behind something new in the language, language that now belongs to the writer. Sometimes, this new thing will be a real poem. In any event, exercises can result in a new understanding of the relation of image to meaning, or a way into the unconscious, perhaps a way of marrying autobiography with invention, or a sense of the possibilities of various kinds of structures, ways to bring a dead poem back to life, a new sense of rhythm, or a slight sharpening of the ear. Exercises can help you think about, articulate, and solve specific creative problems. Or they can undermine certain assumptions you might have, forcing you to think—and write— beyond the old limitations. If an exercise leaves you better equipped to write the next poem, then it has done its job. If it leaves you with a seed that might develop into a poem, then that's a fringe benefit. And if you manage to get a real poem straight out of the exercise, then you are probably a poet and likely to have found your way to that poem regardless, although the exercise may have sped up the process a little.

Good exercises are provocative, challenging, and often entertaining. A good exercise will engage you on at least several levels, and should necessitate the breaking of new ground. To the beginning student, who may be intimidated by the blank sheet of paper (as all of us are from time to time, whether or not we care to admit

it), they provide a way to enter the mysteries. For the more advanced student, they can keep pushing back the frontiers. And if you're the maverick who's already a poet, you'll write your own poem *in spite* of the exercise.

ABOUT THE BOOK'S ORGANIZATION

A glance at the Contents will reveal our basic scheme: the exercises have been grouped by area of inquiry rather than by level of expertise. We've found that many exercises travel gracefully from one level to another. Besides, who's to say what's difficult for whom?

Each exercise consists of the assignment, just as the teacher would give it to his or her students, followed by a brief commentary. Exercises designed for groups are indentified in the Contents as well as in the text.

The exercises have been divided into seven parts. The first, "Ladders to the Dark," explores various means of launching a poem onto the blank page. "Write down these signals from the unconscious," Carol Muske tells us. "Writing is an intuitive process; we must trust our intuition." And then, as Thomas Lux writes, "Figure out what from this huge swamp is potentially poetic material."

In "The Things of This World," the book moves on to consider the physical world of the senses and the use of concrete objects ("the possibility of 'speaking' in images"—Roger Mitchell) and the relation between image and metaphor, which is "both precisely concrete and richly suggestive, both utterly mundane and mysterious at the same time" (T. Alan Broughton).

The third part, "Who's Talking and Why?," begins with suggestions for developing aspects of voice. "The exercises I have liked

best," writes Christopher Gilbert, "call for some transformation of the self. Too often when we begin writing we are limited by the self-importance we give our feelings." Following the set of exercises on voice is a group addressing the problem of subject matter: What can a poem be about? Here, you'll discover a liberating array of ways to think about the poet's relation to subject as well as suggestions for avoiding clichéd approaches, from Rita Dove's "Your Mother's Kitchen" and Garrett Hongo's "Not 'The Oprah Winfrey Show'" to Sandra McPherson's notion that "maybe we should start with what we're afraid to write."

The fourth part, "Truth in Strangeness," is concerned with developing (or reconnecting with) the nonrational part of the mind. Take a hypothetical intelligence test, says Alberta Turner, but answer it "by picking out all the most wrong answers." Or make a "homophonic translation" from a language you don't know (Charles Bernstein), or invent your own "impersonal" or "objective" method for extracting linguistic units (Jackson Mac Low).

Next is "Laws of the Wild," a part designed to sharpen your sense of structural possibilities. Deborah Digges reminds us of William Carlos Williams's definition: "A poem is a large or small machine made of words," and suggests that Heidegger's model of "block, pillar, slab, and beam" may be as useful to poetry as it is to philosophy. Whether dealing with "Opposites" (Stuart Dischell) or "Writing Between the Lines" (J. D. McClatchy), these exercises will expand your sense of the possible shapes a poem can take.

In part 6, "Musical Matters," there are numerous invitations to sharpen aural skills. This ear training, useful for both formal and free verse, directs your experimentation with rhyme, lineation, and rhythm. Exercises such as Richard Jackson's "Shall We Dance?" or Susan Mitchell's rhyme lesson "Emotion/Motion/Ocean/Shun" are engaging ways to approach matters that might

otherwise be perceived as overly technical or dry. At the end of this part is a series of nontraditional assignments in traditional forms from some of the poets who write so well in forms themselves: Agha Shahid Ali, Judith Baumel, Dana Gioia, Andrew Hudgins, Molly Peacock, Thomas Rabbitt.

In part 7, "Major and Minor Surgery," we've gathered the expertise and advice of many poets on the subject of revision. These pieces range from specific assignments—Daniel Halpern's "Writer's Block: An Antidote" or Stephen Dunn's "Stealing the Goods"—to brief, poignant reflections on the subject by Lynn Emanuel, Donald Justice, Stanley Plumly, and others.

We have tried to make the book as adaptable as possible. Although it's divided into parts, we encourage teachers, students, and writers working alone to use it as a sort of cookbook rather than as a prescribed course of study. A teacher could use the book to design a class in any number of ways: working sequentially through it, selecting exercises to clarify or enlarge upon points raised by the students' reading and discussion, or even using it as a source of "prescriptions" to be given individually to students when they encounter a problem or need a new challenge or direction. And enterprising poets not in school could use the book to teach themselves.

We have not attempted to present a complete overview of every problem, question, and concern to which an exercise might provide an answer. Such a book would be a million pages long and growing, since new exercises are constantly being invented. If you're interested in metrics, for example, you'll need to go beyond the scope of this book for a thorough grounding in the history of prosody.

Because *The Practice of Poetry* is not an anthology, one of its essential features is an appendix (p. 263) that lists all the published works referred to in the text. Teachers will probably want to provide the class with a good anthology that includes much of this material, and they should also encourage students to use the library (almost any book is accessible through the interlibrary loan system). Also, a number of mail-order bookstores carry most of the poetry books mentioned (see Appendix A, p. 260).

We hope that this book will make the diets of students richer and more various, that it will add surprising and intriguing new ingredients to the course plans of teachers, and that it will provide the solitary tiller in the fields with some excellent company. Writing, as anyone who's ever tried it knows, is a profoundly lonely pursuit. It's something that happens in the private space between the writer and the language. But apprenticeship takes many forms, among them the garnering, absorbing (and rejecting!) of advice from other writers. We hope that *The Practice of Poetry* will enable a reader to eavesdrop on a great variety of poets as they teach, and that the writing it inspires will be full of sparks, a few of which may even start some of those fires we call poems.

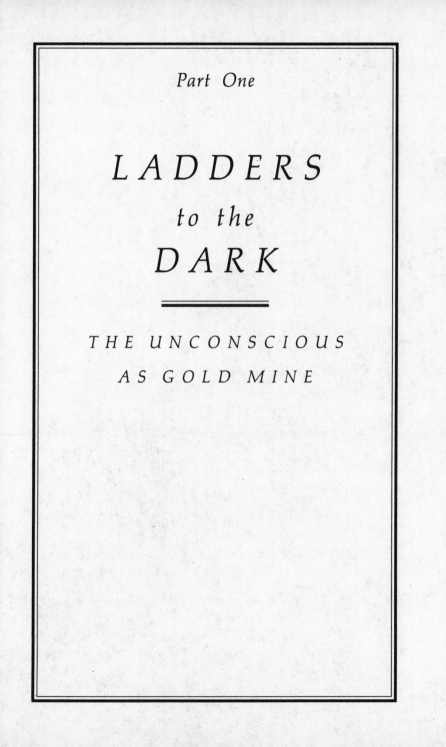

Part One

LADDERS
to the
DARK

THE UNCONSCIOUS
AS GOLD MINE

FIRST WORDS

Ann Lauterbach

Pretend you have never been told anything about poems or poets. In place of that pretense, try to recall a very early experience you had of reading or hearing language that interested or excited or confused or enlightened you. Maybe it was something you overheard, or something someone else read, or a comic-book, or a sign on a billboard. Now write about that experience, trying to describe what about the text got to you and why.

———

This assignment is motivated by my desire to trigger your initial awareness of language, whether written or spoken, without the pressure to impress anyone. I want to engender a sense of how individual and how essentially solitary our relation to words is, and to elicit responses that testify to a fundamental diversity of experience. In my writing classes, I had begun by asking each student to *speak* about his or her interest in literature and language, and the replies were remarkably flat and homogeneous, usually presented in terms of a social (i.e., "my third-grade teacher really liked my poems") rather than a private encounter. Few students mentioned books or individual poems they had read or heard; the answers seemed guarded and not particularly germane. When I changed it to a written assignment, each student was

permitted to retreat and inspect his or her attachment. The answers were, in fact, extremely varied and interesting, ranging from a mother's spoken prayer over a crib to the arduous process of learning English in a foreign country (Japan). This exercise helps set the tone and terms for thinking about the ways in which reading and writing are intimately linked.

NOT-SO-AUTOMATIC

AUTOMATIC-WRITING EXERCISE

Thomas Lux

The point of this exercise is to gather and then to cull, extract, from a large pile of stream of unconsciousness or automatic material the one or two ounces of goods that then might be applied to the writing of poems.

General Rule: Be prepared to do this exercise every day and if possible more than once a day for at least ten days. It can be done at any time (even at its lengthiest it will not take more than about twenty minutes) but it sometimes works better if it is done when one is, for example, tired, or just waking up, or agitated, or elated, etc. In other words, when one's synapses might be a little askew, when one is not feeling most "average."

RULES:

1. Start in the upper left corner of a page and write *without stopping* for a set period of time or until you reach a certain predetermined point on the page. It works better to use a type-writer because it is faster and also less of a physical strain, but it can also be done by hand. Keep it short, particularly at the beginning: five to seven minutes per exercise, a page maximum. Remember: once you start writing *do not stop.* Try to write concretely, sensorially, in images. Do not worry about "sense,"

do not think, pay no attention, at this point, to grammar, punctuation, etc.

2. When the predetermined point on the page is reached or the allotted time is up, remove the paper from the typewriter. *Do not read it. Put it away.*

3. Do these exercises until you have approximately the equivalent of ten single-spaced typed pages. Gradually lengthen the time for each exercise but never more than twenty minutes or so.

4. Once you have the ten pages, read through them all and underline anything that seems in any way interesting, fresh, weird, reverberant. Trust your instincts. Some of the material will be strange, scary, truly bizarre. If you have followed the above rules, you will not even remember having written most of it.

5. Pull out these underlined fragments. Correct spelling, punctuation, etc. The fragments will probably range from single words to word couplings, to images, to passages running three to four lines long. Type the fragments double-spaced (so you'll have room to make hand-written revisions). Maybe you'll have one to two pages of these fragments now, out of the ten with which you began. Number the fragments.

6. Repeat rules 4 and 5, this time being a harder editor regarding what is truly interesting, loaded, fresh, etc. Change, add to, or cut words from fragments, listening to them a little for what they might be suggesting, where they might be trying to lead you. Now you might have less than a page of these fragments, maybe 1 or 2 percent of all the words originally written, a dozen fragments say. Renumber them.

7. Read them, listen to them: somehow numbers 1, 4, 7, 9, for example, will seem to belong together, be thematically/emotionally linked. Ditto numbers 2, 3, 8. Some might not seem to be connected to others but might seem to contain some seed of a poem, a title, a rhythm, etc. Some might be just beautiful, enigmatic orphans.

8. Put the fragments that seem to belong together on a page and use them as psychic notes to a poem. Make the conscious connections, put all the sweat in, do whatever work necessary to write a poem. Good luck.

═══

The point of this should be obvious: to tap into unconscious material, figure out what from this huge swamp is potentially poetic material, and then to use it, add to it, change it, etc. Instead of beginning a poem with a memory or experience, you begin with something less obvious, less literal, and try to find what it was about it that made you write it in its first, roughest form. This is not automatic writing as the surrealists used the term. For them, the poem existed after the completion of rule 1. Nor is this exercise a method for writing poems, a formula—it is simply an exercise of discovery, a way of coming at the process of writing a poem that may help writers write poems they did not know they wanted or needed to write.

TRANSLATIONS: IDEA TO IMAGE

(FOR A GROUP)

Carol Muske

This is an exercise I've tried with students from preschool to MFA programs, mainly to prove that the mind does not "think" in abstractions.

I'd like you all to shut your eyes and I'll say a word. Open your eyes and tell me what you "saw." For example, if I say "justice," you may see the lady with the scales or a judge with a gavel or a courtroom. This is the mind's "translation" of an idea, an abstract concept to a mental picture, an image. The mind does this naturally.

For example:

LOVE	hearts, a loved one's face
DEATH	coffin, grave, tombstone
SELF	mirror, photo, conehead
SOUL	votive fire, black-eyed peas, god's eye

Please write down your "images." Be honest about what you "see." Don't worry if you see a Brussels sprout when I say "self"—your mind is telling you something. It's making a connection, which may not be readily apparent to you. There is no such

thing as a non sequitur, the mind always has logic; it might not be obvious logic, but the mind has its reasons for connecting two seemingly unlike notions.

Let's "track" this process a little bit. I once gave this exercise to first graders. A little girl responded to the word *Happiness* by writing, "I feel like a big orange sun is coming up inside my body." I asked her to continue following this stunning visual presentation, and she described the sun heating up her toes, her shins, ascending through her body, blazing out of her head "like a sunflower," and rising into the sky, where it became a "second sun" that pulled "the real sun" into it like a "black hole." Not bad.

Regarding the "Brussels sprout" syndrome, the process is the same. If I say "self" and you see a Brussels sprout, continue to interrogate that image and write down the next image that it inspires, and the next. You may find that you are "tracking" the ignition of a poem—let's say you see a hand picking up the broccoli, or a toy next to it. You recognize the hand as yours, your hand as a child, you begin to enlarge the frame, you see it's you as a baby eating broccoli for the first time, conscious of being a separate (perhaps suffering!) being. Or the images keep coming and stay mysterious. That's OK too, but keep the record, write down these signals from the unconscious. Writing is an intuitive process; we must trust our intuition.

*T*he poet alone may find "Translations" a rewarding solo exercise, given the often hermetic nature of the evolving imagery and the frequent attendant feeling of unexpected personal revelation. Or, on a

lighter level: personal "etymology" is fun; it's exciting to track words to their surprising sources and can be an effective writer's-block breaker.

Here is a list of "abstractions" displayed in four columns, to enable the solo poet to play a kind of translation "solitaire."

1	2	3	4
RAGE	SOLITUDE	MERCY	PEACE
ORDER	ECSTASY	PAIN	WAR
JUSTICE	EVIL	HUNGER	HISTORY
COMMON	GRATITUDE	GOD	ANGEL

The idea is investigation: follow the thread back through the labyrinth to the literal referent (Minotaur?). Give yourself five minutes. Pick a word, at first glance, from each column, then write down all the non sequitur images you get for each one. See where this takes you. See what connections occur among the columns. Circle the words that seem most vivid and evocative, that seem to reverberate with intention. Take another five minutes. Try these words in lines. Experiment; allow your intuition to lead you. Don't frighten yourself; trust what comes up. If you want to try a kind of solitaire, you could use all the listed words in a kind of nonassociative narrative—place one list over another, try to connect these dissimilar progressions.

DREAM NOTEBOOK

Maxine Kumin

Keep a dream notebook in which, on awakening, you record whatever fragments or scenes you can recall. Do this over a period of two or three weeks, or longer. Don't expect the material to be linear or rational, just write down whatever you can manage to assemble. Some of your dream content may be so bizarre and/or embarrassing to your waking self that you'll censor it on the spot. That's fine. This is not meant to be psychotherapy. What you'll begin to see are the ellipses, the gaps between dream "frames," the abrupt shifts in characters and chronology. Once you see how easily your unconscious mind free-associates, you may be able to carry this technique over to your conscious state.

Not every dream will be useful, but thinking through or trying to "solve" a dream may on occasion lead directly into a poem. Think of this as an experiment and be grateful for what you get.

*T*he editors comment: What we remember from our dreams can provide useful models upon which to base fresh strategies for poems, since dreams rarely follow merely logical or tidy narrative progressions,

yet they often seem to have an emotional wholeness. There's much to be learned, too, from the imagery of dreams—surprising, vivid, sensual—and from their linguistic playfulness (we often dream in puns). As a direct line to the unconscious and an antidote for literal-mindedness, our dream life provides us with private invented worlds that we must approach slantwise, with the indirection of the unconscious itself. But dreams have a way of leaving things out, too, reminding us of the power of whatever's missing: the image expected but withheld, the pervading presence of something left unsaid.

TEN-MINUTE SPILL

Rita Dove

Write a ten-line poem. The poem must include a proverb, adage, or familiar phrase (examples: she's a brick house, between the devil and the deep blue sea, one foot in the grave, a stitch in time saves nine, don't count your chickens before they hatch, someday my prince will come, the whole nine yards, a needle in a haystack) *that you have changed in some way*, as well as five of the following words:

cliff	blackberry
needle	cloud
voice	mother
whir	lick

You have ten minutes.

———

This exercise is an adaption of one I was given as a creative-writing student during my undergraduate years. I usually write the words on the board and spend a few minutes inviting the class to suggest proverbs to put on the board, though I also encourage students to use another adage if it occurs to them. I announce the time limit as the very last thing, and while they are gasping, I

usually tell them not to worry about making poetry—just put it in lines and write whatever comes into their heads.

I think you'll find the results consistently astonishing. In the list are "buzz" words like *mother, needle, cliff* as well as several words that can function as verb or noun. There's a nice balance between fuzzy, dreamy words *(cloud, whir)* and concrete, vivid ones *(blackberry, needle)*. The saying is there to give you a unit of American speech, a homespun rhythmic line to spin off from. If you don't freeze immediately in terror—and the ridiculously short time allotment usually allays panic, since you know it's impossible to write a poem in ten minutes, right?—what tends to come out are scary and wild chunks of psychic landscape.

AUCTION: FIRST LINES

(FOR A GROUP)

Michael Waters

Write a line of poetry that seems to be an opening line. Be prepared to discuss why your line is a first line rather than a line that might function equally well in a different context, and to describe the poem you envision following your line in terms of ideas and form (stanzaic structure, meter, rhyme scheme, length, tone, etc.). Then be prepared to give your line away.

In class, each student reads his/her line and discusses its possibilities. Other students offer suggestions—what sort of poem they see burgeoning from that opening line, and why. These suggestions constitute their bids. Then the author of the line agrees to give it—no strings attached and forever—to the student whose suggestion, enthusiasm, or oddball approach most pleases him/her. The next week the students bring in their drafts, each beginning with a "purchased" opening line, for discussion.

———

"Writing poetry used to be easy," Louis Simpson has half-joked. " 'The stag at eve had drunk his fill'/got you off to a running start." Fortunately, this is no longer true. Many students have told me that they have trouble beginning a poem, that they don't know how to get started. This exercise is designed to give you

that start, in part by relieving you of the burden of literary self-consciousness. "The first line *is* a commitment," exclaimed Robert Frost. It anticipates—no, *requires*—the lines that follow. So the task is simple: attempt to complete the poem. The poet cannot choose to do otherwise.

A good opening line triggers a series of responses, additional lines that surge forward like ocean swells, unstoppable. Suddenly the poet is swimming with possibilities, anxious to chart each direction. Working alone, the poet might free-associate, jotting down line after line without regard for narrative continuity, logic, or craft. Simply allow whatever comes to mind to find its way onto the page. Then consider each line—its evocations, its particular music. Which line crooks its finger to beckon? In which line have you already begun to immerse yourself?

"ONLY CONNECT"

Sydney Lea

Select three entries from your journal, no two dated within four days of each other, and discover in verse the connection among them.

———

Example: On the 6th of May, you saw two dogs locked in their love act, the larger female dragging the male around by his member; on the 10th, you broke your toe; on the 14th, it snowed out of season. Okay: Go for it.

In your daily journal, enter "things that stop you in your tracks," with minimal editorialization or reflection. The three entries on which you'll base the poem should be well removed from one another, so that we won't have a bossy idea, a package, a summary. (For isn't the prime defect in most beginning verse its yen to report *on* experience, rather than artfully to suggest the mind/heart *in process of* experience?)

A Premise: Most writers write, at least in some measure, to find out what their current obsessions are.

A Problem: Many writers have been (mis)educated into believing that literature's aims are abstract or philosophic; thus their great-

17

est block is (quote) "I couldn't come up with an idea." Dogs, snow, toes: *huh?*

A Remedy: "Couldn't come up with an idea"? Well, good! Aprioristic ideas make for writing of no vigor. Poetry is not—as my friend Bill Matthews once quipped—criticism in reverse. A poem's aim isn't to start with a conclusion and then disguise it, so that somebody smart can find the (quote again) "hidden meanings." My exercise, accordingly, should liberate you from the mere ideational into material more properly your own: personal idiom, for starters, and a whole range of as yet unarticulated intellectual/emotional responses to . . . Life.

Reprise: Problem and Remedy: Many academic instructors ask, What is the poet trying to say? As if s/he had some awful throat disease. The poet who successfully completes the above exercise may answer that what s/he is saying is what has been said. (Of course, it ought to make some sense: see Final Note.) The capital-M meaning of the poem, that is, consists exactly in the language, imagination, and logic that *found the connections.*

Such formal abilities as you've developed can surely be part of your means here. You may elect, say, to make every third line a heptameter, to make every fifth one rhyme with every seventh. Or maybe you'll do a quick draft, count its lines, and, using the lowest common denominator as a divisor, break it into stanzas. Whatever. You're free of course to cheat, the point once more being to get the poem off scratch—to show that associations mustn't be too strenuously willed; that even though "ideas" inevitably emerge from one's poetry, they must not determine it. Sure, writing is work, but it is not labor: however mopey or melancholic your verse, it wants to have included some element of the playful, or else it'll be dull for maker and reader both.

Final Note: Lest all this sound too awfully late sixties or vulgar-romantic, I should add that I place great emphasis on the intellect in verse. (How could one read Spenser, say, and not?) But intellectual control of a poem is something to apply *after* the materials have been allowed to float to the surface, as I hope my exercise may help them do.

CHANTING THE FLOWERS
OFF THE WALL

(FOR A GROUP)

Christopher Davis

A few nervous disclaimers. This exercise may seem absurd, pointless, overly romantic, and flaky. It comes from certain assumptions about poetry that one might not agree with. And there is probably a type of student to whom this might be offensive. It's meant to set a tone for the workshop or writing group, no more, no less.

At the beginning of our first or second meeting, I tell the group that we're going to perform a kind of inaugural ritual. We talk for a moment about the way rhythm in a poem connects language to the body's nerve endings. We talk about living inside poetry, giving your self over to its voice, sacrificing, if only in gestural ways, self-consciousness, self-concern, in order to liberate the primal life of poetry. We leave the classroom. We walk either outdoors, into a nearby wooded area or the campus botanical garden, or indoors, into a special enclosed area other than the room in which the workshop will normally be conducted, a basement, possibly. Why not be as stagy as possible? I light incense. I set an alarm clock for twenty minutes. I say, "Okay, let a word—any word—fly into your head. Now we'll repeat our words aloud for twenty minutes, nonstop!"

A little discomfort is to be expected, especially during the first few minutes. Eventually, though, something stronger grows from the chanting. I think it begins to grow for each participant once he or she experiences a kind of wounding of the language, once the word randomly chosen becomes, through repetition, a "meaningless," alien, entirely sensory sound, (*iceberg* becomes *eye spurg*, etc.). After that, the emotional dislocation that had surfaced as embarrassment is in harmony with a dislocation in the logic of vocalizing. Because the experience centers on a word, yet the emotion felt in the chanting has little to do with the etymological, formal tip of the iceberg, a feeling for the tonal, musical values of words is stirred to life. I think, afterward, a sense of poetry as "convulsive beauty" stays with the group, and everyone feels a little less imprisoned in the need to write slick, tightly controlled, "ideal," processed poetry.

AN EMOTIONAL LANDSCAPE

(FOR A GROUP)

Cleopatra Mathis

The teacher begins by reading a poem aloud.

1. Listen carefully to the poem as it is read aloud. It's best if the poem is unfamiliar.

2. Afterward, without looking at the poem, write down all the evocative words you remember, or any other words that the poem triggers.

3. Imagine a journey you might take in a real (concrete) landscape, one that is familiar to you. Use the words you have chosen to guide your way into a poem in which you take that journey, literally or figuratively. Let the borrowed language propose ways to break through your familiarity with the landscape, by suggesting details, a mood, the bare bones of a narrative, a kind of diction, or maybe even something as specific as the name of the place, or words spoken there.

———

The poem read aloud should in some way have to do with a journey. Two excellent poems are "A Blessing" by James Wright and "To Go to Lvov" by Adam Zagajewski. By adopting the

mood and tone the poem evokes through its particular language, you enter an emotional landscape which is crucial in the recovery of memory. That sensibility then determines the location of your poem. The poem might focus on one specific incident or aspect of the journey, it might follow the complete route, or it might end in a place that no longer exists. After you have the first draft of a poem, you might find it helpful to "copy" the poem you heard. Taking the poem line by line, you might model your own poem after the original by progressing similarly from subject to subject, observation, metaphor, tone, etc. This is particularly useful in the Zagajewski poem, which follows.

To do this exercise alone, *outside of a class,* read the Zagajewski poem *once,* and then put it away. Go on to step 2.

To Go to Lvov
by Adam Zagajewski

To go to Lvov. Which station
for Lvov, if not in a dream, at dawn, when dew
gleams on a suitcase, when express
trains and bullet trains are being born. To leave
in haste for Lvov, night or day, in September
or in March. But only if Lvov exists,
if it is to be found within the frontiers and not just
in my new passport, if lances of trees
—of poplar and ash—still breathe aloud
like Indians, and if streams mumble
their dark Esperanto, and grass snakes like soft signs
in the Russian language disappear
into thickets. To pack and set off, to leave

without a trace, at noon, to vanish
like fainting maidens. And burdocks, green
armies of burdocks, and below, under the canvas
of a Venetian café, the snails converse
about eternity. But the cathedral rises,
you remember, so straight, as straight
as Sunday and white napkins and a bucket
full of raspberries standing on the floor, and
my desire which wasn't born yet,
only gardens and weeds and the amber
of Queen Anne cherries, and indecent Fredro.
There was always too much of Lvov, no one could
comprehend its boroughs, hear
the murmur of each stone scorched
by the sun, at night the Orthodox church's silence was
 unlike
that of the cathedral, the Jesuits
baptized plants, leaf by leaf, but they grew.
Grew so mindlessly, and joy hovered
everywhere, in hallways and in coffee mills
revolving by themselves, in blue
teapots, in starch, which was the first
formalist, in drops of rain and in the thorns
of roses. Frozen forsythia yellowed by the window.
The bells pealed and the air vibrated, the cornets
of nuns sailed like schooners near
the theater, there was so much of the world that
it had to do encores over and over,
the audience was in a frenzy and didn't want
to leave the house. My aunts couldn't have known
yet that I'd resurrect them,
and lived so trustfully, so singly;
servants, clean and ironed, ran for

fresh cream, inside the houses
a bit of anger and great expectation, Brzozowski
came as a visiting lecturer, one of my
uncles kept writing a poem entitled *Why*,
dedicated to the Almighty, and there was too much
of Lvov, it brimmed the container,
it burst glasses, overflowed
each pond, lake, smoked through every
chimney, turned into fire, storm,
laughed with lightning, grew meek,
returned home, read the New Testament,
slept on a sofa beside the Carpathian rug,
there was too much of Lvov, and now
there isn't any, it grew relentlessly
and the scissors cut it, chilly gardeners
as always in May, without mercy,
without love, ah, wait till warm June
comes with soft ferns, boundless
fields of summer, i.e., the reality.
But scissors cut it, along the line and through
the fiber, tailors, gardeners, censors
cut the body and the wreaths, pruning shears worked
diligently, as in a child's cutout
along the dotted line of a roe deer or a swan.
Scissors, penknives, and razor blades scratched,
cut, and shortened the voluptuous dresses
of prelates, of squares and houses, and trees
fell soundlessly, as in a jungle,
and the cathedral trembled, people bade goodbye
without handkerchiefs, no tears, such a dry
mouth, I won't see you anymore, so much death
awaits you, why must every city
become Jerusalem and every man a Jew,

and now in a hurry just
pack, always, each day,
and go breathless, go to Lvov, after all
it exists, quiet and pure as
a peach. It is everywhere.

A JOURNEY TO NOWHERE

Susan Snively

Write a poem in which you undertake a journey to an unknown destination. The poem does not necessarily have to have a formal "plot," but does have to leave you, at the end of the journey, in a wholly unexpected place: either in the midst of a strange landscape (mental and/or physical) or in the throes of a threatening or exciting discovery (self, other, or both).

Begin the poem with a predicament: the speaker of the poem (the poet, her surrogate, a fictional narrator, or an actual person re-imagined) is lost, or hunting for something (someone), or is being propelled into a quest against her will, or is on a supposedly ordinary journey that turns weird.

Make the poem long enough (sixty-five or more lines) to make it hard for you to predict its outcome. It should be written in some kind of line that you follow more or less consistently throughout (this may be regular iambic pentameter, or something looser). Long verse-paragraphs suit this exercise, as do six-to-eight-line stanzas with informal rhyme schemes (abaccbca, abbcacbc, etc.) or no "scheme" at all. Some regularity of form helps give the sense that the *poem* is taking the *poet* on the journey; it works against a too-rational and too-orderly plotting by setting up a crafty, quasi-deliberate momentum.

Besides being fun to write, this journey-poem is useful for its challenge to your customary anxiety for closure, an anxiety that may prohibit the imagination. As you write your way into a world created as you go along, you have the privilege of using "useless" material: images that exist for their own quirky beauty, flotsam and jetsam from actual journeys, revived memories, "superstitious trash" from old legends and stories, dream images and other nonrational arcana.

Writing this poem deliberately over a period of days or weeks allows you to enact the journey on several levels, so that what you see resonates with what you cannot explain.

Suggested Readings: Elizabeth Bishop's "The Moose," Richard Wilbur's "Walking to Sleep," Robert Frost's "Directive."

THE FREE-LANCE MUSE

Ann Lauterbach

Imagine you are a free-lance muse, looking for work. In recent years you have had to supplement your life with various odd jobs—inspiring an ad executive at Nissan in Japan, writing political manifestos for East German dissidents, and typing numerous grant proposals. You're tired and sad, and want a real poet. Write a job description for the poet you want to inspire.

===

This assignment was simply an attempt to get a sense of how students think about what it means to be a poet. Since I think of poets and poetry as increasingly outside mainstream culture, the desire, however inchoate, to write poems and then, perhaps, to become a poet must be predicated on something other than usual ambitions. That is, I wanted to provide a way for students to begin to explore the social, cultural, and political implications of being a poet, to notice that to be a poet is not just a matter of mastering technique.

Many of the responses were witty, some predictable; most, it seemed to me, were self-limiting. One young man stressed techni-cal proficiency above all else—he saw a poem as a well-oiled machine having only to do with precision. Nothing could per-

suade him of the legitimacy of open forms, nor that poems might do something other than describe. Nevertheless, the discussion that resulted had the desired effect: to allow the students to begin to think about and examine what the role of the poet (and of poetry) might be in a consumer-driven economy. The precarious life of the "free-lance muse" gave them an opportunity to think about the life of a poet as other than a professional career. We had a very lively discussion.

Part Two

The
THINGS
of *This*
WORLD

———

IMAGE AND

METAPHOR

ONE'S-SELF, EN-MASSE

Michael Pettit

> One's-self I sing, a simple separate person,
> Yet utter the world Democratic, the word En-Masse.
> —WALT WHITMAN

With the above in mind, write a description of two or three paragraphs (no longer than one double-spaced page) in which you describe one *particular* member or element of a set:

> one sparrow in a flock of sparrows
> one baby in a nursery of babies
> one fish in a barrel of fish
> one scream in a stadium of screams
> one somersault in a series of somersaults
> one Rockette in a chorus line of Rockettes

The challenge is to perceive the qualities of the group, and to distinguish what makes an individual member of that group both a part of it and apart from it. Avoid the above examples if possible; instead use sets (groups) that you can observe directly, or observe them in your imagination. Try for clarity and simplicity in your language.

33

"Perception," said William Carlos Williams, "is the first act of the imagination." This exercise is intended to alert you to the world of words, to alert you to make distinctions and create particular images rather than vague emotions.

This is a prose exercise. Although there is no reason you can't use lines, beginners usually are not at ease with either the free verse or conventional line. I prefer to have my students look at the line more closely and exclusively in later exercises.

I focus upon concrete particulars, and how they can express the writer's vision to the reader. Although beginners often describe one rather than both subjects well (e.g., the one mackerel, but not the barrel full), it is an exercise at which students can *succeed*. A reminder for subsequent revisions: look before you write.

INTRIGUING OBJECTS EXERCISE/
"SHOW AND TELL"

(FOR A GROUP)

Anne Waldman

Objects are wonderful "presences" to focus writing upon.

This exercise works best in a group workshop situation and may be adapted to any age group. All participants are requested to bring an intriguing object into class that has an interesting history, a *story* to tell—a romantic story, a strange or magical story, a harrowing story. The object might be something beautiful and mysterious. Objects I've worked with have included a small ivory bird carving, for example, and a mica-speckled stone from the desert. The chosen object could be exotic—an ancient Chinese coin or a voodoo charm. Perhaps the object might be associated with a dream. Or it could be terrifying—a kris knife from Bali in Indonesia. Or it might be mundane, yet have a fascinating history. We often carry a modest totem penknife, wallet, photograph, or postcard in our back pockets or handbags for years. The point is for all the writers involved to present an individual object they can speak life into, which will interest and inspire the rest of the writers in the group. The objects are first presented in turn and passed around while the person tells his or her personal "story." Everyone else in the group takes notes. It is fascinating how intense, exotic, and often dramatic these brief narratives are.

Once the oral storytelling aspect of the experiment is completed, all the participants "make" a piece of writing (poem, prose, play, "experimental" or open form) using the objects and descriptions in any manner or order they choose. The point is that the objects themselves and the telling about them have provided marvelous information for writing. I knew a writer who used all the objects as "clues" in a mystery story.

———

I personally have tended to write "lists" that combine the "naming" of the objects and how they've been spoken of. The example I include here I later incorporated into a piece entitled "Realm Which Includes an Eclipse, A Cave, & Some Amulets." I use the word "says" after every line, which is something one finds in American Indian ritual chants, to get across the "oral" nature of the exercise:

> "An Irish tin whistle is cheap, I got it in the Indian
> Chesos Mountains,
> It takes on marks, tone changes," says
> "This horseshoe nail necklace is a surrogate for 4 Corners-
> Indian-squash-necklace," says
> "I'm 28 I have a bird's eye view," says
> "All the color washes out when you hold it to the light,"
> says

I've found in my own writing workshops that this exercise is an excellent way to get acquainted, as people reveal themselves in unexpected ways through the objects they choose to describe and display. It is also a collaborative effort. I think this exercise came out of my early delight with "Show and Tell" in grade school.

BREAKING THE SENTENCE;

OR, NO SENTENCES

BUT IN THINGS

Roger Mitchell

Write a poem that is simply a list of things.

━━━

I often assign this exercise to poets whose minds seem, at the time, overdetermined by the sentence and all its rules and proprieties. Overborne by language, you might say. When someone writes something like, "When I stepped out onto the back porch," it is sometimes difficult for that person to get away from what language is demanding. She might well finish the sentence with a clause like "the moon hung like spittle in the prophet's beard" or something more imaginative (hopefully), but the writing will often seem as if it were made by the sentence rather than by a freed imagination. It makes a kind of writing all teachers are familiar with, more thought than feeling, more concept than image, more of whatever it is that language has been constructed to produce—clarity, coherence, and the like—than that thing which poets hope to isolate through or with the aid of language. We all have a sense of the necessity and beauty of language in writing poetry, but we only come slowly to the realization that language is also an obstacle, almost the enemy.

In the whole process of dismantling the relationship to language all of us are given—language as tool, for the most part—and

learning a more plastic sense of it, this exercise can be helpful. It also has the virtue of urging writers to look outside their minds to or toward the objective world.

What happens in this exercise is that you find you only have images to manipulate. This helps everyone, of course, especially the verbose or verbally facile, begin to see the possibility of "speaking" in images rather than in sentences or concepts. And, too, with the elimination of the traditional structures provided by the sentence, i.e., narrative or exposition, you're freer to arrange "things" in your own order, and that can be a useful introduction to notions of structure in a poem, indeed to the idea of structuring.

So, while we wouldn't want a great many poems that were simply lists, I think the exercise can help with a number of the basic lessons all writers need to learn: that language is a more plastic medium than we are taught, that the objective world is our best (perhaps only) source of images, and that poems are made things.

The only example I can put my hand on at the moment is a section of one of my poems, "Letter to Milwaukee."

The empty stapler, the unsharpened pencil,
the dry rubberstamp of a dead executive,
instructions for the care of lenses,
the closed pipe case, recipes for soap,
unanswered letters from Puerto Rico,
back issues still in plain brown wrappers,
bookmarks stuck into slanted texts
like flags in the sides of whales
hunted by other men in another time.

As you might guess, I was listing things on my desk, including a copy of *Moby Dick*, which I was rereading at the time.

See Robert Bly's *News of the Universe*. The section on the "object poem" is a useful extension of some of these ideas.

Further reading suggested by Christopher Buckley. These poems use lists in a wide variety of ways:

GARY SOTO—"Ode to the Yard Sale," "The Soup," "Song for the Pockets"

JAMES WRIGHT—"Lying in a Hammock at William Duffy's Farm in Pine Island, Minnesota"

JAMES TATE—"The Blue Booby"

ELIZABETH BISHOP—"The Fish"

DIANE WAKOWSKI—"Snowy Winter in East Lansing," "Overweight Poem"

CHARLES SIMIC—"Forest Birds"

GARY SNYDER—"Why Log Truck Drivers Rise Earlier than Students of Zen," "Above Pate Valley"

PHILIP LEVINE—"Grandmother in Heaven," "Salami," "The Cemetery at Academy, California"

LYNNE MCMAHON—"Earth"

ALLEN GINSBERG—"Howl"

PETER EVERWINE—"Back from the Fields," "Learning to Speak"

FIVE EASY PIECES

Richard Jackson

As in the movie this title refers to, we discover things visually in fragmentary form, and what we think we know or see and what someone else knows or sees and what we communicate between those two positions is scant. This exercise attempts to tell a whole story in a quick scene. It is to be written in five sentences, and can be done in a class. There are two preparation steps. The first step is to remember a person you know well, or to invent a person. The second step is to imagine a place where you find the person. Then you are ready for the five pieces.

1. Describe the person's hands.
2. Describe something he or she is doing with the hands.
3. Use a metaphor to say something about some exotic place.
4. Mention what you would want to ask this person in the context of 2 and 3, above.
5. The person looks up or toward you, notices you there, gives an answer that suggests he or she only gets part of what you asked.

━━

Years ago I met a wonderful old woman on Martha's Vineyard. She told me I had the hands of a priest, then went on to invent

a life for me. Maybe it never turned out that way, but I've kept it as an ideal. What has always struck me is how you can invent a story from a part of a person. Here the writer is asked to focus on the hands and what they are doing, then explode the poem out to some widely different, unfamiliar context. Now the trick is to come back, but come back by trusting that your subconscious brought you to a place that has some relation to what you have been observing. The way to come back is usually through some tonal or image path related to the metaphor. Finally, the focus is broken again, this time by the subject. Often the other person ends by saying something about the exotic place that makes all the emotions come together.

The exercise is probably the most successful one I've used in beginning classes and is useful in showing how a poem can condense narrative and characterization, how it can quickly shift focus like a photographer going wild with a zoom lens, how images reveal stories behind them simply by knocking against other images and perspectives, how you can use dialogue in a poem—each time I use it I've found different uses. Sometimes I've made the five pieces sections rather than sentences or lines, but for a first draft, the sentence/line rule is generally best.

AS/LIKE/FINISH THE SENTENCE

Linnea Johnson

Fill in the blanks as rapidly as you can. Do not think. Write. If you have no reflex response, go on to the next sentence. Stop writing when you slow down.

1. A spider on an old man's beard is like _____
2. The oars on the boat rowed as if _____
3. Nothing was the same, now that it was _____
4. The wino took to coma like _____
5. The dice rolled out of the cup toward Len like _____
6. A child in _____ is like a _____ in _____
7. Puffy clouds in your glass of wine are _____
8. _____ is like muscles stretched taut over bone.
9. The fog plumed through the gunshot holes in the train windows like _____
10. The gray honor walked up the satin plank as if _____
11. Canceled checks in the abandoned boat seemed _____
12. If I should wake before I die, _____
13. Alannah poured coffee down her throat as if _____
14. Up is like down when _____
15. You mine rocks from a quarry. What you get from a quandary is _____
16. Marlene dangled the parson from her question as if _____

17. She held her life in her own hands as if it were _____
18. "No, no, a thousand times no," he said, his hand _____
19. The solution was hydrochloric acid; the problem was, therefore, _____
20. Love is to open sky as loathing is to _____

Reread the sentences you've finished, circling a couple you like best. Begin a poem using a simile/metaphor/analogy you've written.

━━━

This exercise asks you to go through a slew of sentences creating image, metaphor, analogy, connection, filling in whichever blanks catch your fancy, leaving blank those that do not trigger any response. The exercise teaches by showing, not telling.

It also causes silliness—an added benefit.

QUILTING IN THE DITCH

James McKean

Choose a particular item or activity and make that the object of
a language search. Find out as much as possible about the lan-
guage associated with that object, especially active and concrete
verbs, the history of the names used for that object, and terminol-
ogy that seems especially colorful. Then save from your search
a list of nouns, a list of verbs, and a list of adjectives. Finally, write
a poem using the words from these lists, keeping one last criterion
in mind—the subject of your poem must be something com-
pletely different from the original object of your language search.

The point of this exercise is, first, to explore language sources
and, secondly, to promote thinking about metaphor. The dictio-
nary, encyclopaedias, etymological dictionaries, instruction man-
uals, and resource books given to a particular activity are a few
of the possible sources. How far one goes in a search like this
depends on how rich the time or activity is in history and lan-
guage. A search for language associated with *engine manifold*, for
example, might not turn up as much material as a search of the
word *quarry* or *juggling* or *furniture* or even *quilting*. And then
again, words such as *fishing* encompass so much that gathering all
the terminology could turn into a lifetime project. Whatever the
case, there will be many surprises.

After a clumsy attempt I once had at rock climbing, I thought there might be a poem in the experience. I read a how-to book on rock climbing not because I thought I could do better a second time but because I was curious about the language of what had happened to me. Thumbing through the pages, I found I was "free" below a "ceiling," too concerned about my "exposure," the "crux" so much at hand that no "smear" nor "cam" nor "armlock" could prevent the inevitable. I was stuck in a "lieback," a word that suggests ease but ironically describes a most strenuous climbing technique, hands pulling one way and feet pushing the other. I wasn't up to it and fell. Thus, my fondness for words such as *rope, anchor,* and *belay.* The writing exercise suggests I explore the metaphoric potential in these words by writing about something other than rock climbing. How many times have I been stuck and then lost my grip? Too many.

Of course, conditions within the exercise are subject to change. The number of words taken from each list and the ratio might be varied, or formal prescriptions might be introduced, such as the number of beats per line, stanza length, and the type and location of rhyme, all intended, as Roethke says in "The Teaching Poet," to "throw the student back on the language and force him to be conscious of words as a medium."

I think there are many benefits with this exercise. One is finding new uses for found language, a process by which poems are often discovered. Another is renewing the metaphoric origin of words that have grown thin with abstraction. Another is the surprise in discovering how language is still used metaphorically. To find, for example, that quilting along the seam of two pieces of cloth is called "quilting in the ditch." To find that twelve-ton limestone blocks are split from the "parent ledge" by the use of steel wedges called "feathers." Even those who work the quarry have a poetic turn of mind. The exercise attempts to foster this kind of thinking.

GETTING AT METAPHOR

Roger Mitchell

This exercise comes in three parts.

A. Describe an object or scene that particularly interests you without making any comparisons of one thing to another. Re-write it, if necessary, until it is as free of comparisons as possible.

B. Take the same object or scene and use it to describe one of your parents. In other words, indulge yourself in comparisons.

C. Write a poem which, though it is a description of the object or scene above, is really about your parent.

═══

I've found it best to do this exercise one part at a time. In fact, I've sometimes split part A in two, first asking a class to describe without comparisons and then having them read their writing aloud, pointing out along the way where they succeed and where they lapse into comparison. It's useful for them to see how automatic and essential the making of comparisons is and how difficult it is to write or think without it. Metaphor is not just a game people play to make their statements striking, and of course it is not just poets' property; it is a basic tool of comprehension.

The exercise helps teach the necessity of indirection. The quickest way from point A to point B (from a person to his clarified feeling, say) detours through metaphor. Not to mention through several drafts in the rewriting.

Sometimes I change the menu slightly. I bring a pinecone or some other complex, natural object to class and have students describe it, or I ask them to use it in part B to get at something they are afraid to talk about.

Anthologies abound with poems that describe one thing in terms of another. Donne's "I am a little world made cunningly" is a good example. Shakespeare has an interesting time in "My mistress' eyes are nothing like the sun" freeing his praise for his mistress of "false compare." Though the poem begins with simile, the principle is the same.

And, I must give a nod to Robert Bly, who, visiting my class many years ago, put us all, himself included, through an exercise that gave me a number of ideas for this one.

A LITTLE NIGHTMUSIC

THE NARRATIVE METAPHOR

T. Alan Broughton

Recall a brief incident from your own life that has *for you* a high degree of intensity. It can be a very fragmentary moment or scene and above all does not need to be a complete "story." (If you are having difficulty identifying such an experience, pay close attention to your dreams for a few nights, tracing any connections you can to your waking life.) Jot down notes, the more incoherent the better, that are only details from that incident. Do not generalize about its meaning. Try to pick details that give you its tone, the emotional core.

Now try to imagine and invent an incident that is not your own experience but is set in the same location as the scene above. Make the tone of this new incident contain a significant contrast to the previous one. Again, do not generalize, but let your jottings be a grab bag of facts concerning the action, plot, basic narrative of the event.

Write a narrative poem that combines or superimposes these two incidents using as many of the words and images you have accumulated as you can. In the first drafts do not demand logic or coherence from your poem. As you revise, do not hesitate to let the poem become a third narrative, as different from the first two as is necessary to make the *poem* work.

An example. I have been driving in the country, in no hurry to get where I am going. I pull over to stop briefly by the side of the road to admire a view. There is a truck nearby; no one seems to be in it, but its radio is loudly playing a Mozart serenade. I look at the landscape for a while, pull out, and continue on my way. That evening I remember the combined beauty of landscape, summer afternoon, the Mozart issuing a little incongruously from a pick-up truck without occupants. I jot down a note because the memory gives me the twitch that indicates a poem might be there. A few weeks later I find myself beginning to work with the note, but as I proceed, for reasons I cannot grasp at the moment of writing but which I have learned not to question at least until the first draft is done, I add an empty police car beside the truck and imagine that the body of a man who has hanged himself from a tree in the woods beyond is being lowered to the ground. (Does this incident actually pick up on the very slight touch of vacancy in the empty truck? Was the beauty already flawed? I suspect almost every experience we have that sinks far enough into us is given ambivalence in the deeper chambers of the mind, although often that does not rise to consciousness.)

━━━

We live by metaphor, even if we are not given to translating into words those complex combinations of emotions and the sensuous information our brains accumulate. The fine lyric poet reveals metaphors to us not as the baubles and decorative *exempla* of argument, but as the source and origin, the power before which mere statement pales because only metaphor can be both precisely concrete and richly suggestive, both utterly mundane and mysterious at the same time.

But metaphor is found not just in image. It is also pervasive in the associative elements of situations. This exercise can result in the kind of suggestive complexity that enriches any narrative, and

perhaps also enables you to understand more fully the ways in which imagination can transform literal experience, freeing you from the tyranny that often repeated statement implies: "But that was the way it happened." To paraphrase Picasso, such an exercise might help you learn how art can lie to tell the truth.

EXPERIENCE FALLS THROUGH
LANGUAGE LIKE WATER
THROUGH A SIEVE

Susan Mitchell

Write a twenty-line poem in which you use similes and/or metaphors to convey a feeling, an idea, a mood, or an experience you have never been able to communicate to anyone because each time you tried it seemed that you were being untrue to the experience—you left out something essential or you couldn't convey how mixed your feelings were. No matter how hard you tried, the feeling or the experience slipped through the sieve of language. In your poem use as many similes and metaphors as you want, but don't use fewer than five. Otherwise, there are no restrictions, so the lines can be of any length and you don't have to use rhyme.

———

Poems begin where ordinary conversation leaves off. If we can say something clearly, we don't need to write a poem about that experience or feeling or idea. Such a poem would be superfluous. Instead, we write poems about what we can't articulate, but feel pressured to say, which is why poems use language in unusual ways. In ordinary conversation we rarely use fresh metaphors. We don't say, as William Carlos Williams does in one poem, "nature in its barrenness/equals the stupidity of man" ("These") or as Rita Dove writes in another, "Every day a wilderness"

("Dusting"). But a poem will often begin with a metaphor that the poet has to learn how to understand. And often, metaphor and simile may be a poet's only means for capturing experience in all its rich complexity.

You may find that you try to control the writing of a poem by choosing an idea and thinking it out in advance. In such controlled writing there is no sense of discovery for either the writer or the reader, and when simile and metaphor occur, they tend to be merely decorative. This exercise is designed to avoid such pitfalls. By asking you to write about what until then you have not been able to articulate, the exercise encourages you to stop controlling the poem; and by suggesting that you attempt to clarify, define, and explain by using metaphor, the exercise teaches that simile and metaphor are functional, rather than decorative. Ideally, the exercise should allow you to discover that when we use metaphors that are mysterious, we often write ahead of our own understanding. Then it becomes our job to understand what we have written, and with that new understanding write the poem further and deeper. Simile and metaphor require a new way of thinking where the writer leads with unconscious or irrational thought processes, then waits for conscious thinking to catch up. Metaphor and simile allow us to say what we might otherwise be unable to say because it would simply fall through the sieve of conventional language.

Suggested reading:
 DAVID ST. JOHN, "Hush" and "Slow Dance"
 PHILIP LEVINE, "Milkweed"
 JAMES FRAZER, "Sympathetic Magic"
 ELIZABETH BISHOP, "First Death in Nova Scotia"
 WALLACE STEVENS, "On the Manner of Addressing Clouds"
 GERALD STERN, "The Expulsion"

WRITING THE SPECTRUM

Elizabeth Spires

Write a poem in which the name of a color is frequently repeated throughout the course of the poem. You may want to begin by cataloguing a number of images associated with a particular color and then deciding on narrative and associative possibilities. Consider, as you write, the symbolic associations of the color chosen: e.g., red: anger, passion; blue: depression, transcendence; white: purity, emptiness, blankness; etc. You may also want to consider the personal associations a particular color holds for you, as when my student Amy Marinaccio wrote in a poem titled "Maroon": "Maroon reminded you of dried blood, blinding rage and your deepest fears." Incorporate, if possible, the name of the color into the title of the poem.

———

This exercise works well for both beginning writers who are learning to unify a poem imagistically as well as for more advanced workshops. Reading my students' poems, I noticed that the poems were usually highly visual, as might be expected, and imagistically focused. Color functioned as a unifying motif. Because colors naturally evoke strong emotional responses, the forced and constant repetition of the name of the color usually ensures that the poem has symbolic and psychological resonance,

that it transcends being merely an "exercise." In some cases, the repetition of the name of the color, if taken to extreme lengths, "defamiliarizes" the word, making the reader hear it as strange and new; the possibilities of the latter are evident in Charles Wright's well-known poem "Yellow." Other examples from published work include the following:

"February: The Boy Brueghel" by Norman Dubie
"The Silver Plough-Boy" by Wallace Stevens
"Disillusionment of Ten O'Clock" by Wallace Stevens
"For George Trakl" by David St. John
"White" by Mark Strand

"TELL BY SHOWING": AN EXERCISE AGAINST TECHNIQUE

Roger Mitchell

The following is a list of quotations from various pre-Socratic philosophers. Write a poem using one of them as an epigraph.

A. Actions always planned are never completed.

—DEMOCRITUS

B. Old men were once young, but it is uncertain if young men will reach old age. —DEMOCRITUS

C. The path up and down is one and the same.

—HERACLITUS

D. Nature likes to hide itself. —HERACLITUS

E. The world is change; life is opinion. —DEMOCRITUS

F. Heraclitus said that a man's character is his fate.

—STABAEUS

G. [Parmenides] speaks of perceiving and thinking as the same thing. —THEOPHRASTUS

H. All things were together. Then mind came and arranged
 them. —ANAXAGORAS

I. Worlds are altered rather than destroyed.
 —DEMOCRITUS

J. Dark and light, bad and good, are not different but one
 and the same. —HERACLITUS

(For further pre-Socratic quotations, see Jonathan Barnes's *Early
Greek Philosophy*.)

I like this exercise for a couple of reasons. For one thing, it gives
writers complex issues to write about right away, issues that seem
that much more complex for having been framed in the remote
past from documents that are often fragments. Heraclitus is fa-
mous for his remark that you can't step in the same river twice,
but Heraclitus's words have apparently been lost. They survive
only in Plutarch's writings. That, in itself, is a lesson.

The exercise also focuses thinking, and it reminds us that poetry
and philosophy are close cousins. In doing all of these things, it
challenges one of the basic teachings of the twentieth century,
codified in the famous maxim "Show, don't tell." I had been
dutifully telling my students that for decades, until one day a few
years ago I realized that I was robbing them of one of the basic
pleasures of writing.

When it's been repeated to you a few dozen times, "Show, don't
tell" sounds like "Don't ever tell" or "Telling is bad." The truth
is, we all want to tell. It is natural to want to tell. Why else write

except to tell? Have we ever read anything of value that didn't tell us, that didn't *want* to tell us, that didn't have telling as its primary purpose?

How did we paint ourselves into this corner? The maxim "Show, don't tell" comes to us from the late nineteenth century. Henry James's chief advice to writers was to use the "dramatic method." It was devised in reaction to the cumbersomely didactic literature of that century. It informed the thinking of the "art for art's sake" movement. We hear it announced by Pound in the early twentieth century: "Go in fear of abstractions."

To be sure, it was a necessary antidote then. Now, however, we live in a time when, having been told it so often and so automatically, we are apt to think that thinking, propounding, generalizing, telling, and the like are crimes against art. In other words, we are still legatees of the Aesthetic movement a hundred years or so after its demise, poets whose work is apt to be sensuous rather than visionary, better at showing than telling, embarrassed by, if not nearly incapable of, thinking.

I don't think James, Pound, or even Walter Pater would object to reframing their advice. "Tell by showing" is probably what they meant anyway. It is still an exhortation to "show."

In giving this "exercise," I hope to encourage you to speak on issues that matter to you, to come right out and *tell* if you have to. You can go back and find images for your urgencies and vision later. "Show, don't tell" is excellent advice for someone who already has the impulse to tell and who knows the value and necessity of it, but many young writers today don't have that impulse, or have it but think it needs to be weeded out of their minds.

Who's
TALKING
and
WHY?

THE SELF
AND ITS SUBJECTS

A. *Aspects of Voice*

B. *What's It About?*

A. ASPECTS OF VOICE

DRAMATIC MONOLOGUE:
CARVING THE VOICE,
CARVING THE MASK

David St. John

Write a dramatic monologue (a poem spoken in a voice other than your own). You might choose a speaker from another time, place, or culture; you might choose a specific figure out of history or invent a fictional speaker (set in either a historical or contemporary context); you might also choose a speaker of the opposite sex; you might choose a speaker much older or much younger than yourself. The point of this exercise is to step into the life of another person and to speak in his or her voice. Perhaps you should say some things you'd never allow yourself to say in one of your "own" poems.

═══

The dramatic monologue exercise is one I've given to beginning writing students as well as to advanced graduate students. It is always, for the students, a revelatory experience, as it helps to show beginners how aspects of voice can be forged by using the mask of an "other," and it helps to free the more advanced students from those constraints of "self" they've already imposed upon their own work, perhaps necessarily, while working toward what they will one day consider to be their "own" poetic voice.

Dramatic monologues reveal both the character and nature of their speakers. Monologues must also establish their own con-

texts for the speaking voice as well—that is, each monologue must make clear to us its setting, both physical and historical; its dramatic situation; and its own particular juncture in time. A strong dramatic monologue reveals something of the psychology or emotional state of its speaker, often at (or leading up to) a significant moment or event in the dramatic situation (or dilemma) of the speaker. A stage soliloquy differs from a dramatic monologue in that the context and setting of the speaker's soliloquy has already been established by the play itself, as has something of the speaker's personality and character. However, in a dramatic monologue, it's the speaker who must provide these shifting backdrops and informing details in the fabric of the poem itself.

Because I believe that every poem must be, to some extent, regarded as a dramatic monologue (I would call them, often in twentieth-century poetry, dramatic lyrics), given that even those poems we offer as being in our "own" voices are created masks we've carved of language, I always feel this exercise is especially useful in asking the writer to pay attention to how a voice can reveal a self that is not necessarily *oneself*. Once you begin to see how both lyric and dramatic elements can work together to help define the complex concerns of your speakers (while actively presencing a self, a voice that is *not* your own), you can begin to see more clearly how you might accomplish the same achievements in your own poems, in your "own" voice. You can learn how to presence yourself as a poetic voice in the same way you have learned how to presence the "other" speaker of the dramatic monologue.

It's often great fun to see the results of this assignment. In one recent class, a young man who'd written a dramatic monologue in the voice of Amelia Earhart read the poem aloud wearing a

classic leather aviator's helmet, antique goggles, and fraying white silk scarf. Somewhat to the astonishment of his classmates, he'd quite clearly become the lost speaker of his poem. Perhaps the most inventive example of the choosing of a speaker was from a young woman whose poem was in the voice of a Siamese twin who awakens to find his attached brother has, in the night, died. What the speaker realizes, of course, is that his own death will follow within hours. It was an enormously moving and clearly ingenious monologue.

There are countless marvelous examples of dramatic monologues from which to illustrate the possibilities and attractions of this exercise. With beginners I tend to use relatively contemporary examples. Some I've found to be especially successful are Randall Jarrell's "Seele im Raum" and "Next Day"; Norman Dubie's "The Czar's Last Christmas Letter" and "The Pennacesse Leper Colony for Women, Cape Cod: 1922"; W. S. Merwin's "Home for Thanksgiving"; Louise Erdrich's "Francine's Room"; Louise Glück's "Gretel in Darkness" (which illustrates a more highly lyric approach); Theodore Roethke's "Meditations of an Old Woman"; Adrienne Rich's "Phantasia for Elvira Shatayev"; Frank Bidart's "Ellen West, Herbert White," and "The War of Vaslav Nijinsky"; Richard Howard's "Wildflowers"; David St. John's "The Man in the Yellow Gloves"; and Karen Fish's "Jeanne d'Arc," "Catherine of Aragon," and "Self-Portrait with Camellia Branch." With more advanced students, I provide a more historical perspective, including poems by Eliot, Frost, E. A. Robinson, Pound, and Browning, of course. All in all, what could be more fun?

THE WIDOW

Maura Stanton

Write a poem in the voice of a widow whose husband has drowned. Invent any story you like. Perhaps the woman's dead husband was a fisherman who was washed overboard in a storm at sea. Perhaps he was canoeing on a neighborhood lake.

Imagine that the widow, who now hates water, is forced through circumstances to confront it in some way. Her house is located beside the sea, perhaps, or her grown-up children insist on taking her on a vacation trip to the beach. Decide on how long it's been since her husband's death, and choose a specific location for the dramatic situation of the poem.

How does the widow feel about this particular river or lake or ocean? Try to express her feeling through concrete details and images as much as possible. It might help to imagine the poem as a letter to someone.

This is an exercise in empathy, as well as in the use of persona, and I've found the specificity of the exercise to be valuable in getting beginning poets to express emotion through concrete detail and imagery. The exercise shows you that emotions come

out of situations, and that feelings need to be dramatized as vividly as possible if they're to affect the reader.

The exercise comes out of poem called "Sonnet for Joe" by Sandra McPherson. Her poem is addressed to a beginning creative-writing student whose poems are full of abstractions, and at the end she tells him to think of a man falling off a fishing boat in Alaska. She tells him to "Think of/his widow who detests the sea, who lives beside it, who writes now to her friend."

I've gotten some wonderful poems from this exercise, and one of my favorite classroom illustrations (in classes where I haven't assigned the widow exercise) is to type up three poems: "The Widow's Lament in Springtime" by William Carlos Williams; "Widow's Winter" by Bill Knott; and a successful student "Widow" poem from a previous class. I type all three poems without names, then ask the students to vote on which poem they like best. It's impossible to predict which poem will win—sometimes it's Williams, sometimes it's Knott, sometimes it's the student poem. It doesn't matter, because the discussion is always lively. I ask the students to provide specific reasons for their vote, and we end up talking about dramatic situation, concrete detail, controlling image, sound, and the indirect presentation of emotion. I don't reveal the authors of the poems until the end. And if I've used an especially fine student exercise poem, there's often a gasp when the class finds out that a *student* was able to write a poem as good (or almost) as the two published poets.

OUR SUITS, OUR SELVES

Christopher Gilbert

Make a metaphor that likens the self to an inanimate thing—e.g., I am a fan, or I am a car's tire. Now wonder what this condensation of yourself into this new nature means for your most precious human attributes—say, your words and language, or, say, your sexuality. What does this new nature imply for your human body parts? Where and in what condition is your heart now? What would your eyes see and your hands touch?

———

The exercises I have liked best in working with student poets call for some transformation of the self. Too often when we begin writing we are limited by the self-importance we give our feelings. But, as Rilke points out in *Letters to a Young Poet*, poems are situations. Given the situation in which to enter, the reader will find feeling there. Self-importance restricts the writer's freedom to pursue the whole of a situation confronting him or her. And self-importance restricts the freedom and ability to see the need to revise.

Transformation of the self prompts the writer to be curious about his or her new body and the world it is in. One of my own poems that I feel surest about—"Saxophone," while not having arisen

from a writing exercise—must have come from realizing my feelings through how I conceived the meaning/situation of a "distanced" thing. I began the poem by jumping into the head of energy, conviction, and muscularity I associate with bop: "My bell is Charlie Parker's/hatband. So few of you who/come to touch me understand/my feelings/only this black voice. I am a temple and he comes/to speak thru me . . ." As you can see, one transformation-metaphor-body of being often leads to another.

With transformation the writer starts to ask himself, What goes with *this?* What lives with *this?* Transformation gives the writer a new perspective from which to conceive. Letting one's writing originate from the perspective of an inanimate thing radicalizes context and empathy. The above exercise is especially useful in "fictionalizing" and should prove helpful to the writer in need of some emotional distance. It provides a kind of container—a body—in which the writer's inner life transacts with his world. The situation.

LETTER POEMS

Robin Behn

Write a poem in which a particular speaker who refers to him or herself as "I" is addressing a particular "you." The poem does not need to be an actual letter (it doesn't have to start out with "Dear X"), but since the speaker will be addressing the "you," the receiver of the poem, readers will feel as though they are over-hearing the words. Give some thought to whom you want to talk in the poem. It might be a stranger or a fictional character. It might be someone who's dead. It might be someone you know very well, although in the poem you are of course free to say anything, not just what you would ordinarily say to that person. (The "letter" might turn out to be unmailable!) Before you start writing, brainstorm for five minutes, making a list of all kinds of persons you could write or talk to. Include some you know well, some you don't know well. You might also make a list of who the "I" could be. If there is an entry in your list of possible "you's" and "I's" that surprises you, an entry that you didn't expect to write down but that intrigues you, that might be a good one to pick.

The poem will get off to a good start if there is some need for the speaker to be talking or writing to the "you." Ground yourself in a particular occasion, aware of setting, circumstances, time, and events.

In writing letters we address a particular person whom we think of as "you," and we let that person know that our words are coming from a particular speaker, an "I," whose voice and choice of words are geared specifically to that "you." If a stranger were to steam open the letter, he or she would have the feeling of eavesdropping on something personal. If the stranger is lucky, the writer will have made enough specific references in the letter that the stranger will be able to piece together the significance of the private conversation.

Good "letter" poems are satisfying to steam open. The reader— or eavesdropper—will find that the speaker of the poem has some need to be talking to this particular you. Even if the speaker doesn't completely understand that reason at the beginning of the poem, there will be an urgency about what is said. The voice of the speaker, the selection of details, the items included or con-spicuously absent—all are determined by the relationship and circumstances between the "I" and the "you." So, during the writing process, be very specific in your own mind about what's going on between these two people, both at the moment of the writing and in the past. Where are they? Are they together or apart? Why? Where were they in the past? What is their story, together and/or separately? What occasion gets the speaker to begin to speak at the moment of the poem? Answering such questions will give the speaker a wealth of detail to draw on in the poem, and in turn will give the reader a means to enter into this world.

This is a helpful exercise for developing voice, since we tend to sound more like ourselves and less like some generic voice-of-poetry when we set the "you" in the room with us in our mind's eye and talk directly to him or her. It's also a good way to practice

changing the imagined circumstances of the poem to help it get written. For example, would it help to picture a glass wall between yourself and the "you" so that you can't be interrupted? Would it help to resurrect the dead, or have knowledge of a stranger's past history, or be guaranteed that your poem-letter will never be mailed? Practice altering the facts and inventing whatever circumstances will keep you interested in the subject.

This exercise will also help you refine your sense of audience. Unlike a real letter, you want your letter-poem to mean something to a third party, those eavesdropping readers, so you will have to include enough details to help them catch on. At the same time, you'll want your letter to sound authentic. Be on the lookout for awkward places where the "I" is saying something to the "you" that the "you" already knows. For instance, unless Daniel has amnesia, the speaker would not be likely to say, "Your name is Daniel." She might, however, *use* his name: "Danny, I can't believe you never called me back!" In that way, the eavesdropping reader still learns the name, and also begins to piece together the circumstances between the two characters.

"I's" have been talking to "you's" in poems for as long as there have been poems. For recent examples, see Maxine Kumin's "How It Is," Adrienne Rich's "Phantasia for Elvira Shatayev," James Tate's "The Lost Pilot," or Richard Hugo's *31 Letters and 13 Dreams*.

TABLOID TONE EXERCISE

Lee Upton

After dividing sections of supermarket tabloids (the more sensa-
tional, the better) and distributing them among ourselves, the
class and I read through for our favorite headlines and stories. A
few before me, at random: "Farmer's Wife Turns Hubby into
Scarecrow," "Cow Pregnant with a Space Alien's Child," "Dead
Woman Wakes Up Wearing Bracelet from Heaven!" We are, in
this exercise, presented with a narrative—usually an invented,
fanciful, outsized narrative of dubious value. I ask that we write
our new invention in the third person, in an attempt to create
tonal distance and to avoid a first-person narration that might too
readily avoid a significant change in tone. (Although I do not use
the tabloids for a persona exercise, I realize that it might perhaps
be peculiarly gratifying to write in the voice of the homeowner
of "The House That Drips Blood!")

The elements of the exercise are simple: (1) Choose a story from
a tabloid; (2) Using the story as a starter seed, compose a poem
in the third person that treats the subject of the story in a serious
manner. Our goal, then, is transformation.

━━━━

Although they are often narratives of grief, rage, and shame, the
tabloid pieces caricature our common vulnerability. We can at-

tempt to reverse this process by adopting that most alchemical of reactions, a tonal shift. Even death in some tabloids is made into a jokey moment: "Golfer Killed in Brawl over Flubbed Putt." And desire—in inflated terms—is ever-present: "Genie Rises from 1000-Year-Old Bottle." Newly transformed into a third-person view that differs significantly from the tabloid's lurid and alarmed sensationalism, the poems resulting from the exercise may prove more compassionate or, conversely, more brutal in a way that breeds revelation.

Emphasizing invented details about an incident may unmask desire or grief. Or we may find that the contours of a story suggest provocative possibilities. (Reconsider "Farmer's Wife Turns Hubby into Scarecrow." Surely there are spouses who have done the same?) When most successful, the results of the exercise often take on a dreamlike quality, the raw material of the tabloid mutating into symbol.

THE PEASANT WEDDING

(FOR A GROUP)

Mary Swander

Part 1: Consider a painting filled with many characters engaged in a central action, like Bruegel's "Peasant Wedding." Think about the focal point and perspective of the work of art, the effect of the setting, colors, shapes, textures, the story that the painting is telling, the relationship of the characters and what affections and tensions are developing.

Part 2: Take the voice of one of the characters in the painting and invent that character's past, his/her feelings at the present, and possibilities for the future. Tune in to the rhythms and diction of your character's speech as well as his/her emotional makeup. Ask yourself: Does my character like or dislike anyone else in the room? Why? Why not? If my character could talk directly to that person, what would s/he say? Once you've thought about what's on your character's mind, write down his/her remarks and shape them into a dramatic monologue or a personal poem.

Part 3: Read your monologue out loud to the rest of the class. Let classmates suggest ways to develop or tighten your poem.

The exercise winds together storytelling and dramatic mono-
logues. It can be used in any of the parts or as a whole sequence.
It stimulates an understanding of your own emotions in some
small part, then helps you develop empathic fictional skills as you
create characterization. While the exercise introduces you to one
mode of poetry—the persona poem—it helps you get inside the
writing process, then grapple with your own identity. It helps
you find out how personal interactions and conflicts shape events,
and what pressures the writer finally brings to raw material to
form "art."

I first used this exercise sequence with a quirky class of twenty
junior-high students in a one-shot three-hour workshop, and as
many times as I've repeated it since then on the college level, I'll
never forget my initial experience. I was told I would have a class
of "talented and gifted" students drawn from all over the city of
Des Moines. About two-thirds of the class was made up of TAG
students, but by some good fortune, the school buses got mixed
up that day, and the other third of the group came from special
education classes. A great mix! None of the students knew me or
one another, but they all plunged right into this painting, found
roles for themselves and suggested ones for their classmates. The
TAG students initially took the lead in the activity but were soon
matched by the rest of the group.

The class loved inventing the romance of the bride and groom.
They relished taking on the voices of the parents, bringing out
the family conflicts, opening themselves to the thoughts of the
servants, the townspeople, even the emotions of the dog. Within
fifteen minutes of the start of the session, I felt a rapport, a
bonding, an excitement, developing in this class of strangers that
comes only once every couple years or so in teaching. On a
purely therapeutic level, these masks allowed the students to

voice their joys, expectations, fears, and anxieties about the issues on their minds. Even though the students made a real attempt to keep their personas within the time period, their masks touched on contemporary issues like love infatuations, divorce, blended families, money problems, and even drugs.

On an artistic level, no, we weren't a bunch of little Brownings. But we got closer to the process. And yes, things got a little silly at times. Due to the bus mix-up, several teachers were on the search for their missing students, and at any one time, I had two or three of them in the room scanning, then listening in. Any moment, I expected the intercom to command me to the principal's office. But giggles, blushes, a few shouts and cheers are good for poetry, and what better way to direct junior-high hormones?

In part 1, I help the students turn on their observation skills, letting them get up out of their seats to move closer to the painting. They stay with the painting long enough to discover the sheaf of wheat decorating the wall, the rough wood of the bench, the spoon in the waiter's hat. In part 2, I try to draw out both the students' personalities and the characterization of the personas. I ask questions. "So how do you as the bride really feel about the groom on your wedding day? Do you have any secrets you haven't told him yet? Will you ever?" And then when the students respond, reaffirming their answers, I may reply, "I see. You don't really want to get married? Not now. To this man at least."

In the future, I'm going to try mixing things up, maybe having the sexes take on opposite roles. I'm going to try different paintings or photographs, or let my undergraduates, many of whom are visual artists themselves, bring in works of their own. I'm going to see where the students take me next.

ESTRANGEMENT AND RECONCILIATION:

THE SELF HAS IT OUT

WITH THE SELF

Leslie Ullman

Imagine two or more sides of yourself as distinct characters, each with reasons to be angry at and to love or need the other part(s). Write a poem in sections where each speaks or writes a letter to the other, letting tension (anger or bewilderment, perhaps) and resolution (reconciliation, appreciation, full-blown affection) provide direction and a sense of discovery. Remember to treat each voice as a character, i.e., to see parts of yourself as distinct characters, which will give you the freedom to invent, exaggerate, and play with material that could otherwise bog down in muddy introspection. You can have one side write a letter to the other and have the other answer, or you could have several voices speak one at a time, maybe have a kind of roundtable discussion.

───

When I tried this, I let each side of me more or less "meditate" to the other in letter form, one letter apiece, moving from resentment to appreciation. I also gave myself, as speaker in both instances, plenty of room to invent material so that the addressee of each "letter" became a kind of caricature rather than anything that really resembled a side of me. I found myself exaggerating shamelessly, mining fantasy material hoarded from several dif-

78

ferent times and sources, and ended up feeling refreshingly liberated from my actual self while working on the poem. This is an exercise, then, that lets you out of yourself and in again by the back door, letting you tap emotional truths by telling literal lies. It allows you to mythologize yourself a little, which is powerful and often healing, an exercise not just in writing but in knowing the self a little better.

"IN THE WAITING ROOM"

Carol Muske

In the Waiting Room
by Elizabeth Bishop

In Worcester, Massachusetts,
I went with Aunt Consuelo
to keep her dentist's appointment
and sat and waited for her
in the dentist's waiting room.
It was winter. It got dark
early. The waiting room
was full of grown-up people,
arctics and overcoats,
lamps and magazines.
My aunt was inside
what seemed like a long time
and while I waited I read
the *National Geographic*
(I could read) and carefully
studied the photographs:
the inside of a volcano,
black, and full of ashes;

then it was spilling over
in rivulets of fire.
Osa and Martin Johnson
dressed in riding breeches,
laced boots, and pith helmets.
A dead man slung on a pole
—"Long Pig," the caption said.
Babies with pointed heads
wound round and round with string;
black, naked women with necks
wound round and round with wire
like the necks of light bulbs.
Their breasts were horrifying.
I read it right straight through.
I was too shy to stop.
And then I looked at the cover:
the yellow margins, the date.

Suddenly, from inside,
came an *oh!* of pain
—Aunt Consuelo's voice—
not very loud or long.
I wasn't at all surprised;
even then I knew she was
a foolish, timid woman.
I might have been embarrassed,
but wasn't. What took me
completely by surprise
was that it was *me:*
my voice, in my mouth.
Without thinking at all
I was my foolish aunt,
I—we—were falling, falling,

our eyes glued to the cover
of the *National Geographic*,
February, 1918.

I said to myself: three days
and you'll be seven years old.
I was saying it to stop
the sensation of falling off
the round, turning world
into cold, blue-black space.
But I felt: you are an *I*,
you are an *Elizabeth*,
you are one of *them*.
Why should you be one, too?
I scarcely dared to look
to see what it was I was.
I gave a sidelong glance
—I couldn't look any higher—
at shadowy gray knees,
trousers and skirts and boots
and different pairs of hands
lying under the lamps.
I knew that nothing stranger
had ever happened, that nothing
stranger could ever happen.
Why should I be my aunt,
or me, or anyone?
What similarities—
boots, hands, the family voice
I felt in my throat, or even
the *National Geographic*
and those awful hanging breasts—
held us all together

or made us all just one?
How—I didn't know any
word for it—how "unlikely" . . .
How had I come to be here,
like them, and overhear
a cry of pain that could have
got loud and worse but hadn't?

The waiting room was bright
and too hot. It was sliding
beneath a big black wave,
another, and another.

Then I was back in it.
The War was on. Outside,
in Worcester, Massachusetts,
were night and slush and cold,
and it was still the fifth
of February, 1918.

Now that you've read Elizabeth Bishop's extraordinary poem, "In the Waiting Room," I'd like you to try to imitate it. I don't mean reproduce the poem *exactly* in structure and style (though wouldn't *that* be nice!) but rather the tone of the poem. Bishop's poem is about, among other things, the temporary dislocation of the self, but let's not write a poem about *that*. Let's do what she does: let's locate a memory from childhood and tell about it. But not one that you already have thought about a lot. I'd like you to remember (or "fake-remember," make it up!) the date in the first newspaper (or magazine or calendar) that you recall seeing as a child—and we'll give the poem that title, e.g., "August 19, 1955." Then let's begin the poem the way Bishop does, by *placing* it exactly, "In Worcester, Massachusetts," or "In St. Paul, Minnesota," then let's place *you* inside it, again the way Bishop does.

Let's see you "in the kitchen" or "in the backyard" or "at the post office" or wherever you were, fill in the visual details, *from the child's point of view.*

Let us enter the newspaper or magazine, the way Bishop as a little girl does, let us see the pictures, the ads, the print. If you don't remember this, make it up. Make up also some other stimulus, some outside noise, like the scream of Aunt Consuelo in Bishop's poem, so that you can experience the "displacement" of the self. You are understanding for the first time that you are the person reading the magazine or the calendar—that you are a *you.* Count the number of syllables in her lines; try for that count.

———

I find that the seeming "exactitude" of this exercise (the Bishop poem, the dates, all of it) is simply an arbitrary "dipping into" the resources of memory, but a very productive charade. The "you were there" feeling and the portentous quality of the date, "August 19, 1955," trick you into believing you really can remember something about a moment in time, made emblematic by the newspaper headline or calendar date. If there is a particular world event in the newspaper that you recall, that's fine, but the external public quality of history should not be emphasized at the expense of the private revelation.

The "sense of the who," the self-awareness, should come quite naturally from this isolation of time and event, and the oddness of self-recognition should attend the outside "stimulus," the cry, or scream, or siren, or whatever brings the meditating consciousness "to."

B. WHAT'S IT ABOUT?

WHO WE WERE

Edward Hirsch

Ever since Wordsworth, childhood has been one of the great, necessary, and dangerous subjects for poets. Write a poem about childhood, about the deep—as opposed to the recent—past. Try to dredge up something otherwise neglected or forgotten, something with special retrospective significance. One of your central strategic decisions will involve the question of tense. Your poem might begin in the past and stay there (as in Theodore Roethke's "My Papa's Waltz"); it might begin in the present and then turn to the past (as in Gerald Stern's "The Dancing"); it might begin in the present, turn to the past, and then come back to the present (as in Robert Hayden's "The Whipping"). Such poems are inevitably crisis lyrics. Think about what triggers the memory, about what's at stake in the experience, about what's lost (and found) in the writing of your poem, about what Samuel Beckett calls "that double-headed monster of damnation and salvation—Time."

———

Marcel Proust distinguished between voluntary and involuntary memory. By voluntary memory he meant that which is intentionally and consciously recalled; by involuntary memory he meant that which is given back to us, as if by magic, unconsciously. The distinction is animated by Randall Jarrell's "The Lost World" and its follow-up poem, "Thinking of the Lost World."

Freud introduced a psychological explanation for the uncanny. He was thinking of unusual, apparently inexplicable, supranormal experiences that turn out to have special buried meaning for the psyche. Something extraordinary outside of us is actually projected from inside of us. This idea is brilliantly demonstrated in Elizabeth Bishop's poem "In the Waiting Room."

Rainer Maria Rilke asserted that there are two inexhaustible sources for poetry: dreams and childhood. We drink from the well, but we never drink it dry.

YOUR MOTHER'S KITCHEN

Rita Dove

Write a poem about your mother's kitchen. (It helps if you actually draw the kitchen first, with crayons!) Put the oven in it, and also something green, and something dead. You are not in this poem, but some female relation—aunt, sister, close friend— must walk into the kitchen during the course of the poem.

In one class, I first made the students clear their desks, as an elementary school teacher would do. Then I passed out computer paper, perforations attached, one sheet per student, broke out a brand new packet of one hundred Crayola crayons—certainly one of the symbols of pleasurable magic in our age—and told them to pick a crayon, pass the carton on, and continue passing the box around in this manner until it was empty. And then? Why, draw the place that immediately came to mind at the mention of the word *home*. After they had colored for about fifteen minutes, exchanging crayons, cursing the perforated edges (which I refused to let them remove), and asking for extra paper in order to start over (which I also refused), I told them to turn the paper over, take a deep breath, and draw the place they were

living in now. This took about five minutes. The final leg of the assignment was to take the drawing home and live with it for a week. The poems that emerged from this assignment were varied and significant, even though they often did not mention the drawings.

THE NIGHT AUNT DOTTIE CAUGHT ELVIS'S HANDKERCHIEF WHEN HE TOSSED IT FROM THE STAGE OF THE SANDS IN VEGAS

David Wojahn

The exercise itself is simple: *write a poem about a family member meeting a famous person.* All of us have such incidents embedded in family history or folklore: the day Dad shook hands with Ike in France; the time Mom spilled coffee on Elizabeth Taylor and all the other waitresses snickered; the night Aunt Dottie caught Elvis's handkerchief when he tossed it from the stage of The Sands in Vegas. In most cases, our loved ones' encounters with the famous or powerful tend to be fleeting and bittersweet, however memorable they may later seem—and it's this aspect of the encounter that helps us to envision our family members in contexts that avoid easy sentimental gestures. These are situations in which, in a small way, the forces of public history and private history collide, and these meetings help us to see our loved ones as individuals, not as types.

Guidelines for the exercise: (1) the encounter can be real or imaginary, but should at least be plausible—no meeting between Cousin Ed and Genghis Khan; (2) the family member, not the famous person, should of course be the protagonist of the poem, and it is his or her consciousness that the poem should try to enter and understand; (3) the writer of the poem should be an effaced presence, understanding the inner workings of the family

member's mind but seeing the family member as a *character* referred to in the third person ("my father" and not "Dad," in other words); (4) the famous person can be anyone in politics, entertainment, or the arts, JFK to Sammy Davis, Jr., Robert Frost to Bela Lugosi; (5) since the exercise tends to demand a fairly complex profile or portrait of the family member in question, it is best suited to longer poems—at least thirty lines.

━━

Write about what you know: this is easily the hoariest of writerly clichés, in part because it's pretty good advice. In poetry-writing workshops, this dictum very frequently translates into an assignment on the order of Write a Poem About a Family Member. Even those of us who grew up in the suburbs—places where children are so systematically protected from the realities of life that Chinese emperors prohibited from venturing beyond the walls of The Forbidden City seem world class travelers by comparison—have family members, and strong enough feelings about our families so that poems might arise from this assignment. Unfortunately, it's not that easy. Most of the poems we write about our families succumb to some predictable pitfalls. The poems tend to be sentimental, so distorted by our gestures of affection (or, more rarely, of anger) that the family members we seek to portray emerge as out-of-focus snapshots. All too often, the family members are little more than types, no more complex than Ward and June Cleaver, seen not as individuals but as kinds of appendages to the speakers of the poems. We see them not in terms of historical or societal forces, but as stick figures—Good Mommy, Dutiful Daddy, Granny-in-the-Kitchen-Baking-Pie, Grandpa-Taking-Us-Fishing-the-Year-Before-His-Stroke, and so forth. Such blunders are not the exclusive province of younger writers, either. Those of us who reach child-bearing age seem to have a time bomb ticking within us, ready to explode into hun-

dreds of bad poems about our offspring. Why, when our families are the most important things in our lives, must we do them the disservice of writing about them in such inept fashion? This exercise is designed to circumvent some of the pitfalls that usually bedevil us when writing about family members.

A better-than-average number of good poems seems to emerge from creative writing classes given this assignment. It's also a delight to see the astonishing and strange variety of encounters students record, ranging from the sublime to the ridiculous. Over the years I've received poems that not only depict the invariable Elvis, Kennedy, and Beatles sightings, but also, among others, a father who is shaking hands with his boyhood friend Senator Joe McCarthy—this at a ceremony to dedicate as a public park a piece of land where the father and young Joe once "hunted skunks"; a meeting between a much-beloved uncle who works for the National Security Administration and President Harry Truman, in which the uncle urges the president to drop the bomb on Nagasaki; a mother, playing an extra in a Peter Cushing horror film, who flubs her lines when she must recite them before the Great Thespian. In some ways, the trick of the assignment is merely to find the right situation. If it is ingenious and poignant enough, the poem can almost write itself.

Some published poems that can serve as models for the assignment are Stanley Plumly's "For Esther" (sister sees Truman making a speech); Robert Pinsky's "History of My Heart" (mother sees Fats Waller Christmas shop at Macy's); Lynda Hull's "1933" (mother as infant being put on the lap of Leon Trotsky); Paul Muldoon's "Cuba" (father and sister respond to the Cuban missile crisis).

NOT "THE OPRAH WINFREY SHOW"

(FOR A GROUP)

Garrett Hongo

Make up a secret about yourself. It doesn't have to be completely true. It can be a lie—or a partial truth, a revelatory blend of true confession and a dose of fiction.

Type it up on a blank sheet of paper. Don't sign your name. Just write down the secret. We're going to collect them all, shuffle them up, and draw for them from a hat. Then, each with another's secret, write a poem telling the story of that secret as if it were your own and addressing what you think about it now that you're older, now that you're a poet.

Examples:

"Salmon" by Jorie Graham
"The Abortion" by Edward Hirsch
"My Story in a Late Style of Fire" by Larry Levis
"First Boyfriend" by Sharon Olds
"Blades" and "Combat" by C. K. Williams
"Hollow" by Susan Wood

*T*he editors comment: Poets are always walking a tightrope between truth and fiction. Sometimes, in writing about "what you know," it's hard to achieve the necessary objective distance because autobiography gets in the way. If you write "Grandfather's backyard," *you* may see his amazing collection of hybrid lilies, but the reader won't unless you put them into the poem. It's easier to tell what's actually there in the writing if you've invented it than if it's something deeply familiar. This exercise asks you to invent details that carry emotional weight, and in so doing it demonstrates the value (and necessity) of looking at your own writing from an imaginative distance, as if it had been written by someone else.

To do this exercise alone, outside of a class: Ask someone to tell you—or make up—a secret, and go from there.

EXTRAPOLATION

Pamela Alexander

[The teacher brings several unrelated objects to class, or the writer can choose the objects for himself.]

Write a poem describing the room from which these objects come.

━━━

This experiment was given to a class I took in autobiography as fiction taught by Kendall Dudley at the Cambridge Center for Adult Education in the early 1980s. I have found it also works well with poets. Part of its success may be its "shock value," its ability to startle.

The objects should be as disparate as possible so as not to lead you in a given direction. Any small number of odd objects works—three to five, let's say. I've used Swiss army knives, an old photo of Paris, a movie ticket stub, and a book about linear algebra, among other things.

Sometimes students ask me if they have to write about a room. What about a place outdoors? a ship at sea? Questions like these mean they already have some ideas, often interesting ones, and can simply be encouraged onward.

EVOLUTIONS

Deborah Digges

This assignment was given to me in 1981 by my teacher Larry Levis, who said that his teacher, Philip Levine, had once given it to him. Said Levis via Levine, "When you can't write, try writing about an animal." Since then I have revised and expanded the assignment for my undergraduates at Tufts University.

Assignment: Write a poem in which an animal figures prominently. As you decide on your subject, consider an animal that fascinates, even confuses you, one that incites in you wonder, perhaps even fear. Brainstorm a bit, taking quick notes on any particular experiences you've had or heard about in relationship to that animal. Reread stories, fairy tales, biology texts, in which your animal appears. Go look at it if you can, or study its features in a book. You might also trace the etymology of its name to discover new facts and information that might trigger your imagination. For instance, *squirrel* comes from the Latin *skia* or *shadow*. *Tortoise* comes from the Greek *tartarchos*, meaning *god of the underworld*.

There are risks to this assignment, and once you have your notes/drafts in front of you, be careful not to begin with the most obvious details. And be careful not to sentimentalize, to usurp the animal you have chosen by turning it into a flaccid symbol for

human emotions. The animal is not a stand-in. The animal is itself. Look hard at your subject and render it in its strangeness, in its integrity, wholly animal.

Try, initially, to go fifty lines. Connect descriptions, pieces of stories, and your own details of narrative. Work always with information your reader won't already know and assume about your subject. Be open to rearranging the text, playing with sequence, information. There are many wonderful animal poems for you to take a look at. Some of my contemporary favorites are Bishop's "The Moose," "The Fish," and "At the Fishhouses," Lowell's "Skunk Hour," and Kinnell's "The Bear," "The Porcupine," and "St. Francis and the Sow."

AFTERIMAGES:

THE HISTORY OF A REFLECTION

Jay Klokker

Step 1: Make a list of at least twenty intense physical experiences that you have actually had. Include a wide range of both the ordinary (waiting tables in a busy restaurant) and the momentous (giving birth to a child). Write quickly. If stuck, think of the last time you went to bed physically exhausted or emotionally drained.

Step 2: From the list select one item that is especially vivid. This will be your subject.

Step 3: Without writing, let your mind drift back to the time when the physical intensity of the experience was over and you could look back at it. Take as long as you need to fully reexperience that moment, including all that you saw, heard, felt, and thought. When you feel ready, jot down what you have recalled. Include as many details as you can.

Step 4: Using words, phrases, and memories generated in the previous step, write a poem that shows what went through your mind as you looked back at your intense experience. Pay special attention to thoughts and perceptions that surprised you and to

the way your mind moved from one scene, idea, or feeling to another.

========

Although designed to encourage beginning writers to trust the language of their own senses, "Afterimages" is appropriate for poets of all levels who are looking for new subject matter to explore.

Robert Frost's "After Apple-Picking" is a fine example of a poem that shows how the mind works after a day of hard physical labor. None of Wordsworth's recollection in tranquility here—Frost's apple-picker lies in bed while visions of apples proliferate in his mind's eye and the feel of the ladder rung still makes his instep ache. Such obsessive perceptions are the stuff of which insomnia—and poetry—are made.

Different poets—whether beginners or professionals—have different strategies in choosing the subjects about which they write. Exhaustion often leads the mind to repeat obsessive images and ideas—Frost's apples, again—and to juxtapose violently thoughts and feelings that would usually be seen as incongruous. This exercise encourages you to use these naturally occurring repetitions and contrasts as a structural principle in a poem.

SUBJECT AND SOUND:

THE BLACK SHEEP

Kenneth Rosen

I call a written assignment that often provokes an unexpectedly deep emotional and visceral response The Black Sheep. Write a poem about or from the voice of someone who has been cast out or has voluntarily left the family: the drunkard, the thief, or the perpetrator of the otherwise unforgivable. The poem should confront the unforgivable deed and its mystery, as well as confront the judgment of those who determined to say no more and to turn their backs, which may be mysterious too. Our deepest feelings draw on our childhood expectations of unqualified love and acceptance, our terror of rejection and abandonment, intellectually incomprehensible but emotionally all too familiar. Ultimately, though not autobiographical, the poem should draw on your own dread of expulsion and exclusion, though it may be appropriate and desirable to side with the "black sheep."

While the poem is still in a rough form, sort out the sounds, the high-pitched and intense or crying vowels, the swift quick ones, the low ones of woe, the awesome and august, the ludicrous or comically gruesome, the aggressive gutturals, the lusciously musical labials, the hideous sibilants, and the combinations that suggest strength on the one hand, little smells and smirks on the other.

Ask yourself what kind of a sound pattern exists, where your poem begins on the vowel register, and where it ends, what consonant accumulations seem significant. Consider the extent to which the transgression and the family remedy are realized in images. Notice how internal rhymes, assonances, and alliterations expand sounds and create emphasis.

————

The idea of a poem, its subject and theme, profits from having a physical (or physiological) antecedent, a knot in the stomach, a whistle at the roof of the mouth, a yearning or a dizziness somewhere, that instructs word choice, and in turn creates a physical impact on the reader, an emotional music that is the basis of a poem's authority, intimacy, and pleasure, whether harsh or mellifluous.

So that equivalences can be drawn between the idea, the feelings it provokes, and the poem's words and sounds in combination, it is worthwhile to work toward an awareness of the scale, of the vowels from the high to the low, of the consonants from the rough to the smooth, and to explore poetry's preference for particulars—e.g., the concrete detail and the image, the credible voice, the specific moment of utterance, and so forth.

A form this assignment often takes is that of remarks to a parent about an uncle or family friend who should have been excluded, about protection, discernment, and sensitivity that proved to be inadequate. Or else a sibling, ne'er-do-well uncle or aunt, is addressed, their shortcomings and deceits questioned. The poems of Elizabeth Bishop are helpful to explore in this connection, especially "In the Waiting Room" (foolish female behind closed door with powerful male who makes her say "Ooh!" and one's consequent need for epistemological coordinates), "The Prodigal" (especially for sibling resentments in the spoiled brother or outcast's

voice), "At the Fishhouses" (the voluntary outcast's progress, from the net mender to whom she gives a Lucky, the seal to whom she sings a hymn, the ocean to which she utters a prayer for deadly ecstasy), even "The Fish," which is almost a how-to-do-it: have your cake and eat it too, catch your big fish and let it go, one outcast to another, rainbow, rainbow, rainbow.

For a poem in the voice of The Other, look at Jarrell's "The Woman at the Washington Zoo," where The Other is a presence in the self that's worth liberating. Such poems shift to apostrophe to rhetorically indicate a breaking out. The poems of Norman Dubie, from one end of his *Selected and New Poems* to the other, are swell examples of poems in voices and are often disrupted by italicized exclamations or apostrophes.

A few other specific assignments are oddly related to this one. There's the Fairy Tale Retold, which explores how poems often argue with received knowledge. I suggest the appropriated fairy tale be broken into its key elements and then related backward, so that Goldilocks' story begins with Goldy watching the Baby Bear discovering his empty cereal bowl, then working back to how it all began, the bed, the chair, the unlocked door. By isolating and manipulating the story's elements, it's easier to feel in them a wider personal significance and create something new. Though I don't know anyone who deliberately tells such stories backward except, perhaps, James Joyce in *Finnegans Wake*. What Randall Jarrell does in "Cinderella" (Fairy Godmother and Cindy woman-to-woman), "A Hunt in the Black Forest" (all of the figures in a dream or fairy tale are metaphors of the self), or "The House in the Wood" (the importance and consequences of getting lost in the forest with Gretel can be ignored yet nevertheless lamented) might also be helpful.

A POEM THAT SCARES YOU

Sandra McPherson

Write a poem that scares you.

———

"I just wrote a poem that scared me," the young woman called up to say to her older friend and mentor, with whom she was privately workshopping. When he told me she had exclaimed this, I remember feeling a "new emotion," an exhilaration over the possibility of scaring oneself with what one writes. Maybe we should start with what we're afraid to write, I thought.

The poem that scared its author, Brenda Hillman, was "The Wrench" from *White Dress.* It doesn't matter whether or not the poem scares the reader; as far as I know, Hillman did not compose the work to spook someone else. But it does matter that during composition the writer felt chills, alarm, a boundary shattered, a shock at what she'd done, a sense perhaps of going beyond control or of seizing control bravely. Without a doubt a physical sensation signaled the awe.

I read another poem, much later, that scared me—Dorianne Laux's "What My Father Told Me":

WHAT MY FATHER TOLD ME

Always I have done what was asked.
Melmac dishes stacked on rag towels.
The slack of a vacuum cleaner cord
wound around my hand. Laundry
hung on a line.
There is always much to do and I do it.
The iron resting in its frame, hot
in the shallow pan of summer
as the basins of his hands push
aside the book I am reading.
I do as I am told, hold his penis
like the garden hose, in this bedroom,
in that bathroom, over the toilet
or my bare stomach.
I do the chores, pull weeds out back,
finger stink-bug husks, snail carcasses,
pile dead grass in black bags. At night
his feet are safe on their pads, light
on the wall-to-wall as he takes
the hallway to my room.
His voice, the hiss of lawn sprinklers,
the wet hush of sweat in his hollows,
the mucus still damp
in the corners of my eyes as I wake.

Summer ends. Schoolwork doesn't suit me.
My fingers unaccustomed to the slimness
of a pen, the delicate touch it takes
to uncoil the mind.
History. A dateline pinned to the wall.
Beneath each president's face, a quotation.

Pictures of buffalo and wheatfields,
a wagon train circled for the night,
my hand raised to ask the question,
Where did the children sleep?

Her subject is incest. There is terror in the fact and terror conveyed by the art of this softspoken but inexorable narration.

Poems written in response to this assignment make readers feel everything from appalled to grieved to wickedly delighted in overdue revelations. So there is great range—the poem needn't be about atrocity, it need only scare its writer. Write it with your spine as audience.

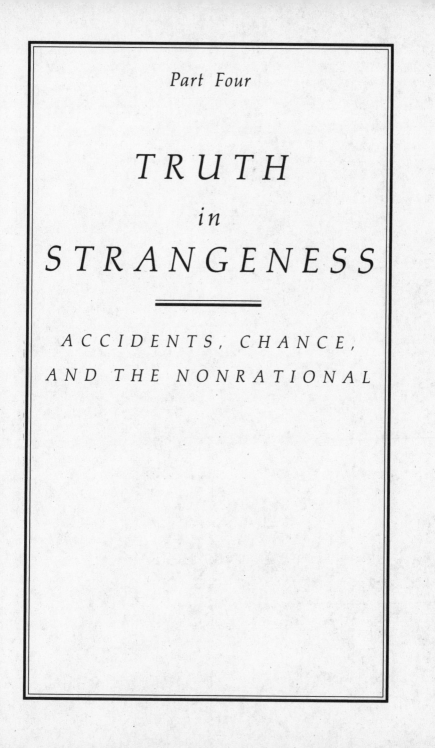

Part Four

TRUTH
in
STRANGENESS

ACCIDENTS, CHANCE,
AND THE NONRATIONAL

INTELLIGENCE TEST

Alberta Turner

Answer the following questions from a hypothetical intelligence test by picking out all the most wrong answers. Select several you wish were true. Make those into a poem.

1. What can you catch on your tongue? (butterflies, crows, foul balls, snowflakes, shooting stars?)

2. How do you wash your hair? (wait till it rains, stand in the shower, rub it with dry oatmeal, leave it alone, rub it with cooked oatmeal?)

3. Can you (toss, advise, bounce, inflate, tolerate) a balloon?

4. What can you do with a hen? (teach it to answer the phone, eat it, teach it to make soup, sell it a lottery ticket, make it wear shoes, make it tell the truth?)

5. What can't you do with an egg? (steal it, crack it, lay it, dye it, fake it?)

6. What can you do with an ax? (powder your nose, brush your teeth, eat spaghetti with it, sharpen it, play it?)

7. What can be safely carried in a quart berry basket? (water, foxes, watermelons, small silver bells, talcum powder?)

8. Which of these would you eat? (bullets, blackberries, plastic grapes, marginalia, unfamiliar mushrooms?)

9. Which of these could you breathe? (fire, miasma, turbine, oxygen, milk?)

10. What does a screwdriver do? (drive a truck, molest screws, make his kids work on Saturday, twist screws into holes, help a carpenter twist screws into holes?)

11. What would you do if you shrank to the size of a pea? (shout for help, hide under a leaf, go back to sleep, eat your hat, wash your feet?)

12. How would you handle a tail? (put it in your pocket, drape it over your arm, thread it through a slit in your pants, cut it off, pretend it wasn't yours?)

═══

This exercise surprises you into realizing the difference between factual truth and psychological truth. For example, if an intelligence test asked, "Complete the statement 'Kittens drink' by choosing one of the following five words or phrases: milk, beer, air, little green apples, viscous fluids)," *milk* would be the correct factual answer, but *beer* would be the most humorous, *little green apples* the most allusive, and *air* the most metaphorical. Combined with enough other selections of like or contrasting connotations, you could surprise yourself into writing a poem you could not consciously have planned.

PERSONAL UNIVERSE DECK

Linnea Johnson

This exercise involves constructing a list/deck of cards to use as associational sparks for your writing.

To construct the Personal Universe Deck, take a pack of one hundred 3 × 5-inch index cards, a pen, and a sheet of paper. You may wish to construct a list of words you then transfer to the cards. Begin by following these instructions:

Write down as many words as you can, either on a sheet of paper or on the 3 × 5 cards, then sort the words into the categories outlined below. If you work from a list, at some point transfer each word onto a 3 × 5 card, eventually completing each category. Write as quickly as you can.

CATEGORIES:
16 words of each of the five senses (16 × 5 = 80 words)
> The words must mean, suggest: taste, touch, sight, smell, and hearing. For instance, *desiccated* or *frozen* might suggest touch to you, or *birdsong* hearing.

10 words of motion
> The words must mean, suggest, motion to *you*. They do not

necessarily need to be verbs. *Baby* could be a motion word to someone, for instance.

3 abstractions
Like *love* or *freedom* or *truth*.

7 anything else
Names, days of the week, and so forth—any word with meaning to *you* which does not fit into the other categories.

All words on the list, in the deck of cards *must*

1. have *significance* to/for you.
2. be *specific;* that is, the word must not be "bird" but "robin," not "tree" but "aspen."
3. *sound* good to your ear.

Use no adverbs. Use no plurals.

When you have the hundred words written down on the hundred 3 × 5 cards, spread out the cards. Choose cards to create a skeleton of a poem. Write the poem, the memory, what the cards suggest.

Keep the pack of cards with your journal. Move them around each other every day for a week, or choose one card at random from the pack; write what the word(s) sparks, what the juxtaposition of the words builds for you.

———

I have modified this exercise from one Anita Skeen used in a poetry workshop circa 1975. It creates a personal lexicon that can be mined almost endlessly. I use it for both poetry and fiction

workshops. It serves as yet another *guarantee* against (the myth of) "writers' block"—a guarantee implicit in all exercises, really— pick them up and voilà, you're writing.

Do not think of this as a permanent or definitive list. Consider constructing a new set of cards to work with every few weeks, months, or years.

*T*hings to do with the *Personal Universe Deck* in a group: Pass around the decks in rapid succession (this requires group consent). Flip through the cards, jotting down a word (or several) that catches your attention. At the end of this pass-around, write several favorite words on a blackboard, with everyone writing at once. I like the scrawly chaos this creates. Talk about the words, their associations, pairings, juxtaposition, and possible phrasings. Organize the words into meaning chunks like images, sentences, or haiku.

From the individual decks, each writer selects five words to contribute to a communal pile of words. Sometimes words can be organized into lines to effect a poem. Sometimes rhyming words as fast as possible sparks further associations. Sometimes rapid-fire free association takes the words new places.

THE CUT-AND-SHUFFLE POEM

Jack Myers

Write out (in prose form, if you like) two completely unrelated and emotionally opposite six- to ten-line dramatic situations, depicting

1. a physically inactive or quiet scene, and
2. a physically active or emotionally charged scene.

Then, as one might shuffle the playing cards in a deck, alternate the first line or two from scene 1 with the first line or two from scene 2, then the second line or so from scene 1 with the second line or so from scene 2, and so forth, until all the lines from the two scenes are roughly dovetailed into a single stanzaic unit.

After reading the combined version, the reader assumes there is some sort of dynamic tension in the relationship between the two characters and/or actions in the poem, possibly even an interdependency.

By alternating the actions and characters from the two separate scenes, a third, implied quantity arises. This will be true of almost any two things placed side by side: the creation of a third entity.

While the cut-and-shuffle technique has been and can be used as a model of the formal structure for a particular type of poem, this exercise is intended to go beyond that and to exteriorize the synthesizing quality and very function of the associating poetic sensibility. As the critic/poet I. A. Richards once wrote, "The mind is a connecting organ." Its basic function is to establish relationships, even unintentional ones, between and among things. Furthermore, the exercise hopes to show the power of extrapolation that the simple device of *juxtaposition* creates when two unrelated and mutually exclusive entities are placed side by side.

This exercise often results in weird, improbable, and humorous connections—evoking wonderfully unexpected effects in a very efficient manner.

FINISH THIS!

Stuart Friebert

In the following poem by Edna St. Vincent Millay, you'll find some things missing: single words, part of a line, maybe even most of a stanza. Try your mightiest to replace what's missing with good choices that fit the poem snugly, never mind whether or not they agree with the original poem's choices . . .

CHILDHOOD IS THE KINGDOM WHERE NOBODY DIES

Childhood is not from birth to a certain age and at a
 certain age
The child is _____ , and puts away _____
 things.
Childhood is the kingdom where nobody dies.

Nobody that _____ , that is. _____ relatives
 of course
Die, whom one never has seen or has seen for an

 _____ ,
And they gave one _____ in a pink-and-green
 stripèd bag, or a _____ ,
And went away, and cannot really be said to have
 _____ at all.

* * *

And _____ die. They lie on the floor and lash their
 tails,
And their _____ fur is suddenly all in motion
With fleas that one never knew were there,
 _____ and brown, knowing all there is to know,
 _____ off into the living world.
You fetch a _____ , but it's much too small, because
 she won't curl up now:
So you find a bigger box, and _____ her in the
 yard, and _____ .

But you do not wake up a month from then, two months,
A _____ from then, two years, in the middle of the
 night,
And weep, with your _____ in your mouth, and
 say Oh, _____ ! Oh, _____ !
Childhood is the kingdom where nobody dies that
 matters,— _____ and _____ don't die.

And if you have said, "For heaven's sake, must you always
 be kissing a person?"
Or, "I do wish to gracious you'd stop _____ on the
 window with your _____ !"
Tomorrow, or even the day after tomorrow if you're busy
 having fun,
Is plenty of time to say, "I'm _____ , Mother."

To be grown up is to sit at the _____ with people
 who have died, who neither _____ nor
 _____ ;

Who do not drink their _____ , though they always
 said _____ was such a _____ .

Run down into the _____ and bring up the last jar
 of _____ ; they are not tempted.
_____ them, ask them what was it they said

That time, to the bishop, or to the _____ , or to
 Mrs. Mason;
They are not taken in.
_____ at them, get red in the face, _____ ,
_____ them up out of their _____ by their
 stiff _____ and shake them and yell at them;
They are not _____ , they are not even
_____ ; they slide back into their _____ .

Your tea is _____ now.
You _____ it standing up,
And _____ the _____ .

This is a useful exercise because, in my experience, once you're
"off the hook" of having to come up with a good idea for a poem,
and in a sense have been given a framework, you can pay atten-
tion to details that will be useful to you later on in the composi-
tion of your own poems. For instance, exact word choice, phras-
ing, lineation, etc., can be practiced in this way and what's learned
can then be put to use when you find the next text on your own.

(The complete Millay poem is reprinted at the end of the chapter.)

TWENTY LITTLE POETRY PROJECTS

Jim Simmerman

1. Begin the poem with a metaphor.
2. Say something specific but utterly preposterous.
3. Use at least one image for each of the five senses, either in succession or scattered randomly throughout the poem.
4. Use one example of synesthesia (mixing the senses).
5. Use the proper name of a person and the proper name of a place.
6. Contradict something you said earlier in the poem.
7. Change direction or digress from the last thing you said.
8. Use a word (slang?) you've never seen in a poem.
9. Use an example of false cause-effect logic.
10. Use a piece of "talk" you've actually heard (preferably in dialect and/or which you don't understand).
11. Create a metaphor using the following construction: "The (adjective) (concrete noun) of (abstract noun) . . ."
12. Use an image in such a way as to reverse its usual associative qualities.
13. Make the persona or character in the poem do something he/she could not do in "real life."
14. Refer to yourself by nickname and in the third person.

119

15. Write in the future tense, such that part of the poem seems to be a prediction.
16. Modify a noun with an unlikely adjective.
17. Make a declarative assertion that sounds convincing but that finally makes no sense.
18. Use a phrase from a language other than English.
19. Make a nonhuman object say or do something human (personification).
20. Close the poem with a vivid image that makes no statement, but that "echoes" an image from earlier in the poem.

Open the poem with the first project and close it with the last. Otherwise use the projects in whatever order you like, giving each project at least one line. Try to use all twenty projects. Feel free to repeat those you like. Fool around. Enjoy.

Initially, I created this exercise for my beginning poetry writing students who—as best I now recall—seemed to me to be overly concerned with transparently logical structures, themes, and modes of development at the expense of free-for-all wackiness, inventive play, and the sheer oddities of language itself.

I created the exercise in about a half hour, simply listing, in no particular order, a lot of little sillinesses I had seen and liked, or had not seen but thought I would have liked, in poems here and there. Inasmuch as I created the exercise during a semester in which I had decided to do, with my students, all poetry assignments, and inasmuch as I thought a model might be helpful—if only as an example of my own willingness to be ridiculous—I then *did* the assignment myself, again taking only about a half hour. Subsequently, incidentally, my poem from it, "Moon Go

Away, I Don't Love You No More," was published by *Poetry*. (The students *like* that story.)

Generally, I give the assignment toward the end of the term, hoping to bring together a lot of things the class has been doing right along, and hoping to get a little play back into the class at a time when overseriousness and burn-out tend to occur. Generally, I read the sample poem first (never claiming it as my own), and generally people get a big kick out of it. How do you write a poem like that? I ask, then pass out copies of the assignment and the sample poem and send the students off to work.

This has been, far and away, my best exercise—it is the most popular among the students, it's the most widely used (many of my teacher-friends are using it across the country, and they say it's the best exercise they use too), and, frankly, it has produced consistently good student poems, often the best ones written during the term. You might like it, because in some ways it relieves you of responsibility for your own writing ("I was only following orders"). Though, as I said, I designed the poem for beginning writers, I find it also works for advanced students, particularly those suffering writer's block or hopelessly stuck in a single style. Indeed, I've since gone back to the exercise, as have published writer-friends, when I've felt blocked or stuck. It still works for me.

MOON GO AWAY, I DON'T LOVE YOU NO MORE

1. Morning comes on like a wink in the dark.
2. It's me it's winking at.
3. Mock light lolls in the boughs of the pines.
 Dead air numbs my hands.
 A bluejay jabbers like nobody's business.

Woodsmoke comes spelunking my nostrils
and tastes like burned toast where it rests on my tongue.

4. Morning tastes the way a rock felt
kissing me on the eye:

5. a kiss thrown by Randy Shellhourse
on the Jacksonville, Arkansas, Little League field
because we were that bored in 1965.

6. We weren't *that* bored in 1965.

7. Dogs ran amuck in the yards of the poor,
and music spilled out of every window
though none of us could dance.

8. None of us could do the Frug, the Dirty Dog

9. because we were small and wore small hats.

10. *Moon go away, I don't love you no more*
was the only song we knew by heart.

11. The dull crayons of sex and meanness
scribbled all over our thoughts.

12. We were about as happy as headstones.

13. We fell through the sidewalk
and changed color at night.

14. Little Darry was there to scuff through it all,

15. so that today, tomorrow, the day after that
he will walk backward among the orphaned trees

16. and toy rocks that lead him
nowhere I could ever track,
till he's so far away, so lost

17. I'll have to forget him to know where he's gone.

18. *la grave poullet du soir est toujours avec moi—*

19. even as the sky opens for business,
even as shadows kick off their shoes,

20. even as this torrent of clean morning light
comes flooding down and over it all.

COLLABORATIVE "CUT-UP"

Anne Waldman

The idea of the "collaborative cut-up" is to take a text utilizing a vocabulary not your own—such as a paragraph from a *Popular Mechanics* magazine or lines from a medical textbook or from a pop song—and intercut them with lines of your own. You might try literally intercutting line by line at first so that you challenge the logic of your phrasing. Then you might take larger chunks, move them around with more intent, and possibly intercut or add to the ingredients a third text.

——

The written "cut-up" was made famous by the Romanian dadaist poet Tristan Tzara who suggested cutting up a page of a newspaper, putting the pieces in a hat and lifting out the lines one by one to make a poem. Experimental writers such as William Burroughs have continued the practice to this day (see *The Third Mind* by William Burroughs and Brion Gysin). Of course, from a certain point of view, all writing is "cut-up" and the writer in this line of experimentation works very much the way a filmmaker does, shifting frames and images around, or the collage artist who glues disparate images together to make a cohesive whole.

The point of this experiment is to work with the elements of "chance" and "surprise" as well as be able to manipulate words as "things," as tangibles. This is often easier when the words are not your own, or not *entirely* owned by you. The other "bonus" with this exercise is the surprise that arises when things come together in unexpected ways.

FOUND IN TRANSLATION

Theodore Weiss

Translate a poem, preferably one you like, from a foreign language you know:

First, literally, as accurately in idiom and meter as you can; use dictionaries and whatever other helps you can find.

Second, freely into your own current speech.

Third, using the original as a subject or an item of argument, write a poem of your own in reply.

———

This exercise obliges you to deal with another language—as well as your own—firsthand. It immediately introduces you to a basic sense of language, especially your own, by the problems it presents. It involves you in all kinds of critical, crucial choices. It is also extremely valuable to live, even if briefly, in and through another poet, to flex muscles you didn't know you had.

HOMOPHONIC TRANSLATION

Charles Bernstein

Take a poem, or part of a poem, in a foreign language and translate it word for word according to what it sounds like in English. Try this with a language you know and then with one you don't know. Don't use a dictionary, just rely on what your ears hear and go from there.

Homophonic means "same sound": try to stick as close as possible to what each word sounds like in the original when thinking of an equivalent-sounding word in English. Use slang and other nonstandard English words. Let the syntax take care of itself.

This exercise works differently for languages that share many cognates with English—such as French, Spanish, and Italian—than it does for languages that do not have much in common with English. Experimenting with Oriental, Slavic, or Native American languages is likely to produce a wilder range of possibilities.

━━

Basil Bunting, the great Northumbrian poet, liked to read Persian poetry to his class, remarking that 90 percent of the meaning comes across even without any knowledge of Persian! Poetry

communicates as much by its sound as by its lexical meanings. Yet too often sound is taken to be an almost extraneous factor in a poetry that emphasizes content or voice above all else.

Homophonic translation provides a radically different way to bring a poem from one language to another. In the process, it allows for (fairly wacky) explorations of English syntax. Along the way, an unaccountable amount of poetic energy gets set in motion, and the results can be surprisingly revealing of unconscious aesthetic and personal proclivities. Indeed, it's remarkable how differently different writers will homophonically translate the same source text.

The classic work of homophonic translation is Louis and Celia Zukofsky's *Catullus*. A more recent work of homophonic translation is David Melnick's reworking of the *Illiad*, *Men in Aida*.

Here are a few lines of my own homophonic translation of a recent French poem by Dominique Fourcade:

> *En lisière autant que central le beau ses crimes que*
> *tient la rose infurieuse*
> *Toute la nuit et encore le lendermain j'ai séparaé*
> *isolé les chose tenté d'arrêter ou de rompre en*
> *vain il y a toujours plus bas des rétablit les*
> *séquences*
> *Ou un relais inexpiable qui rétablit les séquences*
> *Rien . . .*

An' listen, okay, *key* central elbow sez crime's key
 tent arose infurious
Toot the night! yet encored the landman jay separate
 isolate lay choices tented dared, or, duh, romp in

 vain, ill, ya to your blue bah, duh, rescue, duh,
 conductor's key person-nah-put, attend
Ooh, hun, relay inexplicable key *re* tablet lay
sequences
Re end . . .

*P*amela Alexander *comments:* Like many useful experiments, this one tracks you away from the usual and overworked. While the results may or may not be useful as they stand, they may provide happy accidents, associational gems, or a tonal structure you can use to envision a poem of your own. It encourages strangeness that arises from the experience of being lost in the foreign land of the incomprehensible page, that land where meaning has to be invented.

This exercise puts everyone on an equal footing—*everyone* is lost. The results are often greeted with laughter when read aloud, but it's the laughter of camaraderie. Early in the semester, it can help change a collection of individuals into a community.

Teaching at M.I.T., I often call exercises "experiments" and the class a "poetry lab." This experiment reminds me of those unknown substances in freshman chemistry waiting for students to liberate them from the mute realm of color, texture, and chemical properties and to label them with their discovered identities.

INDEX/TABLE OF CONTENTS EXERCISE

Lee Upton

Paul Violi's poem "Index" serves as guiding spirit for an exercise in which you have two choices: invent a mock index focusing on a character or subject of your choice, or invent a mock table of contents for a future book. Page numbers should be listed; these supply interesting effects, revealing, for instance, the amount of space an author devotes to each subject.

━━━

In *Ecstatic Occasions, Expedient Forms*, Paul Violi discusses the evolution of "Index." Through the index form he attempted "to play-off an 'argument' between the neutral if not deadpan tone and the wild particulars of the life it described." Here is a brief portion of Violi's "Index," written after he had read the autobiography of "an egregiously self-indulgent man":

Bigamy, scandals, illness, admittance of being "easily
 crazed, like snow." 128
Theories of perspective published 129
Birth of children 129
Analysis of important works
 wine glass with fingerprints
 Nude on a blue sofa

The drunken fox trappers
Man wiping tongue with large towel

Beyond simple listing, a submerged narrative is encoded in Violi's index. Similarly, in an exercise we may move rapidly over space and time in a character's life. (Violi's poem also presents wonderfully inventive titles that may inspire those who wish to write a table of contents.)

As exercises, both the mock index and the mock table of contents reveal potentials in ordering fragments of language—the line without ligature, without conjunctions as lubricants. This exercise typically works well in class, stimulating discussions about arrangement, chronology, concision, submerged narratives, and the mind's movement among fragmentary pieces of information. And the table of contents exercise (particularly if composed for a mock book of poetry) may prove suggestive, for the orphaned titles that have been invented may seek out in the writer's mind the as yet nonexistent parent poem (just as an index may call out for renewed invention).

MAKE YOUR OWN SYSTEM!

Jackson Mac Low

Choose a short text as a source of words, phrases, sentences, or other linguistic units that may be, in some way or other, brought into a poem. It will help if the subject matter of this text (e.g., a short article, news item, or philosophical passage) has especial resonance for you, whether for aesthetic, moral, religious, political, social, philosophical, scientific, or any other reasons.

Devise a relatively "impersonal" or "objective" method by which to extract linguistic units from your source text. I give the following as an *example* of such a method, but I request that you do *not* use *this* method in making your own poems. *Please devise your own methods!*

Since 1963 I have often used (alternately with a number of other ways of writing and making artworks) what I call "diastic" ("spelling *through*," on analogy with "acrostic") methods for extracting linguistic units from source texts. In using a diastic method I read through my source and take into my poem linguistic units that "spell through" a "seed" word, name, phrase, or sentence. This means that the successive linguistic units taken into the poem have the seed's successive letters *in corresponding places*.

Thus, I recently wrote a series of poems by applying diastic methods to "Net Murder at Sea," an article on drift-net fishing that had been reprinted from *The New York Times*, February 17, 1986, by the Environmental Defense Fund. While writing one of these poems I used the article's title as "seed" and followed a diastic method that took sentence fragments running from a word that had one of the seed's letters in a corresponding place to a punctuation mark. The article begins:

An unusually destructive method of ocean fishing now jeop-
ardizes the Alaska salmon catch. Even more is at stake,
however, and the United States has only begun to do any-
thing about it.

The technique employs huge drift nets that can be stretched
across 30 miles of sea.

The resulting poem begins, by "spelling through" the word "net":

now jeopardizes the Alaska salmon catch.
̄begun to do anything about it.
 nets that can
be stretched across 30 miles of sea.

Quite dissimilar poems can be made from the same source text by using various combinations of methods. For instance, from the same source I obtained the following short poem by "spelling through" the seed sentence "Drift nets are killing millions of sea birds, sea mammals, and fish" via two computer programs (first, Hugh Kenner and Joseph O'Rourke's *Travesty*, which selected and rearranged words from the editorial; second, Charles O. Hartman's *Diastex4*, an automation [which counts apostrophes and

hyphens as letters] of one of my diastic methods) and minimal editing:

Do drifting drift-nets suffocate?

Least netting,
sea into purse a drift
American
Korea viable salmon cycle,
victims salmon fishing might miles miles small netting,
million drift-nets
Alaska's one of set near trapped buoys fisherman more hun-
 dreds
across sinks
require than marketable radio limit salmon
Korea finally interested and on radio for fish.

Mysterious fish.

Remember that you do not need to use the material just as it is given to you by the method you devise. You may edit the material in any way you see fit. However, *you should respect the results of your method* so that you do not just end up with some-thing such as you'd have written anyway. There should be a *creative tension* between the "objective" method and its products and your own predilections. Your method and your use of it should redound upon your taste, your poetics, and upon your beliefs about art and life in general.

———

I have been using methods such as that exemplified above for over thirty-five years, but I do not expect you to use them for reasons identical with my own. Like the German collagist, painter,

poet, and sculptor Kurt Schwitters, who wrote: "Striving for expression in a work of art seems to me injurious to art," I felt it necessary to get away from artmaking methods springing mainly from "the ego." I was influenced toward doing this by the works and theories of the composer John Cage and his friends, as developed around 1950, and by Zen Buddhism, as expounded in the books and Columbia University classes of Dr. Daisetz Teitaro Suzuki, which also influenced Cage.

However, I do not expect you to share the theories and beliefs of either Cage or Zen Buddhists, much less my own, which have developed and proliferated in many directions since 1954. I merely wish you to explore methods of this sort as a means to expand your horizons and possibilities. I wish you to become conscious of what you now do and what you *could* do when you write poems.

Too many young writers feel that they have to do what other writers are and have been doing and to believe as they do. They often passively accept and follow without questioning their contemporaries' (and their immediate predecessors') assumptions about poetry, about art in general, and about the role of the artist, which they may perceive as self-evident "intuitions" and as universally valid judgments of "taste" or of "quality." Through inventing your own methods for making poems, you may become conscious of what you have absorbed from your cultural environment and of your freedom to *choose* other assumptions and other ways of working and making than those you've received without fully realizing it and introjected—unconsciously made part of yourself.

I regard this and similar exercises as ways through which writers may empower themselves.

Here is the complete poem from Stuart Friebert's exercise on page 116.

CHILDHOOD IS THE KINGDOM WHERE NOBODY DIES
by Edna St. Vincent Millay

Childhood is not from birth to a certain age and at a
 certain age
The child is grown, and puts away childish things.
Childhood is the kingdom where nobody dies.

Nobody that matters, that is. Distant relatives of course
Die, whom one never has seen or has seen for an hour,
And they gave one candy in a pink-and-green stripèd bag,
 or a jack-knife,
And went away, and cannot really be said to have lived at
 all.

And cats die. They lie on the floor and lash their tails,
And their reticent fur is suddenly all in motion
With fleas that one never knew were there,
Polished and brown, knowing all there is to know,
Trekking off into the living world.
You fetch a shoe-box, but it's much too small, because she
 won't curl up now:
So you find a bigger box, and bury her in the yard, and
 weep.

But you do not wake up a month from then, two months,
A year from then, two years, in the middle of the night

And weep, with your knuckles in your mouth, and say Oh,
 God! Oh, God!
Childhood is the kingdom where nobody dies that
 matters,—mothers and fathers don't die.

And if you have said, "For heaven's sake, must you always
 be kissing a person?"
Or, "I do wish to gracious you'd stop tapping on the
 window with your thimble!"
Tomorrow, or even the day after tomorrow if you're busy
 having fun,
Is plenty of time to say, "I'm sorry, mother."

To be grown up is to sit at the table with people who have
 died, who neither listen nor speak;
Who do not drink their tea, though they always said
Tea was such a comfort.

Run down into the cellar and bring up the last jar of
 raspberries; they are not tempted.
Flatter them, ask them what was it they said exactly
That time, to the bishop, or to the overseer, or to Mrs.
 Mason;
They are not taken in.
Shout at them, get red in the face, rise,
Drag them up out of their chairs by their stiff shoulders
 and shake them and yell at them;
They are not startled, they are not even embarrassed; they
 slide back into their chairs.

Your tea is cold now.
You drink it standing up,
And leave the house.

LAWS
of the
WILD

STRUCTURE,
SHAPELINESS,
AND ORGANIZING
PRINCIPLES

BLOCK, PILLAR, SLAB, AND BEAM

Deborah Digges

"A poem is a small or large machine made of words."
WILLIAM CARLOS WILLIAMS

Write a poem in which you literally build and/or take apart
something for your reader. Focus your attention on constructing
or deconstructing concretely your object, taking into account
technical terms, instructions, perhaps even the source of your
materials. The object you build or take apart may be small, like
a bird feeder or a model plane, or it may be huge, like a house or
a monument. Likewise you may treat this occupation very liter-
ally, as Elizabeth Bishop does in her poem, "The Monument," or
figuratively, as Carlos Drummond de Andrade does in his poem,
"The Elephant," a work that creates an otherworldly animal from
scraps and garbage.

═══

The purpose of this assignment is to help you take your mind off
emotional content and invest it in a process. In fact, this assign-
ment could also be expanded to include the very enactment of a
process. That is, you could interpret your object by way of
instructing your reader how to build or destroy it. In this case you
might try a present tense, directional tone, as if you were writing

an instruction manual. On the other hand, you might begin your poem in the past tense, chronicling a construction through memory. Then connect, as you write, narrative details of character and scene. What season was it when your father built the fallout shelter? What did the light look like, or the snow, or the dirt piles? This exercise will help you to understand that a poem proceeds, line by line, and is built, itself, of words, of a language full of things that resides against a horizon, a horizon that can focus and enhance the subject.

Originally I designed this assignment for my undergraduates, but I have used it myself many times. Some poems that might help you get started, besides the ones mentioned above, are Frost's "Directive" and "The Woodpile," along with John Ashbery's "The Instruction Manual," and Stanley Plumly's "Hedgerows." Note that the title of this assignment is taken from one of Wittgenstein's language games in *Philosophical Investigations*. This, too, might make for some interesting reading.

THE FILL-IN-THE-BLANKS OR DEFINITION
POEM

Jack Myers

Choose an ordinary object, such as a door, then make up a list of functions for that object. Try to select functions that lend a symbolic meaning or quality to the object. For example, a door opens, closes, locks, blocks the view, separates inside from outside, etc. When you have created the list, begin the poem with the object and then follow that with a series of functions selected from your original list. Select the functions with an eye toward some larger insight or theme, and structure the poem in the following sequence: (1) title and subject, (2) the list of functions, and (3) a summary statement. For example:

(title and subject) THE DOOR

(list of functions) The door locks
 the outside out,
 the inside in.
 It divides space
 into time, the drab
 present from the promise
 of the future. As it opens
 and the darkness pours out
 and the light floods in,

 or night pours
 into darkness—
 it into you
 and you into it—
(summary statement) it makes you realize
 there is no reason
 for a door, that opened or
 closed, absent or present
 it is there and not there.

Although there is no fixed external form to the fill-in-the-blanks or definition poem, it has a rigorous inner structure that depends upon a list of observations that coheres around its subject. The major challenge of this type of poem is that your final list be highly imaginative and selective. For a variation of this exercise, try it using an abstraction (such as democracy) or a collective noun (such as American poetry).

OPPOSITES:

THE ATTRACTION OF TITLES

Stuart Dischell

(1) Choose a pair of words with opposite or nearly opposite meanings. Primary choices such as "hot and cold" or "good and evil" might be avoided, although sometimes the obvious can be a good place to begin. Try instead to find a more suggestive or playful pairing such as "calm and calamity." (2) Write a poem titled and based upon each of the words you have chosen. If you have trouble getting started, you might make a list of all the associations of imagery each word contains and all the personal associations you have with each word. (The more eccentric the better!) In this way a dramatic situation can evolve. (3) You might also consider whether the two poems should be formally similar or dissimilar. What is gained or lost? Does one poem lend itself to traditional form, another to a freer verse?

———

This is an exercise in the suggestive relationship between title and text. I have often found that a title can engender an entire poem, if not the crucial first line that can play off the title. The exercise is particularly useful in opening your mind to the potentials of associative writing. Moreover, I like getting students to think in terms of opposites and antipathies; and, of course, there is the issue of the poem that exists between the two poems. Part three

of the assignment can get you thinking about the uses and appropriateness of form and whether there is such a thing as the imitative fallacy.

Reading List: Christopher Marlowe, "The Passionate Shepherd to His Love" and Sir Walter Raleigh, "The Nymph's Reply to the Shepherd"; Ben Jonson, "Still to Be Neat" and Robert Herrick, "Delight in Disorder"; Andrew Marvell, "A Dialogue Between the Soul and Body"; John Milton, "L'Allegro" and "Il Penseroso"; William Blake, "Songs of Innocence and Experience"; William Wordsworth, "Expostulation and Reply"; William Butler Yeats, "A Dialogue of Self and Soul."

CLEAVE AND CLEAVE

Carol Muske

Brenda Hillman wrote a brilliant poem called "Cleave and Cleave," which examines these words that sound and can be spelled the same, but have opposite meanings. I'd like you to think of two words that are homonyms but mean different things, e.g., *lie* and *lie*, *stone* and *stone*, *bear* and *bear*, *write* and *right*—think of an emotional situation in memory that these homonyms might speak to, then imagine yourself "encountering" each of these words separately, in concrete examples—e.g., you are "writing" your name on a blackboard as a child, over and over; the sun is spilling in the window, fading the slate as you write. You start to think about your "right" to be yourself, and you look at your self, the clothes you're wearing, your hands, etc. Then you bring both words together at the poem's conclusion, like Hillman, who dramaticized the words' opposite meanings by ending with two strong sentences: *You* might say, e.g., "I will write my name over and over on the glass." Then, "I will disappear: my right."

This exercise is a great exploration—it forces you to "leap," to create a bridge between two words twinned by sound but different. It is this unlikeness beneath obvious similarity, the true

isolation of each word, that is the first object of the search. The second is to relink the two words on a profounder level, in an overview, a kind of philosophic conclusion. So the poem, though usually emotional in content, ends up intellectual in construct. This exercise develops imaginative and analytical "muscle."

MATTHEWSIAN INVISIBLE HINGE

Pamela Alexander

Write a poem in which some major change (in style or content) occurs across a stanza break. The poem should not explicate or comment on the change; it should rather absorb or reflect it.

The experiment is based on William Matthews's delightful discussion of the genesis of his poem "Merida, 1969" in *Ecstatic Occasions, Expedient Forms.* ("Invisible hinge" is his phrase.) Across the hinge (or pivot or dovetail joint) "the poem could propose . . . an implied relationship" between its two parts.

This is a fairly sophisticated assignment that can be perceived as vague or overwhelming to beginning students. Don't try to define the nature of the hinge before starting; instead, allow it to arise from some opportunity presented by a poem underway.

"QUE SERA, SERA"

AND OTHER FALSE PREMISES

Christopher Gilbert

Take a line that makes an assertion from one of your own poems (or from one of your favorite poets) and regard that assertion as a false premise. Write a poem making that false premise a moment that touched you in your past or that will come to be a factor in your future. For instance, a writer might regard the line ". . . because in the dying world it was set burning . . ." (by Galway Kinnell) as "It was never set burning." What does this imply for you right now? In this example, the generality of the line and the pronoun in the line allow for the metaphorical condensation of some important lack in the writer's past with the intensity, destruction, or exhaustion, etc., of burning.

———

This exercise turns on highlighting the if/then connections the writer makes on a not-so-conscious level and the delights and values he or she consciously believes and adheres to. The exercise condenses two "contents" into one event—the present moment, a future moment, etc. The exercise demands that you make reconciliations and write down what you feel is the logic of life. It is a useful exercise for a more advanced student who wants practice with "sequence" and "connection."

This exercise—like any exercise—does not necessarily result in a poem. Usually it leads to an impulse that one feels clear about.

Finally, the "challenging" attitude—the argument with the premise—of the exercise does not necessarily lead to a political poem, but—good god—it might.

"THE PROPS ASSIST THE HOUSE"

James McKean

First choose a line or a rhythmical phrase. Salvaged or lifted from another poem or given by the muse as Spender suggests when he mentions Valéry's *"une ligne donnée,"* this base line is the place where the writing process starts, where it rests, and where it finishes. Next read the base line and write whatever comes to mind, avoiding anything that stops the flow of words. Let the lines come as rapidly or at least as steadily as possible. If the words stop or if you have the urge to read what has been written or if you pause to reflect or to make conscious decisions about the direction, subject, nature, theme, importance, significance, or need of what you are writing, repeat the base line. Repeat it until the flow of words begins again unmediated by decision making. This is not a time to choose and shape, but to invent spontaneously and to record whatever is invented. Follow rather than lead with the base line serving as a resting place, a safe haven, and a rhythmic source.

Finally, remove the base line entirely. What you have left is the material to make a poem.

The point of this exercise is to create a fixed point from which to improvise. It's a child's game of wandering farther and farther into a strange neighborhood, each time returning home safely. This exercise is informed by many sources—poets, blues singers, jazz musicians, even the street jugglers I once saw in Baltimore. Each improvises in response to something fixed—a form, a melody, a system of rules. When I listen to John Coltrane play a sequence of notes uniquely his, individual and spontaneous, his return to a set figure seems to validate and frame his improvisation, and then he's off again, one free cast of mind playing in terms of another.

The repetition of the base line provides a resting place, a mantra of sorts, a rhythmic undercurrent quieting the noise of the self-conscious should's and supposed to's. Once the imagination is recharged, we're free to improvise again. Even repeating the base line over and over again is probably more valuable than forcing the poem toward some willful end. Write. Repeat. Write more.

Many years ago Kim Stafford, in a version of this exercise, suggested deleting the baseline. It's all two-by-fours. Remove it if it's really good and especially if you've grown fond of it. There is no getting rid of this line's influence, however, for its strength will lie behind the scenes as a secret unit of coherence.

This exercise reminds me of Emily Dickinson's poem that begins "The props assist the house / Until the house is built." Our base line serves as a prop, and the improvised lines in between stand as the house, unfinished perhaps but nearly self-supporting, spontaneous and fresh. The "auger and the carpenter" are everywhere present but nowhere visible. The props define a space until the

house defines itself. And then Dickinson finishes her poem by making the house itself serve as a prop, so that we might understand through metaphor what leads to a "perfected life": "A past of plank and nail / And slowness,—then the scaffolds drop— / Affirming it a soul."

THE FAMILIAR

Alicia Ostriker

Choose a set of poems derived from scenes of ordinary life, by a variety of contemporary American poets with highly distinctive styles: Creeley's "I Know a Man," Ferlinghetti's "pennycandy-store beyond the el," some early Bly, poems by Richard Hugo and Stephen Dobyns that take place in a bar, some Levertov, some May Swenson, Ginsberg's "Supermarket in California," some Frank O'Hara city poems would be examples. Pick the poem you like best and write one in that author's style, but in a different location.

$$===$$

In class, after the student reads his/her poem, the others guess which poem from the group was being imitated. Then we go to that poem and talk about what devices the student has adopted, about how successful the adaptation is in reproducing the tone and feel of the other poet, and about how strong the new poem is on its own. Commonly students balk at the idea of this assignment. They hate sacrificing their "originality," they don't want just to "imitate" somebody else, they want to be "themselves." But when they actually do the assignment, they often love it and want to do it again because they discover—as I think you will—that it gives you an opportunity for freedom as well as structure,

and can even help you discover your own voice. From my point of view another advantage of the assignment is that it pushes you into becoming more conscious about poetic strategies, and into analyzing what other poets have done with diction, structure, metaphor, etc.

WRITING BETWEEN THE LINES

J. D. McClatchy

AN ASSIGNMENT

Choose a poem of between ten and twenty lines. Not a favorite
poem, but an obscure poem by a favorite poet. (I suppose this
could work with an older poem, but contemporary work is to be
preferred—the tone is more suitable. Ashbery works well, or one
of Lowell's unrhymed sonnets. Something a little abstract. Bishop,
for instance, resists this kind of tampering, and Plath can be
overpowering. But Robert Hass perhaps, or Louise Glück?) Type
out the poem, triple-space. Then, between the lines, fill in a new
line, based on or suggested by the original line. Don't be dogged.
Use the original, don't merely be used by it. Next, eliminate the
original poem (a word processor makes this a snap), close up your
own "poem," and tinker with it to make it cohere. Consider it the
first part of a longer poem, and label it so. Then write a compan-
ion section—Part II, and entirely your own—that extends the
first part by continuing or departing from or in some other way
varying the themes and images of the first.

AN ASIDE

This exercise merely makes literal what is implicit about any
poem. Whoever thought of writing a poem before having read

one? Looking back over his career as a composer, Igor Stravinsky once wrote, "I have been formed in part, and in greater and lesser ways, by all of the music I have known and loved, and I composed as I was formed to compose." So each of us writes as we were formed to write—formed by the poems we have, from childhood on, read or studied. It is curious to read Thomas Lovell Beddoes's lurid nineteenth-century poem "The Phantom-Wooer," whose speaker is a ghost trying to seduce a living lady fair into the grave, and to encounter these lines:

> Young soul, put off your flesh, and come
> With me into the quiet tomb,
> Our bed is lovely, dark, and sweet;
> The earth will swing us, as she goes,
> Beneath our coverlid of snows,
> And the warm leaden sheet.

As a schoolboy, Robert Frost must have read this poem, then an anthology favorite. Decades later, it echoes through "Stopping by Woods on a Snowy Evening"—and not just in the crucial line "The woods are lovely, dark and deep," but in the patterns of imagery and emotion as well. Frost's great poem does not set out to imitate or echo its model. I suspect, rather, that for years Frost carried around a rhythm in his head, a single line with a certain cadence, and that it came (unconsciously) both to shape his own line and to prompt its associated images.

We've all had similar experiences, and they can be disheartening. We write a line we're especially proud of, and weeks later find it staring—no *glaring*—back at us from some stanza in George Herbert or Emily Dickinson. All poets have debts outstanding. It's how we learn, how we adore; we come to ourselves by putting those selves into the hands of masters. With experience we learn

how to disguise our thefts (sometimes by flaunting them). It is how we both continue and extend a tradition.

Twenty years ago, before retiring to a new home in England, W. H. Auden made a farewell reading tour of the States. When he came to Yale, where I was then a graduate student, there was a rapt and overflowing crowd in one of the college Common Rooms. I was lucky to get a seat—on the floor. (It gave me a view of Auden's ankles, so that I noticed his socks didn't match.) I was spellbound by his reading, and afterward rushed up to ask him to inscribe my copy of his *Collected Poems*. He looked at me and said, "Turn around and bend over." What he wanted, of course, was to use my back as a desk. And he did. Auden was writing on my back! It wasn't until years later I realized he's been doing that ever since. Smart poets let the masters keep writing by becoming desks for them, or using them as desks for ourselves. And that is the purpose of the exercise above.

THE POETRY OBSTACLE COURSE

Marcia Southwick

Write a poem in which you include approximately one object and one action per line. Each individual line should make sense in and of itself, but don't worry about connecting one line logically to the next.

———

Many students start out by writing sentences that join together to express a single thought or central idea. Their first poems usually consist of paragraphs chopped into lines. This exercise prevents "paragraph thinking" and slows down the composition process by causing the mind to focus on small units of language. You shouldn't worry about connecting lines logically because often you'll discover that lines don't always have to be written in order, from beginning to end, and that logic can work in subversive ways, as a kind of undercurrent below the surface.

Consider writing the last line first, working your way upward through the poem to the first line, just to get used to the idea that poetic thinking can move forward or backward from any given point during the process of composition. Occasionally, I'll provide oddball lists of objects for in-class exercises. I'll suggest that the poem shift from place to place in every line, while restricting

itself to a single moment in time; or I'll suggest the reverse—that it stick to a single location, while shifting around in time.

The point of these exercises is to show how logic can be applied to "accidents" in order to move the poem beyond ordinary patterns of thought. The "accidents" form a kind of obstacle course for logic, which otherwise would travel in a straight line.

IMPORTANT EXCITEMENTS:
WRITING GROUPS OF RELATED POEMS

Maggie Anderson

> So much is involved in the writing of poetry—and sometimes, although I don't like suggesting it is a magic process, it seems you really do have to go into a *bit* of trance, self-cast trance, because "brain work" seems unable to do it all, to do the whole job. The self-cast trance is possible when you are *importantly* excited about an idea, or surmise, or emotion.
> —GWENDOLYN BROOKS,
> *Report from Part One*

The rules for this exercise are simple. Write a group of poems related to each other in form, in content, or both. Start by writing a brief proposal of what you intend to do in advance and then stick with it. The number of poems you write can vary. I suggest no fewer than five (to allow room for frustration and boredom to set in), and no more than twelve (to avoid the point of diminishing returns). Ten is a good number in part because it suits the usual length of an academic term, which is also roughly the length of a season in most parts of the world. Occasionally, students I have worked with have written twelve or thirteen poems in their group; rarely has anyone shown us more than fifteen.

The specific technical skills that an exercise like this can teach are as idiosyncratic as the choice of format and are intricately connected to each individual poet's obsessions, whatever *"importantly"* excites you. If you choose, for example, to write a group of sonnets, you will undoubtedly learn much about rhyme and meter through the consistent practice of it. If you choose to write a group of poems about seashells, you will probably learn some things about objects in space, about enclosures and coverings, about marine detritus, and about who-knows-what in yourself that has generated your interest in shells. In either case, you will almost certainly learn something about your own imaginative process: your habitual gestures, your extravagances, and your reticences; the places where you give up or the places where you push ahead.

Because this exercise requires that you work out your concerns through more than one poem, it widens the pallet. When your usual poetic strategies have been used up, you may find that the three or four poems you still have to write will surprise you as they come out of boredom, sheer tenacity, nerve, or some hidden pocket in the imagination that you didn't even know you had.

The imagination is often an oddly conservative faculty. Like the child who wants the same story over and over again in exactly the same way, the active imagination delights in the repetition of a good line. But a few good lines or gestures can be a rather thin repertoire. Writing a group of related poems asks that you think, consciously and in advance, about what you are *"importantly"* concerned with in your poems, not just line by line or poem by poem, but over the whole of your work. It asks that you seriously consider your work as a continuing project that engages you, with the fullest range of options, over a period of time.

One of the things I admire about Gwendolyn Brooks's subtly evocative description of the process of writing poetry is that it takes for granted the existence of "excitements" which are not all that important. Obviously, not every agitation of the mind or heart will yield a poem. Determining what we are *"importantly"* (and I read here also, "truly") excited about is difficult. But it is crucial if we are to write poems that are truly engaging to ourselves and others, if we are to evoke what Brooks calls the "self-cast trance."

I find that working on groups of related poems helps me remain conscious of what I am truly engaged with in my own interior life. It seems also that having the group there in the back of my mind as a kind of steady hum of interest keeps me working, even when the external demands on my time are overwhelming much of my interior life entirely. Over the last few years I have written several groups of related poems, one on Walker Evans's photographs of West Virginia people and one on the dreams of vegetables.

For the last five years, I have made this exercise the only requirement in the graduate poetry workshops I teach. Besides the obvious practical value that working with a group of poems has for students who are in the process of putting together book-length manuscripts, this exercise focuses our critical responses in the workshop in interesting ways. Since we know in advance (at least in a general way) what each poet intends, we are forced to be both more specific and more informed as readers. While honoring the legitimacy of individual ambition and concern, the framework of this exercise also insists that we respond to the poems we read in relation to other poems by that poet, rather than in relation to other poets in the workshop who may be doing vastly different things. It challenges us as readers to learn something about sonnets, for example, or seashells, in order to respond

intelligently. And, it provides us with resident experts on those things: those who have declared themselves to be deeply engaged by them.

The most frequent resistance to this exercise comes from those who feel strongly that poems can only be discovered in the doing of them and that articulating a project in advance may interfere with the process. While I respect that concern and understand it to be a part of any exercise for writing, I believe that accommodations can be made in the way the exercise is set up. It's important to define a project that allows as much room as you feel you will need. A group of poems concerned with light seems considerably roomier than a group of poems in dactylic hexameter about your grandfather. In any case, part of the energy for this exercise (maybe for any exercise) comes out of resistance. Some of the most surprising poems I have seen from my students have come at the moment when they have created a way to slip through their own defined parameters, when, for example, the group of poems *about* Atlantic City turns into a direct address to the city itself; or when the sonnet sequence ends with a thirteen-line poem called "Not a Sonnet."

The point of an exercise like this is not, finally, in the "success" or "failure" of the group as a whole, but in what we learn about acknowledging and embracing our own idiosyncrasies. To make this exercise the central focus of a poetry workshop keeps the poetic life close to the lives we are actually living, with their pain and complaint, their grandeur and despair, their *"important* excitements."

THE SHORT NARRATIVE POEM

Roland Flint

Write a poem, eleven to fifteen lines long, in which you tell a story.

Specifics: First of all, your poem must tell the story of some one incident, something that really happened, at a specific time and place; either to you or to someone you know; or, if not, it should be an incident you know enough about to imagine the rest. (I actually have no objection to its being completely fabricated, but you must make it a *believable* story.) Next, the lines may vary from nine to ten to eleven syllables, but must not *all* be nine or all ten or all eleven. In other words, it is to be a rough approximation of a blank-verse poem, but without iambic pentameter; it is a bit like a sonnet, but without rhyme. (In fact, you are not to try for rhyme or for iambic rhythm.)

Not an absolute requirement, but *try* not to have more than one line in four or five ending in a period; that is, you are to vary the structure and length of sentences and, obviously, the relation of sentence endings to line breaks. One mark of beginners writing in forms is that many of the lines end exactly where the sentence does, the worst case being that every sentence is only one line.

Obviously it's useful to ask yourself if this is an incident worth telling about, worthy of a poem, of possible interest to others. But don't tell, in the poem, *why* it is interesting or what it *meant;* use *all* your space to tell *what happened.* Its meaning beyond itself (the theme?), your attitude, your feelings, your ideas about it—these must all be *implied,* not stated. Also, don't worry, especially at first, about actively implying; just tell what happened, exactly as you remember (or imagine) it, and all of your most important feelings, prejudices, biases, convictions, will be implied—which is to say that the careful reader will be able to infer them.

Advisory: Why not start, after you have decided on the incident to relate, by writing it out as prose, with no concern for length or syllable counting. Do this to make clear to yourself what details exactly are essential for telling this story. When you have it as nearly complete in this form as you can make it, then cast it into lines in the required number that make the best reading sense and come as close as possible to the variable nine-, ten-, or eleven-syllable count model. If what you have written is much too long, then you must consider again what is essential to telling the story, revise accordingly; then go to work on the form. It may be easier than you expect, that is to say, you may find that only a little tinkering will bring it into compliance with the simple technical demands of the assignment. And if you tinker, with attention to keeping the language and the story clear, you will probably also improve the piece as narration.

It is important to remember when revising that you want it to be as plain and direct as you can make it: as ever, remember that you are *not* to be deliberately "poetic" in a bad, mannered, sense; if there are figures, or comparisons, permit yourself only those that come naturally and self-insistently to the story. At the same time,

try to avoid all clichés of both diction (word choice) and figure (simile, metaphor).

━━━

The assignment is intended to teach you the structural rigor of the sonnet, without the compromises of rhyme and a fixed metric. There are lots of examples of the short narrative, in poems of roughly this structure, by Robinson, Frost, James Wright, Sharon Olds, Henry Taylor, Linda Pastan.

THE CAT POEM

Alicia Ostriker

Read a number of short William Carlos Williams poems including "This Is Just to Say," "The Red Wheelbarrow," "Iris," "Danse Russe," and "Poem." Notice the apparent naturalness and ease of Williams's language combined with the precision of his observations. Scan "This Is Just to Say," "The Red Wheelbarrow," and "Poem" and try to deduce the set of formal rules or constraints each of these poems is obeying—for example, "This Is Just to Say" consists of four four-line stanzas with one major stress in each line, yet no two lines scan alike. The assignment is to write three poems modeled on Williams's cat poem:

POEM

> As the cat
> climbed over
> the top of
>
> the jamcloset
> first the right
> forefoot
>
> carefully
> then the hind
> stepped down

into the pit of
 the empty
flowerpot

Each poem observes the following rules: It consists of a single
sentence describing a single action which is composed of several
distinct smaller actions, and the syllabic pattern should be the
same as Williams's or as close to it as possible. The three poems
should describe radically different actions from one another—the
contrasts should be as wide as possible.

In a class, we can usually read and comment on at least a half-
dozen sets of these. The smallness of the poems makes it possible
to examine the success or weakness of every word and phrase, as
well as to talk about building a whole structure, including closure.
The usually wild variety of responses to my basic demand (a
sentence describing an action) begins to show everyone what art
is and how a first impulse isn't the only possible response—there
are always multiple quite different possibilities to explore.

THE SEDUCTION POEM

Alicia Ostriker

Write a "seduction poem" in tetrameter couplets, in a modern voice. This can be a sexual seduction, and feel free to make it as cynical as you like. But it can also be any other kind of seduction. It is a poem in which you try to convince somebody of something they don't want to be convinced of. The poem is an argument, an attempt to persuade. I'm assuming it will be light and clever on its surface, but remember that for a witty poem to work, it should be about an experience people normally take very seriously.

━━━

Read Marvell's "To His Coy Mistress" and think about the structure, which is that of a syllogism, a logical argument. Notice how Marvell mocks the conventions of courtship, how the poem addresses itself to an implied hearer whose reactions the reader can guess—and how both witty and powerful the poem is. Notice how the tetrameter couplets work. What does it mean to have a "punch line" every two lines? How is enjambment important for a building up of force? What kinds of internal caesurae does Marvell use? You might look at a Gjertrud Schnackenberg poem to see how couplets work for a contemporary American poet.

The first thing that's fun about this assignment is the range of situations it provokes you to write about. There are sex poems, of course; and it's useful to see how you can outdo rock songs on this subject. You can be down and dirty, you can be cynically analytical about power relations in sex, you can play with conventions everyone is familiar with. My students have written poems in which the speaker tries to convince a cop not to give her a ticket; or tries to persuade Dad to send more money; or a professor not to fail him; or muggers not to mug. These are among the more light-hearted efforts. I also once had a student write in the persona of an older boy persuading a younger boy to take drugs; and one by a woman dissuading a friend from suicide, which was not at all funny but very strong.

MUSICAL MATTERS

SOUND, RHYTHM, AND THE LINE

A LEWIS CARROLL CAROL

Karen Swenson

Go through your dictionary and choose unfamiliar words, ignoring their meaning and what part of speech they are. Make a list assigning each to whatever part of speech you choose and write a poem or series of lines using them in the grammatical slots you have put them in. As you do this pay attention to their sounds. The object is not alliteration, which can become heavy or silly: The wraith of the willow whipped and whined in the wind. Instead, work for a repetition of unaccented with accented consonants or similar but not identical sounds such as these in the following categories:

Dentals: t, d, th, either as in "think" or "this."
Labials: b, p.
Gutturals or velars: g, k, ng.
Labiodentals: f, v.
Sibilants: s, z, sh, ch, zh, j.
Nasals: m, n, ng, nk.
Liquids: l, r.

Vowel sounds are also very important and should be utilized. Make words into adverbs by adding *ly* and add whatever tense ending you need onto words you use as verbs.

EXAMPLE

> Noun: oca
> Verb: dextran, rhonchus, umbles
> Adjective: maravedi, saccade
> Adverb: pavid, tectum

> The oca moaned all night in the dump
> among cars rhonchused, cankered with
> the maravedi dust. Dextraning
> pavidly in moonlight it
> woke neighbors who umbled tectumly
> down to the pit with guns and baseball bats,
> a saccade crowd bent on murder.

To break this down a bit: *oca* and *moaned* are paired for their *o* sound; *night* picks up the nasals in *moaned* and *dump*. In the next line the nasals of *among* match with the *on* of *rhonchused* and the *n* in *cankered*. *C* marches through the line from *cars* to *rhonchused* to *cankered*.

═══════

The object of the exercise is to develop the ear so that it automatically picks up on related sounds. Therefore, it is important to go back at once and draw circles or underline the related sounds. The use of nonsense words helps to keep the mind focused on sound rather than meaning. I have also found that nonsense words help one focus on the grammatical relationships of words and will reveal any excessive use of adjectives or adverbs.

Susan Mitchell

If you read the title of this exercise aloud, you will hear a quadruple rhyme. But if you examine the words themselves, you will notice that there is something special about this rhyme scheme. The sound of the word *shun* is contained in *ocean*, the sounds of both *shun* and *ocean* in *motion*, and *shun*, *ocean*, and *motion* can all be folded into *emotion*. Such a rhyme scheme, which incidentally was favored by the seventeenth-century poet George Herbert, is called diminishing rhyme because the rhyme words get smaller as you move from *emotion* to *shun*. But I prefer the term *nesting rhymes* because the words nest one inside the other like Russian wooden dolls.

Write an eighteen-line poem that uses diminishing, or nesting, rhyme. Order your eighteen lines into six three-line stanzas. Each stanza will take its end rhymes from a single word. Say, for example, the first line of the first stanza ends with the word *manifold*. Then the second line would end with the word *fold*, the third line with the world *old*. For the second stanza, choose a different word that introduces a new rhyme sound—say, *stumble*, *tumble*, *bull*. There's nothing wrong with sticking to the same rhyme sound for all eighteen lines as long as you use six different words to produce those rhymes—e.g., *emotion* supplying the

rhymes for stanza one, *attention* supplying the rhymes *tension* and *shun* for stanza two. But realize that if you do that, you will make writing the poem more difficult.

━━

I like this exercise because the rhyme words already suggest the kind of relationships that can generate a poem. Say you choose the words *emotion, motion,* and *ocean.* Is emotion bigger than an ocean because the word *ocean* can be folded into the word *emotion?* Because emotion swallows up all the other words like a big fish, a fish that gulps down the ocean that contains it? See what I mean? The kind of thinking I'm led to is wacky and intuitive. Language seems to be generating thinking, making the poem.

Since this is an introduction to rhyme, it also helps to do ear-training exercises. I ask my students to listen to all the sounds the ocean makes: our university is only a mile or two from the Atlantic. I ask them to listen to the sounds of the wind. I also urge them to listen to children—to the rich variety of sounds they make. I play tapes of whale songs and Webern's *Six Bagatelles.* The bagatelles take only three minutes to play, but introduced into modern music a whole new vocabulary of sounds. I ask them what they think Paul Valéry meant when he said that "the ear speaks, the mouth listens"? How many sounds are left out of language? What sounds is it impossible for language to include? Or can language include all sounds? How can we bring into poems the sounds that elude written language?

PATTERNING

Stephen Dunn

Write a poem in which an element (a phrase, a motif, a particular kind of diction, etc.) is returned to several times in the course of the poem. Each time it occurs it should of course be recognizable, but should be a variation of, rather than an exact duplication of how it was used before. That is, I'm not asking for a refrain. The recurrences should occur at intervals regular enough as to suggest method, and should become part of the poem's music. By the end of the poem, there should be some surprising release from these formal expectations. No end rhyme permitted.

———

Before I give this exercise, I read to the class two poems with very obvious patterning: Henry Reed's "Naming of Parts," and Stephen Dobyns's "How to Like It." (In the latter, there's discursive detail about a restless man thinking about getting in his car and leaving his present life *mixed with* comments that his dog makes, which are always funny, and which serve as the man's alter ego.) The Reed poem suggests how different kinds of diction might be successfully alternated and juxtaposed. The Dobyns poem demonstrates how straight narrative blended with some foreign element (the dog speaking) can work together to create and defy expectation. I point out, of course, that both poems have a serious

governing intent, which permits them to be more than just verbal play.

Then I read them Randall Jarrell's "Next Day," which is more subtly patterned. It is apparently rendered in direct, natural speech (a middle-aged woman musing about her trip to the supermarket, and her sense of aging), but has at least three bursts of more highly stressed and cadenced language. These two dictions comprise the poem's texture and contribute to its effects. Jarrell's pacing is especially noteworthy.

And finally I read Section 2 of Mark Strand's "Elegy For My Father," which is built on a series of questions by a son and answers by a father, each question always asked twice and eliciting a different answer. The formal strategy of the poem is rather clear after a few questions and answers, but at its end it has a beautiful release from its formal expectations. Just when we expect the son to ask the father the same question and to get a different answer, the section ends this way:

> How long shall I wait for you?
> *Do not wait for me. I am tired and want to lie down.*
> Are you tired and want to lie down?
> *Yes, I am tired and want to lie down.*

The danger of this exercise is that you may do it too mechanically. But when it works it demonstrates a few ways in which free-verse poets infuse their poems with rhythm and music, not to mention form. Kenneth Burke said that "form is the arousal and fulfillment of desires." Yes, we must learn to think like lovers when we compose poems. All expectations must be fulfilled, or brilliantly varied or defied.

BREATHLESS, OUT OF BREATH

Richard Jackson

This is a formal exercise in developing and stretching syntax. The assignment is to write a poem of considerable length, say fifty to sixty medium-length lines, that consists of one sentence. A good preparation is to read a syntactically intricate poet like Stevens (say, "Prologues to What Is Possible") or Ashbery, or a prose writer like Henry James or William Faulkner. The point is to try to keep the sentence pushing ahead, grammatically correct, and draped across the lines in variable ways.

════

This exercise can be used to get you away from writing simple dull sentences, but then later also for the way it drives qualified narratives, stories, that is, with subsets and conditions and shades of various tones that threaten to interrupt the flow but are carried on by syntax. Not only does it teach about sentences and syntax, but it shows a lot about what the line is in relation to the sentence, showing the importance of possibilities of what Stan Plumly calls the vertical rhythm of the words as they flow down the page in addition to across the line. It also teaches a lot about the way certain elements in a sentence have to keep a relationship to earlier parts, sometimes repeating, sometimes qualifying or even contradicting earlier parts.

A second step that can be added is to take the one-sentence poem and write a contrast poem, that is, a poem on a related but opposite theme that deploys numerous short sentences or perhaps fragments. The contrast in tone and movement is instructive. Even just breaking up the original one-sentence poem into fragments will show different effects. Finally, the line length can be altered for either the long or fragmented version to show even more varied effects.

FREE-VERSE LINEATION

Sharon Bryan

Ask someone to take two contemporary poems you've never seen before and have them type them up as prose paragraphs. Read them both over several times, and then choose one to concentrate on. Try out various line lengths and line breaks until you arrive at a version you're pleased with. Work toward a sense of line that operates consistently throughout the poem, rather than shifting from one rhythm or principle to another every few lines. Since you've been given all the words, you can concentrate on the lines and line breaks.

This is a good way to help you begin to realize that writing free verse is not like playing tennis with the net down, that it is just as formally demanding as metrical verse, that it has aural and visual rhythms of its own, even if it's difficult to spell them out. If you're given the content, you can devote all your attention to line, line breaks, and the rhythm of the poem as a whole. I think it speeds up understanding of form in free verse—many of you may be surprised to discover that the decisions are other than random. It's also very helpful to compare the different versions in class, since the students can see how important form is: no two versions are the same poem, though all of them use identical words. Once we've looked at all theirs, we look at the original—

not to see the "right" answer, but to look closely at the form arrived at by an author who has been practicing longer than they have.

(A follow-up.) Now that you've worked with someone else's poems, write one of your own in two different versions—*but* the only difference should be line length and line breaks. Otherwise, the two versions should be identical. Compare the two: which one do you prefer, and why?

——

I've found that in addition to helping develop a sense of line, this assignment also reminds you that your poems are drafts, experiments, not finished products carved in stone. It also gives you something specific to do when you revise. Compare the effects of the different lineations, in terms of rhythm, clarity, impact, connotations, and so on.

A variation by Jack Myers: Take a paragraph of prose from a newspaper, say, or a magazine or book, and fragment the syntax of the sentences into various combinations of "lines" of poetry. There is no "correct" formulation at which you might arrive. The idea here is simply to watch the various kinds of semantic effects created by breaking the given sentences into smaller line units. Also, feel free to either maintain or rearrange the syntax of the original prose.

Here are two types of line endings you can create:

THE TRANSFORMATIONAL LINE ENDING: This type of line creates new meanings through the use of fragmented syntax and the resulting new juxtaposition of elements in a line:

PROSE SAMPLE: He just laid bare his heart and the young woman kissed him until he yelled "Stop fooling around and get down to business!"

Prose Cut into Lines:

> He just laid bare
> his heart and the young woman
> kissed him until he yelled "Stop
> fooling around and get down
> to business!"

The lined-out version, because of the new emphasis put on words at the ends of lines (the most important and dramatic position in a line of verse), takes on a much more decidedly sexual overtone and more torque in the relationship.

THE EMPHATIC LINE ENDING: This type of line emphasizes, reinforces, and/or restates previous context, often with new semantic and tonal effects.

PROSE SAMPLE: My readers are confused. They feel that more examples are necessary. They are bored and this is unfortunate.

Prose Cut into Lines:

> My readers are confused. They feel that
> more examples are necessary. They are
> bored and this is unfortunate.

Here, the lined-out version creates reflexive and enjambed meaning and a sense of surprise (created from the newly formulated beginnings of lines) that are not present in the prose version.

"LYRIC" POETRY

Dana Gioia

DAY 1

Take the melody to a popular song and—without writing any words down on paper—compose new lyrics for it. Your new words should fit the old melody exactly, using the same rhyme scheme and meter, but your lyrics should either tell a different story or explore a different mood. Compose the new words entirely in your head by singing them to the original tune. (Don't cheat by writing them down.) Perform the new lyrics by singing them—no matter how bad your voice may be.

DAY 2

Write down the lyrics you composed and evaluate them solely as a poem—without any reference to the original tune. Revise and condense the song lyrics into a written poem. Try to maintain as much as possible of the original metrical scheme.

The purpose of this exercise is to help train the ear by composing an entire poem "in the air" rather than on paper. Trying to create a poem out of sound alone (and holding the words in your

memory without the aid of writing), you learn to exploit the music of language differently from how you might when composing for the page. The tune provides a structure for the poet attempting auditory composition for the first time. This exercise can be tried without music, using a poem you have memorized. But since few student poets today memorize poems, popular songs provide an easier starting point. A popular song also makes the exercise a little less intimidating.

Many young poets feel that writing in metrical forms is a highly intellectual, even abstract undertaking. Working with song lyrics, however, reminds one that rhyme and meter are essentially popular devices that—when used well—add energy, pleasure, and memorability to a poem. Fitting words to a tune also reinforces the essential relationship between auditory arts like poetry and music. Poets weren't always writers. Like musicians, they were originally performers as well who created invisible worlds out of sound.

Writing well in form requires practice. One must master the rules of a particular meter like the steps of a dance or the motions of a sport. But as in dancing or sports, the movements eventually become intuitive rather than intellectual. Since the song's melody and rhythm aurally communicate a metrical pattern, even if you don't understand prosody you will gradually feel your way through the form. You will learn at least this one metrical form intuitively by listening rather than intellectually by studying an abstract metrical pattern. As all musicians know, it's more fun to master a rhythm by tapping your feet than by counting on your fingers.

Examples by Other Poets

"Victor" by W. H. Auden
 (written to the tune of "Frankie and Johnny")

"In a Prominent Bar in Secaucus One Day" by X. J. Kennedy
 (written to the tune of "Sweet Betsy from Pike")

SHALL WE DANCE?

Richard Jackson

One of the most popular songs in Europe recently was "Little Viennese Waltz" as sung by Leonard Cohen. The lyrics are actually by the great Spanish poet Federico García Lorca, from *The Poet in New York*. The poem works in triplets and variations off of triplets ("Te quiero, te quiero, te quiero," reads one line) to effect a sort of waltz rhythm—something Cohen's version really accentuates. And why not, if the origins of lyric are in songs played on a lute? What would happen if we changed the waltz-like rhythm to a polka? Or to the four-beat line of rock and roll (and Old English)? For one, the somber surrealistic mood would have to change. The polka rhythm might make it more frivolous, or might undercut the death images. Could we still use Vienna? These are all answers you might find in this exercise, which is to write a poem in which you try to use a rhythm that suggests a dance form, and then to write another version of the poem in a different dance form—sort of rhythmic variations on a theme. You might include musical forms that aren't dance forms— sonata, aria, concerto, madrigal, march, etc. It's a good idea to listen to the various dance/music styles, even if you think you are familiar with them—listening with a poem in mind or poetry in general in mind unveils a different sense of the sound. Besides, it's a good way to get you to listen to some good music. You might

also think of the rumba, the samba, the twist, the cha-cha, the Charleston, the fandango, the jig and jazz strut, the rap strut (if you think about it, you might see rap as a descendant of the form of Middle English skeltonics), etc. Remember that each of these has certain associations with cultures, ages, settings that you might exploit or undercut as it applies to your subject.

———

This is a terrific way to explore what rhythm really does as opposed to some dry and sterile textbook account. A waltz rhythm is a sort of dactylic, for example, if one wants to use traditional metrics, and a waltz suggests a certain civilized and public gesture. This can be used to develop or, in the case of Lorca, to counterpoint the subject. But rhythm should also be thought of in terms of the overall structure, and the movement or pace of the poem. Looking at a couple of rhythmic variations for the same subject leads first to wildly different tones and so different attitudes toward the subject, and then most often to real changes in the subject. But the exercise is also a catalyst for other sorts of procedures, and a number of variant exercises can be spawned from it. For example, you might use this as a way to explore the potential in a single poem, actually trying several rhythmic formats and echoes, and so also discovering things through each version that you wouldn't have dreamed of by sticking to what you felt was the base rhythm. Sometimes it leads to longer poems that make several shifts in rhythmic gear, tone, mood, within the poem itself.

SHORT LINES AND LONG LINES

Andrew Hudgins

One week's assignment: write a poem in which every line is seven or fewer syllables long.

The next week's assignment: write a poem in which every line is longer than seven syllables.

———

In class, when we discuss the first week's poems, I direct the students' attention to imagery, rhythm, enjambment—and don't even address the issue of line length. I save that for the second week. The two assignments together lead naturally to discussions about the different effects, constraints, and possibilities of long and short lines. We talk a lot about how line length influences rhythm, and how short lines can become fragmentary and jarring, while long lines can easily flatten into prose if the flow isn't kept moving through syntactic repetition, meter, or some other rhythmic strategy. We also talk a lot about the sensuous play of syntax over lines, and whether line breaks coincide with breath pauses or cut against them. Though it is a pretty arbitrary length, I find seven syllables to be a good measure for this assignment because it is just a syllable or so longer than most people's phrasing when they speak.

189

I like this pair of exercises because it directs your attention to crucial questions for beginning poets (and, hell, for advanced ones too): what is a line of poetry and how can I make lines work for me? Later, cast aside the restrictions of the exercises and rewrite the poems in any manner or form you find satisfying. Oh, one last thing: don't use rhyme until you develop the necessary skills to keep rhymes from distorting your sentences and squelching the discovery process in your writing, a process that is new to most beginning writers and easily squelched.

WORD PROBLEMS AND SCIENCE TESTS

Robin Becker

Close your eyes and try to remember your early experiences in that "other" culture of mathematics, chemistry, mechanical toys, and science class. In a free-writing, try to describe your wonder and awe at the way things worked. Show your frustrations, too. Your goal is to collect your early experiences with math and the physical sciences. Consider biology class, a chance physics encounter, fractions, computers, anything that brought you into contact with scientific principles and suggested the worlds which lay within them. Do a ten-minute free-writing focusing on one experience or moving from one to another. Review your free-writing and organize your best material into phrases or sentences that capture your experience. Pay attention to word choice and try to enliven your lines with active verbs and fresh images. Does regularizing your rhythm with recurrent stress patterns evoke the tone and feeling of the experience? If so, experiment with blank verse. If a looser, more irregular and jagged line feels right, try free verse. If you choose free verse, be sure to use both end-stopped and run-on lines. Aim for a fifteen-line draft. Think about your choice of rhythm and its effectiveness.

———

Most of us have something to say about our early experiences with science or math. I'm frequently surprised or delighted to see

the range of poems this assignment provokes. In class I try to use it during a discussion of blank verse, to show the storytelling as well as the elastic qualities of unrhymed iambic pentameter. If you write about machinery and high-tech equipment, your poems may be particularly suited to the formal properties of blank verse, making a felicitous pairing of rhythm and subject. Like many quirky assignments, this one teaches that poetry can incorporate all kinds of subjects.

ANGLO-SAXON LINES

Judith Baumel

Write a poem using the Anglo-Saxon (Old English) line. Old English prosody counted only the strong stresses in a line. It didn't use stanzas and very, very rarely used rhyme, which was in any case not part of the formal system.

The line is really composed of two half lines, each of which has two heavy stresses and a variable number of unstressed syllables. There is a strong pause, caesura, between the half lines. In the most restrictive form of Old English poetry, the first three stressed syllables alliterate, but some of the twentieth-century versions, those of Pound, Fitzgerald, Wilbur, try for three alliterations, anywhere in the line, and often settle for two.

Richard Wilbur's "The Lilacs" offers a good example of technique and variation.

THE LILACS

Those laden lilacs
 at the lawn's end
Came stark, spindly,
 and in staggered file,

Like walking wounded
 from the dead of winter.

Remember that alliteration only counts if the sound *begins* the
stressed syllable so that "compost composed" doesn't alliterate
since COMpost has a *C* sound and comPOSED has a *P* sound. In
Old English all vowel sounds alliterated with each other.

Although you can have any number of unstressed syllables in a
line, there was a tendency to have lines no shorter than eight
syllables and no longer than twelve. In fact the lines tended to be
about ten, the length of iambic pentameter.

Using Old English will get you thinking about matching and
correspondences that are related to rhyme but come from a
different part of our poetic/linguistic heritage. The emphatic beat
(think about the recordings of Pound reciting "Canto I" with the
heavy drumbeat emphasizing the stress) and the alliteration bring
out a joyful language play and tend to draw out a different
vocabulary and different topics.

Examples:
 "The Seafarer"—Pound's rough and magnificent translation
 "Cobb Would Have Caught It" by Robert Fitzgerald
 "Junk" and "The Lilacs" both by Richard Wilbur
 Auden in parts of "The Age of Anxiety"
 Eliot in parts of "Four Quartets"
 "My Grandfather's Church Goes Up" by Fred Chappell
 "Gangaridde" by Karl Kirchwey

SAPPHIC STANZAS

Judith Baumel

Write a poem using sapphic stanzas. The stanza is made of four lines, three identical long(ish) lines and a final short one. The long lines have an alternating pattern of hard and soft (stressed and unstressed) syllables that looks like this:

-u-u-uu-u-u

where the dash represents a hard syllable and the *u* a soft one. The fourth and the final syllables are common *u* and can be either hard or soft.

The final line looks like this:

-uu-u

You don't have to establish any sort of pattern in the way you choose your common syllables.

This stanza, based on the form that the Greek poet Sappho used, has an interesting transformation into English. Greek prosody used a quantitative system based on how long the sounds of syllables are; we use instead an accentual-syllabic system that counts stressed and unstressed syllables. In English the form seems to produce a wide variety of effects. Each of the lines of the

poem starts off with an emphasis or a boom, and the way you use the rest of your syllables can create comic effects or haunting effects, happy or sad.

William Meredith offers a recent example on a contemporary theme. He works with surprise and irony in the beginning of "Effort at Speech":

> Climbing the stairway grey with urban midnight,
> Cheerful, venial, ruminating pleasure,
> Darkness takes me, an arm around my throat and
> > *Give me your wallet.*
>
> Fearing cowardice more than other terrors,
> Angry I wrestle with my unseen partner,
> Caught in a ritual not of our own making,
> > panting like spaniels.

The form asks two different skills of you. I use it as a tough early exercise in training the ear because the lines don't come from our naturally iambic speech. So you have to hear where the stress goes, have to worry about how context affects the way we understand stress.

But perhaps more interesting to me is the stanza-building skill—creating a stanza in which the three lines have their own integrity and the fourth line stands in some separate relationship, either a summing up or a moving forward, or a linking forward and backward.

The rhythm of the fourth line in a Sapphic poem is hauntingly beautiful to me. I always hear it as DAH dah dah *dah* da. A sad

melancholy. And I always tell my students to try very hard to get that fourth line right and everything else will fall into place.

When I started to look for examples of Sapphics in English, I was surprised to find as many as I did; some are translations of Sappho, Alcaeus, Horace, Catullus (the classical poets who used the form) but many are wonderful inventions in their own right.

Examples:
 "Lines Written During a Period of Insanity," William
 Cowper
 "Sapphics," Algernon Charles Swinburne
 "The Day of Judgment," Isaac Watts
 "The Widow," Robert Southey
 "Sapphics: The Friend of Humanity and the Knife Grinder,"
 George Canning (funny, a parody of "The Widow")
 "Apparuit," Ezra Pound
 "June Thunder," Louis MacNeice
 "Legend for a Shield," Richard Lattimore
 "Portrait," Louise Bogan
 "The Lady of the Castle" and "After an Old Text"
 (and many more), John Hollander
 "Sapphics Against Anger," Timothy Steele
 "Effort at Speech," William Meredith (wonderful)
 "Erinna to Sappho," James Wright
 "Catullus XI," W. S. Merwin (nice translation of the
 famous poem)

PANTOUM

Judith Baumel

This poem uses a four-line stanza in which lines 2 and 4 are carried over, whole, to the next stanza where they become lines 1 and 3. You write new lines 2 and 4 that both fit into the stanza and will be carried over into the next stanza. The poem can be of any length and the final lines 2 and 4 are in fact lines 3 and 1 of the very first stanza. This creates a tidy closing of the circle.

The poem asks for an extreme version of repetition with change, or what Pound called the fixed element and the variable. No matter how you solve the technical problems of carrying over whole lines, you resort to some form of word play—punning, subtle and not so subtle transformations of your lines. Here are some of the possibilities: as you repeat the line you change nothing, or you change nothing but the punctuation, or you change the tense of a verb, or a noun goes from plural to singular, or you substitute words, or you use homonyms . . . or, or, or.

Examples:

"Fortune's Pantoum" by Jane Shore
"Pantoum" by Joyce Carol Oates
"Pantoum" by John Ashbery
"Market Day" by Marilyn Hacker
"Amnesia" by David Lehman

ATTEMPTING A VILLANELLE

Molly Peacock

In the attempt is the success. Simply attempting a villanelle might allow you to reformulate an unclear idea—and to see something clearly always amounts to a kind of triumph.

Although the villanelle is a French troubador form derived from folk song, the serious villanelle in English is rooted only in this century, beginning with Dylan Thomas and Edwin Arlington Robinson. Two references which might help you are Babette Deutsch's *Poetry Handbook*, which gives a clear explanation and example, and *The Princeton Encyclopedia of Poetry and Poetics*, which gives a history of the form.

Briefly, a modern villanelle is usually five tercets rhyming aba, followed by a quatrain rhyming abaa. The first line of the first stanza becomes the last line of the second and fourth; the last line of the first stanza becomes the last line of the third and fifth. These two refrain lines form the couplet at the end of the final quatrain.

Drawing a chart of how a villanelle goes will release you from having to keep the complex pattern in your head. Label the lines AbA', abA, abA', abA, abA', abAA' (the capitalized lines repeat).

Many villanelles start out with self-contained lines because these are the lines that will repeat. Later on in the villanelle, however, the repeat lines might be altered or enjambed, adding link words, dividing the line into short sentences, etc.

Try to discard the pressure of the common advice that the repeat lines (A and A') have to be dense and "memorable." They can be very ordinary and work just as well. Sometimes in the very repetition the idea takes on a significance one wouldn't have predicted.

Try to pick something to write about that you don't have to tell the story of. Villanelles are not built for narrating. The reader needs to understand the context fairly quickly; because of the repetition there's little room for information giving. If there's someone who infuriates you, and you want to repeat "I hate you," the villanelle is a good place to do it. Likewise "I love, I used to love," etc. It's also a good place to give instructions, to give advice, or, to refuse to.

The rhymes don't have to be perfect or exact. You don't have to be Dr. Seuss. Worry about what you want to say, first. If you can't rhyme it exactly, copy some element of sound. Because there are only two alternating rhymes, you can certainly afford to vary them.

Modern villanelles in English generally have lines of even length. They are often ten syllables, often iambic pentameter, but meter and syllables vary. Try to take a certain number of syllables or stresses and keep to it generally. If counting stresses unnerves you, simply count syllables. If you've never written in meter but

would like to try, count stresses per line *according to your own ear*, for this, even if you feel you do not hear "officially," will be your most reliable guide. A book that helped me very much with meter is Paul Fussell's *Poetic Meter and Poetic Form*.

Here is the making of a mock first stanza in dialogue form:

LINE ONE: "I hate the way you brush your teeth."
COMMENT: Made a mistake already! It's only eight syllables.
RESPONSE: Keep it anyway.
COMMENT: Oh, no, what rhymes with teeth?
RESPONSE: Try not to use a rhyming dictionary. Make a list of teeth rhymes and near-rhymes: sheath, heath, beneath, death, faith, belief, leaf, brief, reef, grief, chief, deaf, fief, thief. (March right through the alphabet when you do this.) Then try to write toward one of the words you listed.

LINE TWO: "You never make a sound when you gargle."
COMMENT: Well, it's not iambic, but at least it's ten syllables.
RESPONSE: Better, now keep it and go on.

LINE THREE: "Silent brushing is a breach of faith."
COMMENT: Can I say this? How is it a breach of faith? I would never have said "faith" if I hadn't had to rhyme with "teeth." I'm afraid I don't know how to go on. Also, I fell back to nine syllables.
RESPONSE: You've got the rest of the poem to work out why noiseless brushing is a breach of faith. Nobody said you wouldn't have to stop and think, or that you wouldn't have time to enjoy yourself, your language and ideas. Put down your stopwatch, please. Incidentally, you wrote a very nice trochaic pentameter line minus the last syllable.

COMMENT: But it's not . . . monumental enough. The light isn't dying, and I'm not facing disaster.

RESPONSE: Try to shut your ears and listen to your own voice. Your poem is about brushing teeth. You'll have to be monumental next time. You've got all the tradition you need in the pattern before you.

After you write the first stanza, fill in the rest of the repeat lines down the poem, even if you may not use them exactly the way they are. This way you'll see them coming up and will be able to anticipate choices.

It's hard to revise a villanelle because you often have to recast whole areas. A change of word or phrase may do it, but most likely the rhyme or repeat will get damaged, and a major portion will have to be recast. If it comes out, lovely. If you don't like it or you want a major change, write a new one. Until you have the expertise to recast rather than revise, try either to be content with the flawed product (formal poems often have these flaws, though they're not immediately apparent) or to write another one. After all, the success is in the attempt.

A good time to write a villanelle is when you have a feeling or a subject you're afraid to write about. The form will both contain and release the feeling. Those two repeat lines can be like a pair of arms wrapping around you in comfort. If you choose this formal entrance to the painful emotion, you won't have to confront the pain alone. A and A' become a guide and a companion.

Suggested reading: You can find a number of beautiful twentieth-century examples in the anthology *Strong Measures: Contemporary*

American Poetry in Traditional Forms edited by Philip Dacey and David Jauss; the three I feel may be most useful to you are "One Art" by Elizabeth Bishop, "Villanelle" by Marilyn Hacker, and "The Waking" by Theodore Roethke. Two others which you can find elsewhere are "If I Could Tell You" by W. H. Auden and "Do Not Go Gentle into That Good Night" by Dylan Thomas.

GHAZAL: THE CHARMS OF A CONSIDERED DISUNITY

Agha Shahid Ali

Because such charms often evade the Western penchant for unity—rather, the unities—I offer a truly liberating experience: the ghazal. (It is pronounced *ghuzzle*, the *gh* sounding like a close relative of the French *r*.) When my students ask about a poem such as *The Waste Land*—How does it hold together?—I suggest a more compelling approach: *How* does it *not* hold together? I underscore *How* to emphasize craft. The ghazal has a stringently formal disunity, its thematically independent couplets held (as well as not held) together in a stunning fashion.

To begin with, an explanation of the form, of which Hafiz (1325–1389), a contemporary of Chaucer's, is the acknowledged master in Persian, his tomb a place of pilgrimage; Ghalib (1797–1869) is the acknowledged master in Urdu. The ghazal is made up of couplets, each autonomous, thematically and emotionally complete in itself: one couplet may be comic, another tragic, another romantic, another religious, another political. (There is, underlying a ghazal, a profound and complex cultural unity, but that is not of relevance here.) A couplet may be quoted by itself (anytime, anywhere) without in any way violating a context—there is no context, as such. Then what saves the ghazal from what might be considered arbitrariness? It is a technical context, a

formal unity based on rhyme and prosody. All the lines in a ghazal must have the same number of syllables (I will not go into metrical subtleties because there are no English equivalents for Persian/Urdu meters). The opening couplet must rhyme, setting up a parallel scheme, and then this scheme must be repeated in the second—and only the second—line of each succeeding couplet. That is, once a poet establishes a scheme—with total freedom, I might add—s/he becomes its slave. What results in the rest of the poem is the alluring tension of a slave trying to master the master. A ghazal has five couplets at least; there is no maximum limit. A ghazal, as such, could go on forever.

To make what I have said clearer, let me demonstrate:

> The only language of loss left in the world is Arabic.
> These words were said to me in a language not Arabic.

Now, that is the first couplet of a ghazal I wrote. What it establishes is that the second line of each succeeding couplet must end with *Arabic*. The following two couplets also occur in my ghazal (by the way, it's not necessary to remember the order in which couplets appear in print, except for the first and last ones):

> When Lorca died, they left the balconies open and saw:
> his qasidas braided, on the horizon, into knots of Arabic.

> At an exhibition of Mughal miniatures, such delicate calligraphy:
> Kashmiri paisleys tied into the gold hair of Arabic!

Or let's say we find the following scheme (this is from John Hollander's thirteen-couplet "Ghazals"—to my knowledge the first real approximation of the form in English, though he does not strive for syllabic consistency):

> For couplets, the ghazal is prime; at the end
> Of each one's a refrain like a chime: "at the end."

This means that the second line of every following couplet will end with the phrase *at the end* and that immediately before the phrase will be a word rhyming with *prime* and *chime*. Hollander continues:

> But in subsequent couplets throughout the whole poem,
> It's this second line only will rhyme at the end.

As a further explanation, Hollander could have added a version of the following (rather clumsy) lines by me:

> Each couplet is blessed, surviving thematically apart,
> Though this second line will always rhyme at the end.

All the rest of Hollander's couplets are thematically apart. I'll quote one of them:

> You gathered all manner of flowers all day,
> But your hands were most fragrant of thyme, at the end.

At the very end, a ghazal often (this is not a requirement) has a signature couplet, called *makhta*, in which the poet evokes his/her own name in the second or third person. If I may quote from my own ghazal, the one ending with *Arabic:*

> They ask me to tell them what "Shahid" means—
> Listen: it means "The Beloved" in Persian, "witness" in
> Arabic.

I ask my students to write ghazals of at least five couplets, and to try for as much syllabic consistency as possible (I'm not too

fussy about it). I also encourage the signature couplet, but they seem to shy away from it—drawing attention to oneself is not part of their Puritan inheritance. A point of relief: the title of each effort need simply be "Ghazal." As we all know, coming up with a good title is often a problem. Ghazals, like sonnets, pose no such difficulty.

===

"Since 1960," says Dana Gioia in *The Hudson Review* (Autumn 1987), "the only new verse forms to have entered the mainstream of American poetry have been . . . the double dactyl and the ghazal, the latter usually in a dilute unrhymed version of the Persian original." An unrhymed ghazal would be a contradiction in terms to an Urdu or Persian speaker, and I think it is the seeming arbitrariness of the unrhymed ghazal that has kept it from becoming a necessary part of the American mainstream. I certainly admire Adrienne Rich's "Ghazals: Homage to Ghalib" as well as the effects of Jim Harrison's ghazals, but I think it's time the actual form found its way into American poetry. John Hollander's "Ghazals" is a wonderful beginning, and—if I may be fetchingly immodest—so is my "Ghazal." I have also been quite satisfied with the attempts of my students.

I assign my students both a real ghazal and an unrhymed one. The latter proves interesting because students find some real gems that have been hiding in their journals and notebooks, some individual lines that had gone nowhere. Putting these gems into couplets creates surprising combinations, many of them leading to surreal effects, and the language in these cases is almost always alive, much bolder than in the more regular poems.

What, for me, is missing in unrhymed ghazals is the breathless excitement the original form can generate, though I do enjoy the

interesting combinations and the elliptical moments from couplet to couplet. In the real ghazal, the audience (for the ghazal is recited a lot) waits to see what the poet will do with the scheme established in the opening couplet. At a *mushaira*—the traditional poetry gathering to which sometimes thousands of people come to hear the most cherished poets of the country—when the poet recites the first line of a couplet, the audience recites it back to him, and then the poet repeats it, and the audience again follows suit. This back and forth creates an immensely seductive tension because everyone is waiting to see how the response will be resolved in terms of the scheme established in the opening couplet. For example, if Hollander were to recite, "You gathered all manner of flowers all day," the audience would repeat it and so on, and by the time he came to "But your hands were most fragrant of thyme . . . ," the audience would be so primed and roused that it would break in with "at the end" even before Hollander would have a chance to utter the phrase. And then, in raptures, it would keep on *Vaah-Vaah*-ing and *Subhan-Allah*-ing. Of course, if the resolution is an anticlimax, the audience may well respond with boos. I should mention that a ghazal is often sung. Some of the great singers of India have taken ghazals and placed them gently within the framework of a *raga* and then set the melodic phrase (which contains the individual lines of the ghazal) to a strict *tala* (cycle of beats).

In their evaluations of my poetry workshops, students have consistently mentioned how much they savor the ghazal, more than almost any other assignment. Apparently, the Western mind is ready for a formal disunity.

THE METER READER

Thomas Rabbitt

One Week: Write a poem that employs a regular pattern of syllable count, a corresponding pattern of various types of rhyme, and an odd animal or unusual plant.

Two Weeks Later: Write a poem that employs a regular pattern of stress count, occasional rhyme, almost total enjambment, and a symbol.

Four Weeks Later: Write a poem that employs a regular pattern of stress/syllable count, a rhyme scheme, enjambment, and an ordinary thing (such as an apple) which is transformed into an idea (such as temptation) that is probably what your poem wants to be about.

———

These three assignments are based on the notion that in poetry written in English we either count or we don't count. If we don't count, we're writing free verse (I have to stop fooling around), i.e., vers libre. If we do count, we're writing quantitative verse and we're counting syllables or stresses or both (which last is the same as meter, but I try not to let my students know that until they've committed it).

This is basic stuff. Some of you won't know what a syllable is; some won't understand stress or accent; many will be surprised at how helpful the dictionary can be. While you're counting syllables and making sure that all of the nine-syllable lines rhyme and all of the seven-syllable lines rhyme, the only other thing you have to worry about in this little shop of horrors is Venus's-flytrap. You don't have to worry about making *the official poetry sound.* Read some Marianne Moore. Ask yourself if and why apple and lapel do or don't rhyme. Read some Yeats to see how stress-count works.

Sometimes I give my students a chalkboard version of The Meter Reader. (Actually, I'm making up the title for this very helpful little poem whose author deserves credit and apologies; I wish I knew where to send them.)

The iamb saunters through my book;
Trochees rush and tumble.
If the anapests run like a scurrying brook,
Dactyls are stately and classical.

Then I scan it; put in all the virgules, single for feet and double for caesurae; add the accent marks to indicate stress and a couple of *-lets* to create some feminine rhyme, and count the feet to eight (mono-, di-, tri- tetra-, penta-, hexa- alias Alexandrine, hepta- and octameter) though none of these goes beyond tetrameter; I try to demonstrate that if *through* in line 1 had been *in*, the metric imposition of stress would be even more apparent, and use this to explain the difference between quantitative and qualitative (as in classical Greek and Latin) meter. So, I disingenuously insist, everything they need to know is in The Meter Reader:

The í/amb sáun/tĕrs//thróugh/ mў boók(lĕt);
Tróchĕes/rúsh//ănd/túmblĕ.

If the an/ăpĕsts rún//lĭke ă scúr/rўinğ bróok(lĕt),
Dactўls arĕ//statelў ańd/classĭcal.

And I try to explain end-stop and enjambment; rhymes slant, off, near, sight, true, perfect, sdrucciolo (just kidding), and the like; rhyme scheme; and, of course, symbolism. What I'm trying to do is to expose you to as many of the tools of prosody as I think I can get by with without overloading your circuits, to have you use a few in each exercise, to throw in a crocodile to mix it up good, and finally to tell you that if you worry about anything you should worry about counting. I think that's Richard Hugo's distraction theory; I know it's his crocodile.

Part Seven

MAJOR

and

MINOR

SURGERY

ON REVISION
AND WRITER'S BLOCK

A. Exercises

B. Reflections

A. EXERCISES

WRITER'S BLOCK: AN ANTIDOTE

A THREE-WEEK COURSE

Daniel Halpern

I suggest this series of exercises for poets who are having difficulty in getting to the white page, getting poems started, and getting poems to close.

Although the instructions will appear simple-minded, if they are followed to the letter they work—which is to say, at the end of the exercise period there will be a group of poems, in one state or another. I have found that more often than not they are poems which, with a little revision, manage to become keepers. Regardless, twenty-one "failures" are better for the blocked writer than no poems at all. These are limbering-up exercises, meant to set a poetic metabolism.

THE PROCEDURE

Perform one exercise a day for at least fourteen days; twenty-one, however, is preferable. Spend as many hours per day as possible, but at least two, and at the end of each day type up the poem as you have it, as if it were the final draft, and put it face down in a drawer. Do not look at the poem again until all the exercises have been completed. If these exercises are to work, this procedure must be followed exactly.

1—3. IMITATIONS

Imitate the styles of the following poets as you read and hear their work; concentrate on style, voice, diction, cadence, point of view, etc. Do at least two from the first group, and one from the second.

A

Sylvia Plath	Mark Strand
Robert Lowell	Amy Clampitt
Richard Hugo	Emily Dickinson
James Wright	Ezra Pound
Louise Glück	Wallace Stevens
Ted Hughes	Sharon Olds
Robert Hass	Galway Kinnell
C. K. Williams	

B

Horace	Catullus
Martial	Virgil
Juvenal	Sappho

4. A poem of five tercets, alternating three and five stresses per line.

5. A poem of four quatrains that contains no adjectives, no adverbs, no similes, and the word "lime." Alternating lines of eight and ten syllables.

6—8. First, read *North* by Seamus Heaney, carefully. Next, starting from the beginning, go through each poem and when you come to key lines (i.e., lines that move you), write out whatever comes into your mind. Begin with straight explication, then follow your associations until you've nothing left to write—one page, ten

pages. . . . Note sounds in the poetry, kinds of words (level of diction), voice, subject matter, etc. Then write your own twenty-line poem, using this "reading" as a kind of springboard, or catalyst. Do this for three days and end up with one three-part poem.

9. Take a poem or prose passage from *Cheri* by Colette and use the content of that passage to provide the subject matter for a poem.

10. A poem based on the notebooks or journal of a writer you admire: Virginia Woolf, Kierkegaard, Roethke, Hawthorne, James, etc. You may use a single entry, an entire week, whatever.

11. A poem that employs the use of invective.

12. A poem about food.

13. A poem in which you use a third-person persona: see Weldon Kees's "Robinson" and Berryman's "Henry."

14. Write five pages of free association, then underline relevant and/or interesting passages. Construct some kind of logical framework with these lines and shape them into a poem.

15. An epistolary poem. First refer to Horace's *Epistles.*

16. A didactic poem. First refer to Virgil's *Georgics* and Martial's *Epigrams.*

17. A poem that addresses itself to a relevant obsession of yours.

18. A love poem that uses no words of endearment or adoration.

19. A poem of invitation. See Horace's *Epistles*, Book 1, no. 5; or Ammons's "Visit."

20. A one-hundred-line poem that doesn't use narrative or sequential structure—no sections or stanza breaks.

21. A poem in imitation of Yourself.

SMASH PALACE

William Matthews

Take ten famous lines of poetry, the more widely recognizable the lines, the better, e.g.,

> Whose woods these are I think I know.
> I heard a Fly Buzz—when I died—
> The proper study of mankind is Man.

The assignment is to ruin each line with the smallest possible change.

———

Students in workshops often preface their most pointedly useful comments with apology: "I don't mean to pick nits, but . . ." or, "Maybe this is too tiny to spend time on, but. . . ."

But poems are made from artfully discovered details, and one way to suggest how much this is true is to wreck famously successful lines, the goal being to inflict the largest damage with the smallest stroke.

Thus "I think I know who owns these woods" is a C−, and "I heard a fly zip when I died" a B. For an A+, an intrusive comma turns Alexander Pope into a sage of 1968: "The proper study of mankind is, man. . . ."

RHAPSODIZING REPETITIONS

Lee Upton

When I ask for a rhapsody of repetition my only formal request is that a poem repeat within each line, usually after a break of some sort (a period, comma, question mark, or other pause), the meaning of the first phrase or clause. I do not require a specific syllabic count for each initial unit of meaning; part of the exhilaration of reading or composing in such a form is the pleasure created by varying lengths of language panels within each line. My sole source for this exercise should be noted immediately: John Ashbery's "Finnish Rhapsody." Consider the opening of Ashbery's poem:

> He managed the shower, coped with the small spattering
> drops,
> Then rubbed himself dry with a towel, wiped the living
> organism.
> Day extended its long promises, light swept through his
> refuge.
> But it was time for business, back to the old routine.

Among the pleasures of Ashbery's poem are its insistent repetitions and its leisurely self-revisions.

Repetition is a basic principle of much writing and, of course, particularly of poetry. Yet here it is a repetition of meaning rather than of sound, image, or syntax that compels the poem. Any attempt to duplicate meaning in the second portion of each line must fail; new words present revisions of meaning no matter how closely we attempt an approximation. And often an unexpected shower of imagistic sparks results in the second portion of the line's "translation." This is, then, an exercise of immediate revision, in which we rethink our first reactions, disenthralling ourselves from singular attempts at meaning.

The exercise is simple in terms of instruction and yet challenging in terms of execution as each line searches out new undercurrents of meaning. By writing in this form we are required, in a sense, to throw our voice, for the second phrase or clause in a line must release fresh implications. The form emphasizes an attentive consciousness to word and phrase. And the results of this exercise are often uncanny, each succeeding phrase making for a quirky, miniature déjà vu.

Further Reading: John Ashbery's "Finnish Rhapsody."

STEALING THE GOODS

Stephen Dunn

Take any failed poem of yours (from your notebook of failed poems, which all of us should have) and extract from it the line that most interests you. Use it as the first line in a poem that you will now write. Throughout, the poem should live up to the standard of language and thought that that line represents.

If you don't have a notebook of failed poems, extract a line from a poem of a poet you admire and begin with it, knowing that at some point you will discard that line.

Your charge is to keep finding both cooperative and surprising language *even after* you've found out what you're talking about, what the nature of your subject is. Think in terms of distinctive phrasing as much as you think of extending subject matter or completing an argument.

———

The exercise is designed to teach you how important it is to have a high standard of composition to live up to, or at least to have a phrase, line, or grouping of lines that is exciting, seminal. Flatness breeds flatness. Verve at least has the possibility of breeding verve.

I've found this exercise useful with both beginning and advanced students. With beginning students it often helps in getting them away from known experience as the prime determinant of what goes in a poem. It switches the emphasis somewhat to language and invention. With advanced students (beginning students too) it's a useful way to demonstrate that the first few lines of a poem create expectations of texture, rhythm, tone, and diction, and that the poet must be as alert to those expectations as he or she is to promises and drifts of content.

Almost any good poem will illustrate this. But a few weeks before I give them this exercise I like to show my students a few Russell Edson poems, and have them try to emulate those poems. The virtue in this is that almost every Edson poem begins with an absurd premise ("There once was an ugliness factory . . .") which Edson is true to in his peculiar way. One sees that every line in an Edson poem needs to be invented, the poem needs to ride its own wild logic, and yet the poet is not wholly free, is bound by the terms of his creation and the interdependence of language.

One of the problems you might have with this exercise, a problem not uncommon to any of us, is that when you locate your subjects your language starts to become too purposeful, too in earnest. You lose the compositional verve with which you began. Be attentive to where the poem starts to violate its own terms, or where it starts to lose energy.

The overall purpose of the exercise is to demonstrate that if you begin with what authentically interests you *as language*, there's a chance for more of the same. This is my barometer for myself: I'm not truly in a poem until the first moment I've startled myself. Then I know I have something to propel me forward, and to which I know I must be equal.

JUMP-STARTING THE DEAD POEM

Lynne McMahon

I want you to try an exercise in the not-quite arbitrary. Take as
your starting point an old or abandoned poem, around twenty or
thirty lines, and begin to write its *negative.* If, for example, your
first line is "The early April greens send out their brilliant toxins,"
try isolating the key words and finding their opposite: "The late
October browns take back their analgesia. . . ." Try a line-for-line
reversal for as long as you make sense.

———

It may be that the negative can sustain itself for two lines only,
and another poem begins to appear. If, on the other hand, you can
fashion a complete line-for-line correspondence for the entire
poem, chances are you'll have to abandon *both* poems as hope-
lessly mechanical. But I think the chances of that happening are
negligible. In any case, you may begin to see the possibilities in
language and imagination that even a dead poem can provide.

SCISSORS & SCOTCH TAPE

Chase Twichell

This is an exercise designed to help you rescue poems that are stuck in a state of incompletion, or that disappoint you.

1. Take a pair of scissors and cut the ailing poem into as many pieces as you can, allowing obvious clusters of lines to stay together. Try to cut at all points where *logic* is the splice. Don't just cut stanzas apart. Cut wherever you can leave a fragment that seems to contain some resonance, even (or especially) if it's a resonance that has just occurred to you and seems out of whack with the rest of the poem. Sometimes a fragment will be nothing but a single image, or simply a few words that sound good to you, a pleasingly musical phrase. Don't worry about the parts that seem left over, orphaned pieces that contain little or nothing that interests you—these are easy to abandon.

2. Now take the fractured poem and start fooling around with its disembodied pieces, moving them into various new sequences. Try to forget about the poem you've just demolished. Which line or cluster of lines would make the most exciting opening? (You'll of course have to change lines to make them work in a new role.) Do two or three of the pieces suddenly seem the strongest, the most vibrant, vivid, mysterious, powerful? Do others seem like

duds, like filler? Get rid of them. Maybe the poem will divide itself into several possible poems. Maybe one little fragment will suggest a whole new poem. Sometimes, a single new juxtaposition can throw the whole poem into a different light. Once you've forced yourself to imagine another possible poem, you'll have gone a long way toward divorcing yourself from the failed one.

3. Tape the new, tentative version together, realizing that it's only the skeleton, the bare bones, of the poem you've just discovered. Knock out more lines of rough draft, searching for new linkages, new logic, new imagery. Keep it as loose and changeable as possible until you're sure that a new poem has displaced the old. Revise *that* one.

━━━

The violence done to a poem with a pair of scissors is only the violence of reimagining it, of seeing it again: revision. It's hard to remember, when you're struggling with the words in front of you, that those words found their way onto the paper fairly arbitrarily. That is, you'd certainly have written a different version of the poem had you sat down to work in the afternoon instead of in the morning. Cutting a poem apart is a way of making holes in it, windows, a way of keeping it open for a while, so that you can enlarge and refine your sense of it while it's still rough. The important thing is this: don't start polishing a poem until you're pretty sure of its structure. Obviously, during the writing of the early drafts, you'll happen on phrasings you'll want to keep. That's fine. Just don't try to tidy up while the carpenters are still making sawdust.

Sometimes you'll find yourself reluctant to cut a line, even if it doesn't seem to belong in the new draft. It's very hard to let go of lines we're proud of, even if they spoil the poem. I forget which

famous writer once said that the trouble with writing is that you have to murder your darlings. You can save yourself a lot of grief (murders) if you force yourself to rethink your basic choices before you immortalize them. If your poem begins with a fledgling falling out of its nest, and you've just spent two hours writing five perfect lines of nest-description, it's hard to wonder whether the poem would be better if it began with a lost dog trotting along a road. If you can detach yourself from your first vision of the troublesome poem, something will nearly always "happen" in the new version to which you'll be sufficiently attracted to allow you to let go of the old, dead draft. The poem will suddenly seem alive again, exciting to work on.

IN A DARK ROOM:

PHOTOGRAPHY AND REVISION

Maggie Anderson

> Any photograph has multiple meanings; indeed, to see
> something in the form of a photograph is to encounter a
> potential object of fascination. . . . Photographs, which cannot
> themselves explain anything, are inexhaustible invitations to
> deduction, speculation, and fantasy.
> —SUSAN SONTAG,
> *On Photography*

One way of revising poems is to shake up the original poem
enough to allow us, truly, to re-see it. Sudden shifts in perspective
can open a poem up to us again and help us to surpass our
resistances to revision: stubbornness, attachment to predictability,
fear, and the touching, understandable love of our own first
words. One way of "practicing" revision is to work a poem that
has the same focus of attention through several different points
of view. While the focus of the poem remains the same, we can
shift how we speak it, revising by generating new poems. Photo-
graphs provide a stable focus and seem to be especially suited to
working with these kinds of shifts.

To do this exercise, you need to spend some time locating a
photograph that holds a genuine and compelling interest for you.

It need not be a "good" photograph—in fact, sometimes, the botched one will have more resonance, especially if you took it yourself and can reconstruct the gap between your astonishing vision and what actually showed up on the print. You might choose a photograph that someone has taken of you or of someone you know (portrait or snapshot), a photograph that is more self-consciously artistic (one taken by, e.g., Ansel Adams, Edward Weston, Diane Arbus) or a journalistic photograph that documents a historical event.

When you have found your photograph, spend some time writing out just what you see in it in as much detail as possible: objects, landscape, people, clothes, trees, architecture, light, and shadow. In a sense, you will have to narrate the photograph, or at least create a discernible image so that we can, literally, see what you are talking about. Then, using the same photograph, write at least three different poems from it, from any of the following perspectives or points-of-view:

1. Speak the poem as the photographer.
2. Speak the poem as someone or something in the photograph.
3. Speak the poem as someone or something in the photograph addressing the photographer.
4. Address the poem to someone you know who has not seen the photograph.
5. Address the poem to someone in the photograph.
6. Address the poem to the photographer.

An additional shift in perspective can be uncovered by writing two or three more poems in which you manipulate time, still using the same photograph:

1. Write what happened just before the photograph was taken.
2. Write what happened just after the photograph was taken.
3. Write what happened as the photograph was being taken, outside the range of the camera.
4. Write the poem as if you have found the photograph years after it was taken.
5. Write the poem as if you were planning to take the photograph.
6. Write exactly the same poem in three versions: present, past, and future tense.

John Szarkowski writes, "Photography is a system of visual editing. At bottom, it is a matter of surrounding with a frame a portion of one's cone of vision, while standing in the right place at the right time. Like chess, or writing, it is a matter of choosing from among given possibilities. . . ." To work the same photograph through several poetic versions expands the range of our "cone of vision," not only for that particular poem, but for the revising process of all our poems as well.

═══

My own interest in writing poems from photographs is deeply personal. I was born into two old families, so that most of my immediate kin had died before I was born or by the time I was ten years old. All I had of them, besides the few stories I had been told, was some photographs. Photographs of my grandparents, none of whom I knew, are especially important to me, as well as one I have of my father's sister, for whom I was named, who died in childbirth in 1929. These old photographs, sepia-toned and faded, are evocative in themselves, and I am especially intrigued by the formal and dubious look their subjects have as they peer

into the camera, as if they do not believe in this enterprise at all. These photographs are particularly evocative for me because they are the historical traces of my people, a kind of "proof" that others came before me.

I have discovered that photography is the art form that almost all of us have had some active engagement with. We all take pictures, so I often use photography as example, or as a metaphor for talking about writing. Students I have worked with who might resist changing even one word of a poem they have written seem quite willing to consider how much better their photographs might have turned out if only they had stood on top of the picnic table, or if they had asked their subjects to lean a bit more to the left.

To talk about revision is to talk about manipulation, and I find that many of my students find this more acceptable in camera work than in writing. Writing from photographs provides an occasion for you to bring to poems the knowledge and excitement about creative process that you have discovered through taking multiple pictures of the same event. Spend some time looking at the photographs of well-known photographers and think about how they got different takes on the same subject by manipulating perspective: Edward Weston's peppers, for example, or Doris Ulmann's photographs of Appalachian people's faces and hands; Eugène Atget's photographs of Paris doorways; or Diane Arbus's photographs of those she called "freaks."

The question I am most frequently asked about this exercise is, How can I speak as the photographer or as someone in the poem if I do not know them? The answer of course is, Make it up. Perhaps, that this question is asked at all says something about how firmly we believe in photographs as a kind of "truth." For

me, one of the most remarkable things about photographs is how still they stand while we look at them; how immutable they seem, yet how vulnerable they are to interpretation and manipulation.

The energy of revision is the energy of change and creation, which is also the energy of destruction. Any photograph is a record made by a person who was shifting around something shifting that they saw. When we look at a photograph, we shift around what they have made to stand still. Poems, too, elude us in this way, and they dig their heels in. Each time we re-see them, we change our perspective, which also changes what is there and what has been recorded, like light in a dark room moving through time.

THE PARTY OF THE CENTURY

(FOR A GROUP)

Roger Weingarten

This is a hybrid individual-and-group exercise that involves a word hoard, original composition, collaboration, and several levels of revision. It can be collapsed or expanded to suit particular class needs and time frames.

1. Begin with a one-page hoard of words and phrases that evolves out of the collision of at least two distinct subject matters. To concoct this page you might ransack indexes of highly specialized texts (e.g., a sociological history of death), browse arcane reference books (anything from theatrical disguises to solar eclipses to folk motifs), canvass field guides (wild fungi, animal tracks, birds of prey), or rummage through classified ads from esoteric magazines *(Soldier of Fortune, Mothering, Opera News)*. Leave space at the bottom of the page for synonyms of the noun *party*, such as shindig, pub-crawl, soiree, co-conspirator, junta, or splinter-group.

2. Participants will be writing a twenty-to-thirty-line poem called "The Party of the Century." You can shine your imaginative powers on a social gathering, an individual, a political group, or all three. You should make liberal use of the word hoard, larding particular words or groups of words into your draft. Use most of

your time to write the draft and the rest to fill in, shape, and make it legible. Then the poems are collected, shuffled, and passed out again.

3. Each writer, again plundering the word hoard, contributes another section that adds to, subverts, or spins off from the poem they find in front of them. When you're finished, or at a prearranged time, the poems are again collected and redistributed.

4. Consider the poem now before you as if it were your own; you are responsible for bringing it, as much as possible (given the limitations of the work and time constraints), into fruition. What can be done to enhance the dramatic situation, intensify the thematic concerns and conflicts, the humor, the diction, what-have-you, to make the poem a richer experience for the reader? Maybe the poem is too logical and needs a little Harpo Marx; maybe the sentence structures are too regular, or vice versa. Don't throw the baby out with the bathwater, but give yourself license to build on the existing poem's strengths. Make all your insertions and alterations as clear as possible; transcribe your completed product to a new page.

5. Read the resulting poems aloud and discuss them.

This exercise is designed to help you deepen your experience of the writing process in two areas. Using the predetermined title and word hoard as its starting point, the initial composition encourages you to take your subject and inspiration from the possibilities of the language itself—subverting the conventional view that language is preceded by inspiration. The collaborative aspect of the exercise is not an end in itself; collaboration helps

to break down limiting self-definitions, freeing you to perceive potential new directions in your own poetry and to open your work to editorial participation. The exercise provides an apprenticeship in the revision process you can use to bring your own individual poems to fruition.

THE SHELL GAME

Thomas Rabbitt

Revise one of your earlier poems into a formal structure, either a received form such as a sonnet or a rigorous stanzaic pattern. If the poem you choose to revise is already "formal," transform it.

===

This exercise is the old distraction gambit of the card sharp or shell-game artist: worry about one hand while the other pulls off the trick. And it produces some of the semester's best poems, largely, I suspect, because the formal constraints impose on most students an economy and a visual framework the original poem often lacked.

Choose a poem you like and want to continue working with. Consequently there's often material you'll want to save. By now you should know that you sometimes have to change a thing in order to save it; you know not to pad lines (at least not too blatantly); and you know that, because you may enjamb, you needn't worry about the line as a unit of sense (phrase, clause, or sentence). Sure, the results are sometimes puffy son-

nets or sestinas like Kansas or lilacky clumps of rhyme royal. And sometimes, because you've learned not to fear repetition, the result will be a fine ballad or villanelle. And I think that's finally what it's all about—not being afraid of the art or the craft.

B. REFLECTIONS

THE REWRITE AS ASSIGNMENT

Stanley Plumly

I have never found poetry-writing assignments very useful, unless they can somehow be construed as involuntary, unless they can somehow be made to meet the already established needs of the words themselves through the agency of a first draft. That way, unlike the typical assignment set-up, one is not dealing with a blank page of whole cloth. As for the terror of the original blank page itself: that is a test of whether one should be writing at all. Rewriting, therefore, is, to my mind, the best assignment. Rewriting establishes the palimpsest and permits you to stay in touch with the first cause of the poem, regardless of the number of erasures, writings-over, transformations: the first impulse is the secret that will be revealed the more it is concealed through rewrite.

Some poets, like the young Keats, are impatient and their genius is the degree to which the first cause becomes the ultimate, finished assignment—and how quickly. It is not so much that the odes are written in a brilliant hurry but that they are rewritten and sublayered immediately: they feel crowded with perfectibility. Some poets, like Yeats, age with their poems, and the rewrite becomes the assignment of contemporaneity—changing the poem to make it better is to make it current, more alive, which may be more an obsession of longevity than a desire for immor-

tality. Some poets, like Auden, rewrite reductively, so that the assignment becomes politicized, the art of the agenda.

D. H. Lawrence simply writes another whole version: a kind of paralleling as rewriting. This is obvious in the poems, but it is also true of the novels: something like seven versions of *The Rainbow*, four of *Women in Love*.

Pound's version of *The Waste Land* is rewriting as recovery. Eliot's original is the found text, Pound's "rewrite" is the discovered text—

sometimes it feels you must be two writers: the one who originates the text and the one who discovers it into its achieved version.

And this is true whether you are rearranging and adding stanzas or simply changing a word. When Stevens rearranges "Sunday Morning" from its original appearance in *Poetry* in 1915 by moving his second stanza to the last and replacing its position with two new stanzas he transforms the poem completely. When Yeats, in "Among School Children," exchanges the word *mass* for *mess* in his famous image of Maud Gonne's aging face—"Hollow of cheek as though it drank the wind / And took a _____ of shadows for its meat"—the total imagination of the poem is affected, not just the local moment. *Mess* is the palimpsest word written over the erasure of *mass; mass* was Yeats's way of getting to the rewrite: it was his assignment.

I am leery of the tricks meant to help fill the first emptiness of the page since the emptiness is always part of the subject—or should be. The silence out of which a poem comes is part of its power, just as the words first written are inditements and indictments of what is possible.

HOUSEHOLD ECONOMY, RUTHLESSNESS, ROMANCE, AND THE ART OF HOSPITALITY

Notes on Revision

Richard Tillinghast

> Intensely hot. I made pies in the morning. William went
> into the wood and altered his poems.
> —Dorothy Wordsworth,
> *Journal entry for 28 July 1800*

The willingness, the ardent desire even, to revise separates the poet from the person who sees poetry as therapy or self-expression. To revise is to improve, and I suspect that the desire to improve hints at a longing for perfection, which shows how related the formal and spiritual sides of poetry are. The impulse to improve is also a sign of humility, of bowing one's neck before the humbling undertaking of learning how to be worth one's salt as a writer. Humility is naturally rare, particularly among young writers, for whom the value of doing something remarkable is vastly increased when they can say it only took them fifteen minutes.

A friend once gave me photocopies of Elizabeth Bishop's worksheets for her superb villanelle "One Art," and I have looked at Robert Lowell's early drafts of "Skunk Hour" in Houghton Library at Harvard. In their inception these masterpieces showed, on paper at least (and where else is one to look?), few sparks of genius, few notes of originality or distinctive voice. "Skunk Hour"

being notable for its gradual and seemingly inevitable progression of stanzas, it's surprising to see that the last few stanzas came to Lowell first and that the introductory part of the poem was tacked on later. "One Art" being among a handful of perfect villanelles in the language, it's surprising that the poem began as a series of dispirited and formless reflections on what Bishop would end up calling "the art of losing." These poets were masters of household economy who, upon looking into the fridge and seeing a couple of old potatoes, half a cabbage, and some neglected cheese, could bring to the table a tasty meal based on these scraps. The lesson here is to trust your instincts, to have hope and faith enough to recognize material that you and only you can turn into something savory.

Faith and hope, yes. Charity, no. At least not toward your own material. When you see little spots on the cabbage, throw it out. Ruthlessness, like charity, begins at home. This is a hard one to learn. Robert Lowell was a great writing teacher because he wasn't shy about telling people hard truths about their own poems. Of a seventeen-line effort: "I think this is a marvelous poem. Cut the first sixteen lines and go from there." The author of the seventeen-liner was unlikely to take offense, knowing that Lowell was even more severe toward his own work.

Get a sense of the poem as something not defined by or limited to the words you have written down in your first few attempts. A good poem, even in potential form, has a shape, a life, that floats above the words: "the light around the body," as Robert Bly put it. Memorizing poems and saying them aloud is a good way to become aware of the poem as a metaverbal entity. Apprehend the poem's field of energy, then think, while revising, of coming at that field from a completely different direction than

you have tried so far. Your poem is a city; instead of getting off the freeway and driving into town straight down Main Street, imagine you're out at the junkyard next to the lake, trying to get hubcaps for your '78 Ford Country Squire. Leave your car there underneath the big maples and walk into town through the railroad freightyard, past the greenhouses, up past the soccer field. In other words, start at line 17. Savvy rewriting is a way of staying flexible when entertaining that separate being which is the poem. The metaphor of "entertaining" is deliberate. Being a good host means coming up with fresh things to do that will allow your guest to enjoy herself. And if she's having a good time, well, you take it from there.

If you and your poem like the way it feels when the two of you are sitting together, you will find yourself caught up in the same spirit of inspiration that inclined you to keep company in the first place. Getting back into that spirit, participating in a re-vision, will keep you from knocking the bloom off your original excitement and making the poem seem worked over. While keeping your options open and allowing the poem to suggest new moves, you'll want to live with your guest twenty-four hours a day. When you wake up in the morning you'll be thinking about the poem, when you come back from the pub at night you'll sit down, read it through, and make a few changes. Revising is not so much a task as it is a romance. I like to write the whole poem out fresh whenever I make changes. That puts me into the flow of the poem, the music of the poem. It's at this point that those assonances, consonances, alliterations, repetitions, that give the poem its subtle music become refined.

Here you rely on the ear you have already developed, and you further educate your ear for work you will do in the future. Sitting

down and fine-tuning the poem once it has settled into something like its final form comes at the very end of the process. Like the chocolates, brandy, and cigars that come at the end of the dinner, this phase is the least demanding, most luxurious part. Now you can sit back and enjoy yourself.

OF REVISION

Donald Justice

Of the two best methods of revision the more practical is simply to cut out the bad parts. The whole secret then becomes how to recognize the bad parts, and it is true that many writers are too much blinded by a love for their own creations to see what may prove perfectly obvious to their readers. Poems in fact can and do sometimes hold up very well without certain transitions and connecting passages, and without the elaborations, redundancies, and general long-windedness to which some writers and some styles seem prone.

Pound demonstrated this simple method with his usual flair when "editing" *The Waste Land*, cutting enormous chunks of the original manuscript right out. Although I happen to think that he cut more than absolutely necessary, it is hard to deny that all or almost all of what did pass his inspection deserved to do so, and the very form of the conglomeration of bits and pieces that resulted, when looked at as if they had been intended to make a whole, ended up seeming startling and fresh, a formal revelation.

The other method is to abandon the early draft and think it through again. Completely reconceive the thing! The experience of having tried once before and failed might turn out to be an advantage the next time around.

In any case, it seems futile to hope for perfection. Even the very best poems fall short of such an ideal. For this reason it seems almost always pointless to fuss much over such minute details as a word here or—in current practice that most slippery of considerations—a linebreak there. It wastes a great deal of time to do so. Better to move on quickly to the next poem and trust to the kindness of the muse.

If I myself could have followed the above advice, I am convinced that I would have written more and at the same time no worse, and that all in all I would have spent a happier life.

IN PRAISE OF MALICE:

THOUGHTS ON REVISION

Lynn Emanuel

You don't want to be reading this. And why should you? In the feast of writing, revision is that dark matted lump of vegetation that leaked and wept and seemed to grow enormous on our plates at six. Over my left shoulder a figure with a stick is standing. My portion of the feast is the punishment, the payment extracted for enjoyment of writing. The stick that comes with the carrot.

I don't know if revision is what I love to do best in my own work. It is an acquired taste; its deliciousness comes with a bite, a sting and a pinch. It is the *damn* that braces rather than the *bless* that relaxes. But I do love to teach revision. Talking about revision can be one of the most radicalizing, emotional, vertiginous, and fun moments in the classroom.

I want to talk about the unacknowledged assumptions that inform our models of revision, to acknowledge that these assumptions make revision an almost impossible task.

In revision we come face to face with ideology. If we imagine, in the initial composition of a poem, that we have free will, that we are saying what we want rather than what a culture both permits and demands, then it could be said that when we come to revision

that illusion falls away. Most of us, I think, feel reprimanded. We have been unclear, sentimental, boring. And we have been. Mostly we've been boring. And orderly. And well mannered.

The first unacknowledged assumption from which we write is that of good manners. Good manners is the first thing to give up—at least in the imagination—in order to revise.

Here is a topic that we write about all the time—death. Let's say that grandmother has died. Good manners dictate that one show grief and regret. In most of our poems death makes someone part of the great minority of the underprivileged. One does not speak ill of the disadvantaged. One does not make fun of those turned out of the home of flesh and sentience. And yet there are wonderful writers who do just that. Take for instance Nazim Hikmet's great poem *Human Landscapes*. It is a hugely rude work. It is breathtakingly un-Christian and profoundly uncharitable. It is also passionately compassionate. And wildly intelligent. Because in Hikmet's poem the poor are wicked, they are not worthy of our pity. They will not tolerate it. The poor are not the salt of the earth, they are not transformed by suffering, they persist in appalling human warty ugliness. They are hateful.

Human Landscapes is an indecorous and brilliant poem.

My suggestions for revising the poem that deals tenderly with grandmother's death might begin "This poem is not rude enough and, therefore, it is not smart enough." Because let's face it, this tender and pious poem doesn't really want to be about grandmother's death at all. It doesn't want for the human to swell up into palpability. It wants to be polite and get a B, even when it is written by oneself. It wants to go to the video arcade and hang out. And so it should.

That is why I think that most suggestions for revision—begin
with the last stanza, write it as a *persona* poem, write it from a
different point of view—are really evasions, ways of not thinking
about what one is doing. Such recommendations are palliatives.
I recommend brutality and simplicity. I recommend not loving
one's own grief too much and, instead, having the courage and
charity to put that old woman into the poem. That old woman
who was cruel and sexual. That woman and her appalling and
unbearable body and humanity, her bravery, her integrity, and
her horrible prejudices and small-spiritedness toward the suffering
of others.

It is hard to cram this Amazon into the poem. And I think that
is because of another unacknowledged assumption under which
many of us labor: we compose poems according to some bastard-
ized version of New Criticism. That is: we write a poem the way
we have been taught to read a poem. By bastardized I mean that
the way most of us were taught to read poems bears only the
faintest and most tepid resemblance to the initial radical purposes
of New Criticism. We are simply taught to read. We are not
taught the history of reading. And so, whatever relevance and
juice New Critical methods have is effectively siphoned off. We
are taught in a vacuum.

We are taught to read closely, but "reading closely" has come to
mean a number of things that perhaps we, as writers, should not
agree to. Reading closely, I believe, leads to writing closely and
that, I also believe, is a mistake. Reading closely means not only
looking hard at a text but drawing a relation among and between
whatever we "find" there, trussing the text in the web of our
longing for things to have a relation to one another. It means
creating the Whole. Sometimes we describe that whole in terms
that lean toward the organic: we see the poem as a kind of

254 THE PRACTICE OF POETRY

luxuriant plant that unwinds and burgeons in ways that seem chaotic but, when read closely, really are all part of the shape defining itself as an unwinding and burgeoning one.

Or we see the poem in mechanistic terms: it is a gorgeous machine and we its mechanics. We go about, with our close reading, cleaning the grit from the gears so the poem can make clear to us the smoothness of its operation. Close reading means that the meek and the poor, no matter how dreadful they and their condition are, inherit the earth.

And so grandma has died. Generally, in the beginning of the poem, it will be raining. Let us say that we bring out from the dust cover of the clouds and polish with our tears a bare tree. We are now in desperate trouble. There is, in fact, no poem left to write. Because consistency (no matter how "complex") and good manners (no matter how many tiny tantrums we throw along the way) are writing the poem. If reading a poem means searching out its symbols, metaphors, images, and figuring out what they mean, then writing a poem begins to mean putting in meaningful symbols, images, and metaphors. And so we have a bare tree and it means something: we are sad. The poem is over, except for elaborating on its origins, except for making variations on its theme. We may even be dimly aware of this. And so the sun comes out, hoping, meekly, to dry the torrent of predictability as it sweeps everything up in its teary embrace. But the hug of our schooling is too tight, and we are too utterly in love with our own seduction. The sun that enters the poem becomes "a contrast." It represents Hope. The sun is a hankie. It has come to dry our cheeks. Never once is the sun a holocaust, a storm of fire. It is never permitted to pulverize the sodden dirt, to hammer at it with blows of light until it turns to dust and is blown away. And if, by some chance, that did happen in the poem, how often have

we slapped the wrist of the arsonist who set this blaze, who had the impudence to ignite and bewitch the landscape, by saying that such an "inconsistency" "belonged in another poem." And so grandma is lowered to her dank rewards.

At the bare tree, one could draw a line across the page and say "the poem ends here." I recommend that kind of act as a good way to begin a revision: amputate your ache, do not heal it. I recommend that one begin, instead, with a malicious celebration of grandma's death, telling every naughty secret one can invent, especially sexual ones. I recommend lying and cheating one's way toward the finish line, tripping and elbowing all those dull runners in their costly gear—Love, Respect, Sorrow. Hating is so easy, loving so costly and difficult. Educated consumers that we are, we believe that inaccessibility makes something more valuable. The poor and mean-spirited, those who don't have access to Love, know otherwise.

But I suspect there is another reason we honor the models of composition and revision that we do: We want to protect and promote a definition of the self in which we are highly invested.

Let me return to the beginning: that revision will appear at the back of the book you are now holding in your hands. That the very geography of this volume will enact our sense of the shape writing takes: first we compose, then we revise. First vision, then revision. Even the subjective and inventive and intimate act of writing can be described in terms of temporal progression and shape. But if I look into the heart of myself as I compose, as I sit here this very moment appearing to be a composed and coherent voice, hoping to appear, if not unitary, unified, I know how tenuous, how ephemeral this *I* is. I know that even as I speak to you, even as I compose myself to confront you, the reader, the

multitudinous anonymity of you that assaults me, I am myself a multitudinous anonymity. I look into myself, and I see "there is no there there." I have no eye/I majestic and omniscient. I do, however, have hallucinations that present themselves to me with terrifying vigor. I do have storms and seizures of selfhood, brief and violent. For a moment I *do* see something, I understand, I am invigorated by the power of rationality and sense. But then I look up. I look up to *see* the things seen by that "she" who a moment ago was "I." Even as I describe that to myself, that self that was mine has dissolved and I am rummaging among the junk of what she has left behind.

Revision—the choosing, and shaping, looking backward and forward, the sense of materiality and the sense one is working on *something* that already has its own shape and exists and can be altered—is something that confronts us moment to moment in writing as composition, as vision. And that is all vision is: revisions coming at the speed of light. Writing presents to us the nullity of ourselves, the inaccuracies of our conceptions of selfhood. We are both nothing and everything—provisional, shifting, molten.

Writing forces us to confront that fact. And we can't immure that fickle, promiscuous self with a model of writing and revision that resembles marriage: union, fidelity. As long as we try to be good, we cannot revise. Or this is what she, who has disappeared, thought at some earlier moment when we belonged to one another.

WAITING AND SILENCE

Susan Snively

Franz Kafka is said to have kept a sign above his desk that read WAIT. Kafka's sign could serve as both the first and the last word on the subject of revision. But it is not a command to be passive. On the contrary, waiting is an active state of mind in which important work may take place—perhaps the most important work in the life of a poem.

The most exhilarating, and therefore treacherous, moment in a poem's composition comes when the first draft is done. The poet, relieved of an emotional burden, exalted by self-expression, feels that the world should share the triumph. Under the spell, perhaps, of the word-processor's finished-looking print, she may believe that the poem is ready for instant fame. The greater the exaltation, the more foolish the behavior: some poets have even been known to phone their friends, offering spontaneous late-night declamations. It is sobering to realize, upon subsequent readings, that more work must be done.

The work includes, inevitably, the frustrating but necessary discipline of *leaving the poem alone*. No rules exist for how long the poet must stop fiddling with the thing to let it seal over and form a crust, enabling further breakthroughs. Even for those rare, magi-

cal poems that keep their original form, a stage of waiting in the dark is essential—as it is for every living thing.

More hands-on forms of revision may alternate with or succeed the waiting-in-the-dark stage. Reading a poem aloud, not declaiming it but reading it slowly in a quiet voice, helps a poet hear awkward enjambments, unwitting repetition, and accidental howlers. Casting a cold eye on mingy little words (*and, it, but, which, that*) shows how to clear the underbrush from the living roots. Keeping both eye and ear alert for dead phrases and clichés ("Where have I heard *that* before?") helps a poet replace the derivative with the original.

Coming to terms with the myth of the Perfect Poet, one recalls memorable poems with unmemorable beginnings. The famous line with which Yeats ended "Among School Children," "How can we know the dancer from the dance?" started out as the lame-footed "It seems the dancer and the dance are one." (Notice how Yeats revised the clunky, regular iambs of the original line to create a more lively rhythm suggesting real dancers.) And there is the example of Elizabeth Bishop to shame us all. Bishop composed poems over months and years, pinning incomplete drafts on a notice board with gaps left for the right word, whenever that might come. Her refusal to hurry a poem was, among other things, a way to say that the poem's special life had to be honored above her own need for closure or publication. (See David Kalstone's *Becoming a Poet* for insightful comment on Bishop's significant literary friendships and habits of composition.)

Revision as re-vision has a deeper meaning beyond editorial exercises, a meaning that replaces the usefulness or purpose of a poem with its actual urge to be what it must be. As Bishop said,

"What one seems to want in art, in experiencing it, is the same thing that is necessary for its creation, a self-forgetful, perfectly useless concentration." Seeing oneself anew, reenvisioning the predicament out of which the poem grew, gives it more, not less, to draw upon. Sometimes the questions are painful: "What am I not allowing myself to say? Should it be said? Why do I want this poem to end? Is it a false resolution?" Asking them is necessary, as is admitting that some poems don't make it. As Sylvia Plath lamented in a poem called "Stillborn," "They are not pigs, they are not even fish, / Though they have a piggy and a fishy air." But the "stillborn" poem, by drawing off negative energy, may lead to a viable poem, rescued by silence and waiting.

APPENDIX A:

MAIL-ORDER SOURCES OF POETRY BOOKS

THE GROLIER POETRY BOOK SHOP, INC.
6 Plympton Street
Cambridge, MA 02138
(617) 547-4648

Over 14,000 titles in stock. The largest (and oldest) source.

SPRING CHURCH BOOK COMPANY
P.O. Box 127
Spring Church, PA 15686
(412) 354-2359

Audio tapes, and some fiction and criticism as well as contemporary
poetry. Books sold at a discount. Write for free catalog.

THE POETRY SOURCE
P.O. Box 6866
Lawrenceville, NJ 08648

Specializes in poetry and books about poetry. Some periodicals and audio
tapes. Write for free catalog.

Books & Books
296 Aragon Avenue
Coral Gables, FL 33134
(305) 442-4408

Large stock of contemporary poetry. Will ship anywhere.

Black Oak Books
1491 Shattuck Avenue
Berkeley, CA 94709
(415) 486-0698

Some out-of-print and hard-to-find books as well as contemporary
poetry.

Prairie Lights Books
15 South Dubuque Street
Iowa City, IA 52240
(319) 337-2681

Large selection of contemporary poetry. Credit card/phone orders
preferred.

Chapters
1512 K Street, N.W.
Washington, DC 20005
(202) 347-5495

Large stock of contemporary and classic titles, as well as works in
translation. Some literary journals.

Used, Rare, Out-of-Print and Small-Press Books

Small Press Distribution
1814 San Pablo Avenue
Berkeley, CA 94703
(415) 549-3336

Carries books from over 300 small independent presses. Specializes in
experimental and multicultural work. Send for free catalog.

THE CAPTAIN'S BOOKSHELF
26 ½ Battery Park Avenue
Asheville, NC 28801
(704) 253-6631

Specializes in twentieth-century, second-hand, and rare books. Write for
catalog of rare and first editions.

JAMES S. JAFFE
P.O. Box 496
Haverford, PA 19041
(215) 649-4221

Modern poetry, out-of-print, used, and rare books.

"A Blessing." Wright, James. *Above the River*. Wesleyan Univ. Press, 1990.

"Above Pate Valley." Snyder, Gary. *Riprap and Cold Mountain Poems*. North Point, 1990.

"A Dialogue Between the Soul and Body." Marvell, Andrew. *Complete Poems*. Ed. Elizabeth S. Donno. Penguin, 1977.

"A Dialogue of Self and Soul." Yeats, W. B. *The Collected Poems of W. B. Yeats*. Macmillan, 1956.

"After an Old Text." Hollander, John. *Spectral Emanations*. Atheneum, 1978.

"After Apple-Picking." Frost, Robert. *Complete Poems*. Holt, Rinehart & Winston, 1962.

"A Hunt in the Black Forest." Jarrell, Randall. *The Complete Poems*. Farrar, Straus & Giroux, 1975.

"A Litany in Time of Plague." Nashe, Thomas. *Works of Thomas Nashe*. Ed. Ronald B. McKerrow. Sidgwick & Jackson, 1910.

Ammons, A. R. "Visit." *The Selected Poems*. Norton, 1977.

"Amnesia." Lehman, David. *An Alternative to Speech*. Princeton Univ. Press, 1986.

"Among School Children." Yeats, W. B. *The Collected Poems of W. B. Yeats*. Macmillan, 1956.

Anderson, Maggie. *Cold Comfort*. Univ. of Pittsburgh Press, 1986.

"Apparuit." Pound, Ezra. *Selected Poems*. New Directions, 1957.

Ashbery, John. "Finnish Rhapsody." *April Galleons*. Viking, 1987.

———. "Pantoum." *Some Trees*. Corinth, 1970.

———. "The Instruction Manual." *Selected Poems*. Penguin, 1985.

————. "What Is Poetry." *Selected Poems.* Penguin, 1985.

"A Supermarket in California." Ginsberg, Allen. *Collected Poems, 1947–1980.* Harper & Row, 1988.

"At the Fishhouses." Bishop, Elizabeth. *The Complete Poems, 1927–1979.* Farrar, Straus & Giroux, 1979.

Auden, W. H. "If I Could Tell You." *Collected Poems.* Random House, 1976.

————. "The Age of Anxiety." *Collected Poems.* Random House, 1976.

————. "Victor." *Collected Poems.* Random House, 1976.

"Back from the Fields." Everwine, Peter. *Collecting the Animals.* Atheneum, 1973.

Barnes, Jonathan. *Early Greek Philosophy.* Penguin, 1987.

Beckett, Samuel. "Proust." *Proust.* Grove, 1957.

Becoming a Poet. Kalstone, David. Farrar, Straus & Giroux, 1990.

Beddoes, Thomas Lovell. "The Phantom-Wooer." *The Works of Thomas Lovell Beddoes.* Ed. H. W. Donner. AMS Press, 1976.

Bernstein, Charles. "Rose the Click for 24." *The Sophist.* Sun and Moon, 1987.

Berryman, John. "Henry." *Collected Poems.* Ed. Charles Thornbury. Farrar, Straus & Giroux, 1989.

————. *77 Dream Songs.* Farrar, Straus & Giroux, 1964.

Bidart, Frank. "Ellen West." *In the Western Night: Collected Poems, 1965–1990.* Farrar, Straus & Giroux, 1990.

————. "Herbert White." *In the Western Night: Collected Poems, 1965–1990.* Farrar, Straus & Giroux, 1990.

————. "The War of Vaslav Nijinsky." *The Sacrifice.* Vintage, 1983.

Bishop, Elizabeth. "At the Fishhouses." *The Complete Poems, 1927–1979.* Farrar, Straus & Giroux, 1979.

————. "First Death in Nova Scotia." *The Complete Poems, 1927–1979.* Farrar, Straus & Giroux, 1979.

————. "In the Waiting Room." *The Complete Poems, 1927–1979.* Farrar, Straus & Giroux, 1979.

————. "One Art." *The Complete Poems, 1927–1979.* Farrar, Straus & Giroux, 1979.

————. "The Fish." *The Complete Poems, 1927–1979.* Farrar, Straus & Giroux, 1979.

————. "The Monument." *The Complete Poems, 1927–1979.* Farrar, Straus & Giroux, 1979.

————. "The Moose." *The Complete Poems, 1927–1979.* Farrar, Straus & Giroux, 1979.

————. "The Prodigal." *The Complete Poems, 1927–1979.* Farrar, Straus & Giroux, 1979.

"Blades." Williams, C. K. *Poems 1963–83.* Farrar, Straus & Giroux, 1988.

Blake, William. "Songs of Innocence and Experience." *Songs of Innocence and Experience.* Avon, 1971.

Bly, Robert, ed. *News of the Universe: Poems of Two-Fold Consciousness.* Sierra Club, 1985.

————. *The Light Around the Body.* Harper & Row, 1985.

Bogan, Louise. "Portrait." *The Blue Estuaries.* Ecco, 1977.

Brooks, Gwendolyn. *Report from Part One.* Broadside, 1972.

Burroughs, William, and Brion Gysin. *The Third Mind.* Viking, 1978.

Canning, George, George Ellis, and John Hookham Frere. "Sapphics: The Friend of Humanity and the Knife Grinder." *Parodies and Other Burlesque Pieces.* Ed. Henry Morley. George Routledge and Sons, 1890.

"Canto I." Pound, Ezra. *Selected Poems.* New Directions, 1957.

"Catherine of Aragon." Fish, Karen. *The Cedar Canoe.* Univ. of Georgia Press, 1987.

Catullus. Zukofsky, Louis and Celia. Cape Golliard, 1969.

"Catullus XI." Merwin, W. S. *The Drunk in the Furnace.* Macmillan, 1960.

Chappell, Fred. "My Grandfather's Church Goes Up." *Bloodfire.* Louisiana State Univ. Press, 1978.

Cheri and the Last of Cheri. Colette. Ballantine, 1967.

"Childhood Is the Kingdom Where Nobody Dies." Millay, Edna St. Vincent. *Collected Poems.* Harper & Row, 1956.

"Cinderella." Jarrell, Randall. *The Complete Poems.* Farrar, Straus & Giroux, 1975.

"Cleave and Cleave." Hillman, Brenda. *Fortress.* Wesleyan Univ. Press, 1989.

"Cobb Would Have Caught It." Fitzgerald, Robert. *In the Rose of Time: Poems, 1939–1956.* New Directions, 1956.

Cold Comfort. Anderson, Maggie. Univ. of Pittsburgh Press, 1986.

Colette. *Cheri and the Last of Cheri.* Ballantine, 1967.

Collecting the Animals. Everwine, Peter. Atheneum, 1973.

"Combat." Williams, C. K. *Tar.* Vintage, 1983.

Contemporary American Poetry. Ed. A. Poulin, Jr. Houghton Mifflin, 1985.

Cowper, William. "Lines Written During a Period of Insanity." *Poetical Works*. Oxford Univ. Press, 1967.

Creeley, Robert. "I Know a Man." *The Collected Poems of Robert Creeley, 1945–1975*. Univ. of California Press, 1982.

"Cuba." Muldoon, Paul. *Selected Poems*. Ecco, 1987.

"Cut-and-Shuffle Poem." Myers, Jack, and Michael Simms. *The Longman Dictionary of Poetic Terms*. Longman, 1985.

Dacey, Philip, and David Jauss. *Strong Measures: Contemporary American Poetry in Traditional Forms*. Harper & Row, 1986.

"Danse Russe." Williams, William Carlos. *The Collected Poems of William Carlos Williams, 1909–1939*. Vol. 1. New Directions, 1986.

De Andrade, Carlos Drummond. "The Elephant." *Another Republic*. Ecco, 1976.

"Delight in Disorder." Herrick, Robert. *Selected Poems*. Fyfield Books, 1980.

Deutsch, Babette. *Poetic Handbook: A Dictionary of Terms*. Harper & Row, 1974.

Dickinson, Emily. "The Props Assist the House." *The Poems of Emily Dickinson*. Belknap, 1963.

"Directive." Frost, Robert. *Complete Poems*. Holt, Rinehart & Winston, 1962.

"Dirty Silences." Plumly, Stanley. *Poetics: Essays on the Art of Poetry*. Tenric, 1984.

"Disillusionment of Ten O'Clock." Stevens, Wallace. *The Palm at the End of the Mind*. Vintage, 1972.

Dobyns, Stephen. "How to Like It." *Cemetery Nights*. Viking, 1987.

Donne, John. "I am a little world made cunningly." *The Complete English Poems of John Donne*. Dent, 1985.

"Do Not Go Gentle into That Good Night." Thomas, Dylan. *The Collected Poems of Dylan Thomas*. New Directions, 1971.

Dove, Rita. "Dusting." *Thomas and Beulah*. Carnegie Mellon Univ. Press, 1986.

Dubie, Norman. "February: The Boy Brueghel." *Selected and New Poems*. Norton, 1983.

———. "The Czar's Last Christmas Letter." *Selected and New Poems*. Norton, 1983.

————. "The Pennacesse Leper Colony for Women, Cape Cod: 1922." *Selected and New Poems.* Norton, 1983.

"Dusting." Dove, Rita. *Thomas and Beulah.* Carnegie Mellon Univ. Press, 1986.

Early Greek Philosophy. Barnes, Jonathan. Penguin, 1987.

"Earth." McMahon, Lynne. *Faith.* Wesleyan Univ. Press, 1988.

Ecstatic Occasions, Expedient Forms. Lehman, David. Macmillan, 1987.

Edson, Russell. "How Science Saved People from Holes." *The Intuitive Journey and Other Works.* Harper & Row, 1976.

"Effort at Speech." Meredith, William. *Partial Accounts.* Knopf, 1988.

"Elegy for My Father." Strand, Mark. *Selected Poems.* Atheneum, 1980.

Eliot, T. S. *Four Quartets.* Harcourt Brace & Jovanovich, 1971.

————. *The Waste Land.* Harcourt Brace & Jovanovich, 1962.

Eliot, Valerie, ed. *T. S. Eliot, The Waste Land: A Facsimile and Transcript of the Original Drafts Including the Annotations of Ezra Pound.* Harcourt Brace & Jovanovitch, 1971.

"Ellen West." Bidart, Frank. *In the Western Night: Collected Poems, 1965–1990.* Farrar, Straus & Giroux, 1990.

Erdrich, Louise. "Francine's Room." *Jacklight.* Holt, Rinehart & Winston, 1984.

"Erinna to Sappho." Wright, James. *Above the River.* Wesleyan Univ. Press, 1990.

Everwine, Peter. "Back from the Fields." *Collecting the Animals.* Atheneum, 1973.

————. "Learning to Speak." *Collecting the Animals.* Atheneum, 1973.

"Expostulation and Reply." Wordsworth, William. *Poetical Works of Wordsworth.* Houghton Mifflin, 1982.

"February: The Boy Brueghel." Dubie, Norman. *Selected and New Poems.* Norton, 1983.

Ferlinghetti, Lawrence. "the pennycandystore beyond the el." *Endless Life: Selected Poems.* New Directions, 1981.

"Fill-in-the-Blanks Poem." Myers, Jack, and Michael Simms. *The Longman Dictionary of Poetic Terms.* Longman, 1985.

"Finnish Rhapsody." Ashbery, John. *April Galleons.* Viking, 1987.

"First Boyfriend." Olds, Sharon. *The Gold Cell.* Knopf, 1989.

"First Death in Nova Scotia." Bishop, Elizabeth. *The Complete Poems, 1927–1979.* Farrar, Straus & Giroux, 1979.

Fish, Karen. "Catherine of Aragon." *The Cedar Canoe.* Univ. of Georgia Press, 1987.

————. "Jeanne d'Arc." *The Cedar Canoe.* Univ. of Georgia, 1987.

————. "Self Portrait with Camellia Branch." *The Cedar Canoe.* Univ. of Georgia Press, 1987.

Fitzgerald, Robert. "Cobb Would Have Caught It." *In the Rose of Time: Poems, 1939–1956.* New Directions, 1956.

"Forest Birds." Simic, Charles. *Classic Ballroom Dances.* Braziller, 1980.

"For Esther." Plumly, Stanley. *Out-of-the-Body Travel.* Ecco, 1977.

"For George Trakl." St. John, David. *Hush.* Johns Hopkins Univ. Press, 1985.

"Fortune's Pantoum." Shore, Jane. *Eye Level.* Univ. of Massachusetts Press, 1977.

Fourcade, Dominique. "IV:23." *Rose-Declic.* Spectre Familiars, 1984.

Four Quartets. Eliot, T. S. Harcourt Brace & Jovanovich, 1971.

"IV:23." Fourcade, Dominique. *Rose-Declic.* Spectre Familiars, 1984.

"Francine's Room." Erdrich, Louise. *Jacklight.* Holt, Rinehart & Winston, 1984.

Frazer, Sir James. "Sympathetic Magic." *The Golden Bough.* Macmillan, 1963.

Freud, Sigmund. "The Uncanny." *On Creativity and the Unconscious.* Harper & Row, 1958.

Frost, Robert. "After Apple-Picking." *Complete Poems.* Holt, Rinehart & Winston, 1962.

————. "Directive." *Complete Poems.* Holt, Rinehart & Winston, 1962.

————. "Stopping by Woods on a Snowy Evening." *Complete Poems.* Holt, Rinehart & Winston, 1962.

————. "The Woodpile." *Complete Poems.* Holt, Rinehart & Winston, 1962.

Fussell, Paul. *Poetic Meter and Poetic Form.* Random House, 1979.

"Gangaridde." Kirchwey, Karl. *The Wandering Island.* Princeton Univ. Press, 1990.

Georgics. Virgil. Tr. Robert Wells. Carcanet New Press, 1982.

Ghalib. *Ghazals of Ghalib.* Ed. Aijaz Ahmad. Columbia Univ. Press, 1971.

"Ghazals." Hollander, John. *Rhyme's Reason.* Yale Univ. Press, 1989.

"Ghazals: Homage to Ghalib." Rich, Adrienne. *The Fact of a Doorframe.* Norton, 1984.

Ghazals of Ghalib. Ghalib. Ed. Aijaz Ahmad. Columbia Univ. Press, 1971.

Gilbert, Christopher. "Saxophone." *Across the Mutual Landscape.* Graywolf, 1984.

Ginsberg, Allen. "A Supermarket in California." *Collected Poems, 1947–1980.* Harper & Row, 1988.

———. "Howl." *Collected Poems, 1947–1980.* Harper & Row, 1988.

Gioia, Dana. "Notes on the New Formalism." *Hudson Review* 40 (1987): 395–408.

Glück, Louise. "Gretel in Darkness." *The House on Marshland.* Ecco, 1975.

Graham, Jorie. "Salmon." *Erosion.* Princeton Univ. Press, 1983.

"Grandmother in Heaven." Levine, Philip. *New Selected Poems.* Knopf, 1991.

"Gretel in Darkness." Glück, Louise. *The House on Marshland.* Ecco, 1975.

Hacker, Marilyn. "Market Day." *Going Back to the River.* Vintage, 1990.

———. "Villanelle: Late Summer." *Separations.* Knopf, 1976.

Hayden, Robert. "The Whipping." *Collected Poems.* Liveright, 1985.

Heaney, Seamus. *North.* Faber & Faber, 1985.

"Hedgerows." Plumly, Stanley. *Boy on the Step.* Ecco, 1980.

"Henry." Berryman, John. *Collected Poems.* Ed. Charles Thornbury. Farrar, Straus & Giroux, 1989.

Herbert, George. "Paradise." *The English Poems of George Herbert.* Ed. C. A. Patrides. Littlefield Adams, 1981.

"Herbert White." Bidart, Frank. *In the Western Night: Collected Poems, 1965–1990.* Farrar, Straus & Giroux, 1990.

Herrick, Robert. "Delight in Disorder." *Selected Poems.* Fyfield Books, 1980.

Hikmet, Nazim. "Human Landscapes." *Human Landscapes.* Trans. Mutlu Konuk and Randy Blasing. Persea, 1982.

Hillman, Brenda. "Cleave and Cleave." *Fortress.* Wesleyan Univ. Press, 1989.

———. "The Wrench." *White Dress.* Wesleyan Univ. Press, 1985.

Hirsch, Edward. "The Abortion." *The Night Parade.* Knopf, 1989.

"History of My Heart." Pinsky, Robert. *History of My Heart.* Ecco, 1984.

Hollander, John. "After an Old Text." *Spectral Emanations.* Atheneum, 1978.

———. "Ghazals." *Rhyme's Reason.* Yale Univ. Press, 1989.

———. "The Lady of the Castle." *Spectral Emanations.* Atheneum, 1978.

"Hollow." Wood, Susan. *Campo Santo*. Louisiana State Univ. Press, 1991.

"Home for Thanksgiving." Merwin, W. S. *Selected Poems*. Atheneum, 1988.

Horace. *Horace's Satires and Epistles*. Tr. Jacob Fuchs. Norton, 1977.

Horace's Satires and Epistles. Horace. Tr. Jacob Fuchs. Norton, 1977.

Howard, Richard. "Wildflowers." *Two-Part Inventions*. Atheneum, 1974.

"How It Is." Kumin, Maxine. *The Retrieval System*. Penguin, 1978.

"Howl." Ginsberg, Allen. *Collected Poems, 1947–1980*. Harper & Row, 1988.

"How Science Saved People from Holes." Edson, Russell. *The Intuitive Journey and Other Works*. Harper & Row, 1976.

"How to Like It." Dobyns, Stephen. *Cemetery Nights*. Viking, 1987.

Hugo, Richard. *31 Letters and 13 Dreams*. Norton, 1977.

Hull, Lynda. "1933." *Ghost Money*. Univ. of Massachusetts Press, 1986.

"Human Landscapes." Hikmet, Nazim. *Human Landscapes*. Trans. Mutlu Konuk and Randy Blasing. Persea, 1982.

"Hush." St. John, David. *Hush*. Johns Hopkins Univ. Press, 1985.

"I am a little world made cunningly." Donne, John. *The Complete English Poems of John Donne*. Dent, 1985.

"If I Could Tell You." Auden, W. H. *Collected Poems*. Random House, 1976.

"Il Pensoroso." Milton, John. *Complete Poems and Major Prose: Milton*. Ed. Merritt Y. Hughes. Macmillan, 1957.

"I Know a Man." Creeley, Robert. *The Collected Poems of Robert Creeley, 1945–1975*. Univ. of California Press, 1982.

"In a Prominent Bar in Secaucus One Day." Kennedy, X. J. *Cross Ties: Selected Poems*. Univ. of Georgia Press, 1985.

"Index." Violi, Paul. *Splurge*. SUN, 1981.

"In the Waiting Room." Bishop, Elizabeth. *The Complete Poems, 1927–1979*. Farrar, Straus & Giroux, 1979.

"Iris." Williams, William Carlos. *The Collected Poems of William Carlos Williams, 1909–1939, Vol. 1*. New Directions, 1986.

Jarrell, Randall. "A Hunt in the Black Forest." *The Complete Poems*. Farrar, Straus & Giroux, 1975.

———. "Cinderella." *The Complete Poems*. Farrar, Straus & Giroux, 1975.

———. "Next Day." *The Complete Poems*. Farrar, Straus & Giroux, 1975.

————. "Seele Im Raum." *The Complete Poems*. Farrar, Straus & Giroux, 1975.

————. "The House in the Wood." *The Complete Poems*. Farrar, Straus & Giroux, 1975.

————. "The Lost World." *The Complete Poems*. Farrar, Straus & Giroux, 1975.

————. "The Woman at the Washington Zoo." *The Complete Poems*. Farrar, Straus & Giroux, 1975.

————. "Thinking of the Lost World." *The Collected Poems*. Farrar, Straus & Giroux, 1975.

"Jeanne d'Arc." Fish, Karen. *The Cedar Canoe*. Univ. of Georgia Press, 1987.

Jonson, Ben. "Still to Be Neat." *The Complete Poems*. Yale Univ. Press, 1982.

Journals of Dorothy Wordsworth. Vol. 1. Wordsworth, Dorothy. Macmillan, 1941.

"June Thunder." MacNeice, Louis. *Collected Poems*. Oxford Univ. Press, 1950.

"Junk." Wilbur, Richard. *"Advice to a Prophet" and Other Poems*. Harcourt, Brace & World, 1961.

Kalstone, David. *Becoming a Poet*. Farrar, Straus & Giroux, 1990.

Kees, Weldon. *The Collected Poems of Weldon Kees*. Univ. of Nebraska Press, 1975.

Kennedy, X. J. "In a Prominent Bar in Secaucus One Day." *Cross Ties: Selected Poems*. Univ. of Georgia Press, 1985.

Kinnell, Galway. "St. Francis and the Sow." *Selected Poems*. Houghton Mifflin, 1982.

————. "The Bear." *Selected Poems*. Houghton Mifflin, 1982.

————. "The Porcupine." *Selected Poems*. Houghton Mifflin, 1982.

Kirchwey, Karl. "Gangaridde." *A Wandering Island*. Princeton Univ. Press, 1990.

Knott, Bill. "Widow's Winter." *Selected and Collected Poems*. SUN, 1977.

Kumin, Maxine. "How It Is." *The Retrieval System*. Penguin, 1978.

"L'Allegro." Milton, John. *Complete Poems and Major Prose: Milton*. Ed. Merritt Y. Hughes. Macmillan, 1957.

Laux, Dorianne. "What My Father Told Me." *Awake*. BOA Editions, 1990.

"Learning to Speak." Everwine, Peter. *Collecting the Animals.* Atheneum, 1973.

Lehman, David. "Amnesia." *An Alternative to Speech.* Princeton Univ. Press, 1986.

———. *Ecstatic Occasions, Expedient Forms.* Macmillan, 1987.

Letters of Marcel Proust. Proust, Marcel. Vintage, 1966.

Letters to a Young Poet. Rilke, Ranier Maria. Trans. Stephen Mitchell. Random House, 1986.

"Letter to Milwaukee." Mitchell, Roger. *A Clear Space on a Cold Day.* Cleveland State Univ. Press, 1986.

Levine, Philip. "Milkweed." *7 Years from Somewhere.* Atheneum, 1979.

———. "Grandmother in Heaven." *New Selected Poems.* Knopf, 1991.

———. "Salami." *New Selected Poems.* Knopf, 1991.

———. "The Cemetery at Academy, California." *New Selected Poems.* Knopf, 1991.

Levis, Larry. "My Story in a Late Style of Fire." *Winter Stars.* Univ. of Pittsburgh Press, 1985.

"Line Endings." Myers, Jack, and Michael Simms. *The Longman Dictionary of Poetic Terms.* Longman, 1985.

"Lines Written During a Period of Insanity." Cowper, William. *Poetical Works.* Oxford Univ. Press, 1967.

"Literature." Valéry, Paul. *Selected Writings.* New Directions, 1964.

"Little Viennese Waltz." Lorca, Federico García. *The Poet in New York.* Farrar, Straus & Giroux, 1988.

Lorca, Federico García. "Little Viennese Waltz." *The Poet in New York.* Farrar, Straus & Giroux, 1988.

Lowell, Robert. "Skunk Hour." *Selected Poems.* Farrar, Straus & Giroux, 1976.

"Lying in a Hammock at William Duffy's Farm in Pine Island, Minnesota." Wright, James. *Above the River.* Wesleyan Univ. Press, 1990.

McMahon, Lynne. "Earth." *Faith.* Wesleyan Univ. Press, 1988.

MacNeice, Louis. "June Thunder." *Collected Poems.* Oxford Univ. Press, 1950.

McPherson, Sandra. "Sonnet for Joe." *Radiation.* Ecco Press, 1973.

———. "Wanting a Mummy." *Radiation.* Ecco Press, 1973.

"Market Day." Hacker, Marilyn. *Going Back to the River.* Vintage, 1990.

Marlowe, Christopher. "The Passionate Shepherd to His Love." *The Complete Poems and Translations.* Penguin, 1987.

Martial. *The Epigrams.* Tr. James Mickie. Penguin, 1988.

Marvell, Andrew. "A Dialogue Between the Soul and Body." *Complete Poems.* Ed. Elizabeth S. Donno. Penguin, 1977.

————. "To His Coy Mistress." *Complete Poems.* Ed. Elizabeth S. Donno. Penguin, 1977.

Matthews, William. "Merida, 1969." *Curiosities.* Univ. of Michigan Press, 1989.

"Meditations of an Old Woman." Roethke, Theodore. *The Collected Poems of Theodore Roethke.* Anchor Press, 1986.

Melnick, David. *Men in Aida.* Tuumba, 1983.

Melville, Herman. *Moby Dick; or, The Whale.* Oxford Univ. Press, 1988.

Men in Aida. Melnick, David. Tuumba, 1983.

Meredith, William. "Effort at Speech." *Partial Accounts.* Knopf, 1988.

"Merida, 1969." Matthews, William. *Curiosities.* Univ. of Michigan Press, 1989.

Merwin, W. S. "Catullus XI." *The Drunk in the Furnace.* Macmillan, 1960.

————. "Home for Thanksgiving." *Selected Poems.* Atheneum, 1988.

"Milkweed." Levine, Philip. *7 Years from Somewhere.* Atheneum, 1979.

Millay, Edna St. Vincent. "Childhood Is the Kingdom Where Nobody Dies." *Collected Poems.* Harper & Row, 1956.

Milton, John. "Il Pensoroso." *Complete Poems and Major Prose: Milton.* Ed. Merritt Y. Hughes. Macmillan, 1957.

————. "L'Allegro." *Complete Poems and Major Prose: Milton.* Ed. Merritt Y. Hughes. Macmillan, 1957.

Mitchell, Roger. "Letter to Milwaukee." *A Clear Space on a Cold Day.* Cleveland State Univ. Press, 1986.

Moby Dick; or, The Whale. Melville, Herman. Oxford Univ. Press, 1988.

"Moon Go Away, I Don't Love You No More." Simmerman, Jim. *Poetry* 152 (1988): 314.

Muldoon, Paul. "Cuba." *Selected Poems.* Ecco Press, 1987.

Myers, Jack, and Michael Simms. "Cut-and-Shuffle Poem." *The Longman Dictionary of Poetic Terms.* Longman, 1985.

————. "Fill-in-the-Blanks Poem." *The Longman Dictionary of Poetic Terms.* Longman, 1985.

————. "Line Endings." *The Longman Dictionary of Poetic Terms*. Longman, 1985.

"My Grandfather's Church Goes Up." Chappell, Fred. *Bloodfire*. Louisiana State Univ. Press, 1978.

"My mistress' eyes are nothing like the sun." Shakespeare, William. *Sonnets*. Harper & Row, 1988.

"My Papa's Waltz." Roethke, Theodore. *The Collected Poems of Theodore Roethke*. Anchor Press, 1986.

"My Story in a Late Style of Fire." Levis, Larry. *Winter Stars*. Univ. of Pittsburgh Press, 1985.

"Naming of Parts." Reed, Henry. *Reading Poetry*. Harper & Row, 1968.

Nashe, Thomas. "A Litany in Time of Plague." *Works of Thomas Nashe*. Ed. Ronald B. McKerrow. Sidgwick & Jackson, 1910.

"Net Murder at Sea." Editors. *New York Times*. Feb. 17, 1986.

News of the Universe: Poems of Two-Fold Consciousness. Ed. Robert Bly. Sierra Club, 1985.

"Next Day." Jarrell, Randall. *The Complete Poems*. Farrar, Straus & Giroux, 1975.

Nims, J. F. *Western Wind: An Introduction to Poetry*. Random House, 1983.

"1933." Hull, Lynda. *Ghost Money*. Univ. of Massachusetts, 1986.

North. Heaney, Seamus. Faber & Faber, 1985.

"Notes on the New Formalism." Gioia, Dana. *Hudson Review* 40 (1987): 395–408.

"Ode to the Yard Sale." Soto, Gary. *Black Hair*. Univ. of Pittsburgh Press, 1985.

Olds, Sharon. "First Boyfriend." *The Gold Cell*. Knopf, 1989.

"One Art." Bishop, Elizabeth. *The Complete Poems, 1927–1979*. Farrar, Straus & Giroux, 1979.

"One's-self I Sing." Whitman, Walt. *Leaves of Grass*. Bantam, 1983.

On Photography. Sontag, Susan. Dell, 1978.

"On the Manner of Addressing Clouds." Stevens, Wallace. *The Collected Poems*. Knopf, 1981.

"Overweight Poem." Wakowski, Diane. *Emerald Ice: Selected Poems*. Black Sparrow, 1988.

"Pantoum." Ashbery, John. *Some Trees.* Corinth, 1970.

"Paradise." Herbert, George. *The English Poems of George Herbert.* Ed. C. A. Patrides. Littlefield, Adams, 1981.

"Phantasia for Elvira Shatayev." Rich, Adrienne. *The Fact of a Doorframe.* Norton, 1984.

Philosophical Investigations. Wittgenstein, Ludwig. Tr. G.E.M. Anscombe. Oxford Press, 1968.

Pinsky, Robert. "History of My Heart." *History of My Heart.* Ecco Press, 1984.

Plath, Sylvia. "Stillborn." *The Collected Poems.* Harper & Row, 1981.

Plumly, Stanley. "Dirty Silences." *Poetics: Essays on the Art of Poetry.* Tenric, 1984.

———. "For Esther." *Out-of-the-Body Travel.* Ecco Press, 1977.

———. "Hedgerows." *Boy on the Step.* Ecco Press, 1989.

"Poem." Williams, William Carlos. *The Collected Poems of William Carlos Williams, 1909–1939.* Vol. 1. New Directions, 1986.

Poetic Meter and Poetic Form. Fussell, Paul. Random House, 1979.

Poetry Handbook: A Dictionary of Terms. Deutsch, Babette. Harper & Row, 1974.

"Portrait." Bogan, Louise. *The Blue Estuaries.* Ecco Press, 1977.

Poulin, A., Jr., ed. *Contemporary American Poetry.* Houghton Mifflin, 1985.

Pound, Ezra. "Apparuit." *Selected Poems.* New Directions, 1957.

———. "Canto I." *Selected Poems.* New Directions, 1957.

———. "The Seafarer." *Selected Poems.* New Directions, 1957.

Preminger, Alex, et al., ed. *The Princeton Encyclopedia of Poetry and Poetics.* Princeton Univ. Press, 1974.

"Prologues to What Is Possible." Stevens, Wallace. *Collected Poems.* Random House, 1990.

"Proust." Beckett, Samuel. *Proust.* Grove, 1957.

Proust, Marcel. *Letters of Marcel Proust.* Vintage, 1966.

Raleigh, Sir Walter. "The Nymph's Reply to the Shepherd." *Selected Writings.* Fyfield Books, 1984.

Reed, Henry. "Naming of Parts." *Reading Poetry.* Harper & Row, 1968.

Report from Part One. Brooks, Gwendolyn. Broadside, 1972.

Rich, Adrienne. "Ghazals: Homage to Ghalib." *The Fact of a Doorframe.* Norton, 1984.

————. "Phantasia for Elvira Shatayev." *The Fact of a Doorframe*. Norton, 1984.

Rilke, Rainer Maria. *Letters to a Young Poet*. Tr. Stephen Mitchell. Random House, 1986.

Robinson, Edwin Arlington. *Selected Poems of Edwin Arlington Robinson*. Ed. Morton Dauwen Zabel. Macmillan, 1965.

Roethke, Theodore. "Meditations of an Old Woman." *The Collected Poems of Theodore Roethke*. Anchor Press, 1986.

————. "The Lost Son." *The Collected Poems of Theodore Roethke*. Anchor Press, 1986.

————. "My Papa's Waltz." *The Collected Poems of Theodore Roethke*. Anchor Press, 1986.

————. "The Teaching Poet." *On the Poet and His Craft*. Univ. of Washington Press, 1965.

————. "The Waking." *The Collected Poems of Theodore Roethke*. Anchor Press, 1986.

"Rose the Click for 24." Bernstein, Charles. *The Sophist*. Sun & Moon, 1987.

"St. Francis and the Sow." Kinnell, Galway. *Selected Poems*. Houghton Mifflin, 1982.

St. John, David. "For George Trakl." *Hush*. Johns Hopkins Univ. Press, 1985.

————. "Hush." *Hush*. Johns Hopkins Univ. Press, 1985.

————. "Slow Dance." *Hush*. Johns Hopkins Univ. Press, 1985.

————. "The Man in the Yellow Gloves." *No Heaven*. Houghton Mifflin, 1985.

"Saint Pumpkin." Willard, Nancy. *Household Tales of Moon and Water*. Harcourt Brace & Jovanovitch, 1982.

"Salami." Levine, Philip. *New Selected Poems*. Knopf, 1991.

"Salmon." Graham, Jorie. *Erosion*. Princeton Univ. Press, 1983.

"Sapphics." Swinburne, Algernon Charles. *The Poems of Algernon Charles Swinburne*. Vol. 1. AMS Press, 1972.

"Sapphics Against Anger." Steele, Timothy. *Sapphics Against Anger and Other Poems*. Random House, 1986.

"Sapphics: The Friend of Humanity and the Knife Grinder." Canning, George, George Ellis, and John Hookham Frere. Ed. Henry Morley. *Parodies and Other Burlesque Pieces*. George Routledge & Sons, 1890.

"Saxophone." Gilbert, Christopher. *Across the Mutual Landscape.* Graywolf, 1984.

"Seele Im Raum." Jarrell, Randall. *The Complete Poems.* Farrar, Straus & Giroux, 1975.

Selected Poems of Edwin Arlington Robinson. Robinson, Edwin Arlington. Ed. Morton Dauwen Zabel. Macmillan, 1965.

"Self Portrait with Camellia Branch." Fish, Karen. *The Cedar Canoe.* Univ. of Georgia Press, 1987.

77 Dream Songs. Berryman, John. Farrar, Straus & Giroux, 1964.

Shakespeare, William. "My mistress' eyes are nothing like the sun." *Sonnets.* Harper & Row, 1988.

Shore, Jane. "Fortune's Pantoum." *Eye Level.* Univ. of Massachusetts Press, 1977.

Simic, Charles. "Forest Birds." *Classic Ballroom Dances.* Braziller, 1980.

Simmerman, Jim. "Moon Go Away, I Don't Love You No More." *Poetry* 152 (1988): 314.

Simpson, Louis. "Trouble." *In the Room We Share.* Paragon House, 1990.

"Skunk Hour." Lowell, Robert. *Selected Poems.* Farrar, Straus & Giroux, 1976.

"Slow Dance." St. John, David. *Hush.* Johns Hopkins Univ. Press, 1985.

"Snowy Winter in East Lansing." Wakowski, Diane. *The Rings of Saturn.* Black Sparrow, 1987.

Snyder, Gary. "Above Pate Valley." *Riprap and Cold Mountain Poems.* North Point, 1990.

———. "Why Log Truck Drivers Rise Earlier than Students of Zen." *Turtle Island.* New Directions, 1974.

"Song for the Pockets." Soto, Gary. *The Tale of Sunlight.* Univ. of Pittsburgh Press, 1978.

"Songs of Innocence and Experience." Blake, William. *Songs of Innocence and Experience.* Avon, 1971.

"Sonnet for Joe." McPherson, Sandra. *Radiation.* Ecco, 1973.

Sontag, Susan. *On Photography.* Dell, 1978.

Soto, Gary. "Ode to the Yard Sale." *Black Hair.* Univ. of Pittsburgh Press, 1985.

———. "Song for the Pockets." *The Tale of Sunlight.* Univ. of Pittsburgh Press, 1978.

———. "The Soup." *The Tale of Sunlight.* Univ. of Pittsburgh Press, 1978.

Southey, Robert. "The Widow." *Poems, 1797*. Woodstock Books, 1989.

Spender, Stephen. *The Making of a Poem*. Norton, 1962.

Steele, Timothy. "Sapphics Against Anger." *Sapphics Against Anger and Other Poems*. Random House, 1986.

Stern, Gerald. "The Dancing." *Leaving Another Kingdom*. Harper & Row, 1990.

———. "The Expulsion." *Paradise Poems*. Random House, 1984.

Stevens, Wallace. "Disillusionment of Ten O'Clock." *The Collected Poems*. Random House, 1990.

———. "On the Manner of Addressing Clouds." *The Collected Poems*. Random House, 1990.

———. "Prologues to What Is Possible." *The Collected Poems*. Random House, 1990.

———. "Sunday Morning." *Poetry*, vol. 7, no. 1 (1915): 81–83.

———. "The Silver Plough-Boy." *The Collected Poems*. Random House, 1990.

"Stillborn." Plath, Sylvia. *The Collected Poems*. Harper & Row, 1981.

"Still to Be Neat." Jonson, Ben. *The Complete Poems*. Yale Univ. Press, 1982.

"Stopping by Woods on a Snowy Evening." Frost, Robert. *Complete Poems*. Holt, Rinehart & Winston, 1962.

Strand, Mark. "Elegy for My Father." *Selected Poems*. Atheneum, 1980.

———. "White." *Selected Poems*. Atheneum, 1980.

Strong Measures: Contemporary American Poetry in Traditional Forms. Dacey, Philip and David Jauss. Harper & Row, 1986.

"Sunday Morning." Stevens, Wallace. *Poetry*, vol. 7, no. 1 (1915): 81–83.

Swinburne, Algernon Charles. "Sapphics." *The Poems of Algernon Charles Swinburne*. Vol. 1. AMS Press, 1972.

"Sympathetic Magic." Frazer, Sir James. *The Golden Bough*. Macmillan, 1963.

Tate, James. "The Blue Booby." *The Oblivion Ha-Ha*. Unicorn Press, 1970.

———. "The Lost Pilot." *The Lost Pilot*. Yale Univ. Press, 1967.

"The Abortion." Hirsch, Edward. *The Night Parade*. Knopf, 1989.

"The Age of Anxiety." Auden, W. H. *Collected Poems*. Random House, 1976.

"The Bear." Kinnell, Galway. *Selected Poems*. Houghton Mifflin, 1982.

"The Blue Booby." Tate, James. *The Oblivion Ha-Ha*. Unicorn Press, 1970.

"The Cemetery at Academy, California." Levine, Philip. *New Selected Poems.* Knopf, 1991.

The Collected Poems of Weldon Kees. Kees, Weldon. Univ. of Nebraska Press, 1975.

"The Czar's Last Christmas Letter." Dubie, Norman. *Selected and New Poems.* Norton, 1983.

"The Dancing." Stern, Gerald. *Leaving Another Kingdom.* Harper & Row, 1990.

"The Day of Judgment." Watts, Isaac. *The Poetical Works of Isaac Watts and Henry Kirke White.* Houghton Mifflin, 1864.

"The Elephant." De Andrade, Carlos Drummond. *Another Republic.* Ecco Press, 1976.

The Epigrams. Martial. Tr. James Mickie. Penguin, 1988.

"The Expulsion." Stern, Gerald. *Paradise Poems.* Random House, 1984.

"The Fish." Bishop, Elizabeth. *The Complete Poems, 1927–1979.* Farrar, Straus & Giroux, 1979.

"The House in the Wood." Jarrell, Randall. *The Complete Poems.* Farrar, Straus & Giroux, 1975.

"The Instruction Manual." Ashbery, John. *Selected Poems.* Penguin, 1985.

"The Lady of the Castle." Hollander, John. *Spectral Emanations.* Atheneum, 1978.

The Light Around the Body. Bly, Robert. Harper & Row, 1985.

"The Lilacs." Wilbur, Richard. *Walking to Sleep, New Poems and Translations.* Harcourt, Brace & World, 1969.

"The Lost Pilot." Tate, James. *The Lost Pilot.* Yale Univ. Press, 1967.

"The Lost Son." Roethke, Theodore. *The Collected Poems of Theodore Roethke.* Anchor Press, 1986.

"The Lost World." Jarrell, Randall. *Collected Poems.* Farrar, Straus & Giroux, 1975.

The Making of a Poem. Spender, Stephen. Norton, 1962.

"The Man in the Yellow Gloves." St. John, David. *No Heaven.* Houghton Mifflin, 1985.

"The Monument." Bishop, Elizabeth. *The Complete Poems, 1927–1979.* Farrar, Straus & Giroux, 1979.

"The Moose." Bishop, Elizabeth. *The Complete Poems, 1927–1979.* Farrar, Straus & Giroux, 1979.

"The Nymph's Reply To The Shepherd." Raleigh, Sir Walter. *Selected Writings*. Fyfield, 1984.

"The Passionate Shepherd To His Love." Marlowe, Christopher. *The Complete Poems and Translations*. Penguin, 1987.

"The Pennacesse Leper Colony for Women, Cape Cod: 1922." Dubie, Norman. *Selected and New Poems*. Norton, 1983.

"the pennycandystore beyond the el." Ferlinghetti, Lawrence. *Endless Life: Selected Poems*. New Directions, 1981.

"The Phantom-Wooer." Beddoes, Thomas Lovell. *The Works of Thomas Lovell Beddoes*. Ed. H. W. Donner. AMS Press, 1976.

"The Porcupine." Kinnell, Galway. *Selected Poems*. Houghton Mifflin, 1982.

The Princeton Encyclopedia of Poetry and Poetics. Ed. Alex Preminger et al. Princeton Univ. Press, 1974.

"The Prodigal." Bishop, Elizabeth. *The Complete Poems, 1927–1979*. Farrar, Straus & Giroux, 1979.

"The Props Assist the House." Dickinson, Emily. *The Poems of Emily Dickinson*. Belknap, 1963.

"The Red Wheelbarrow." Williams, William Carlos. *The Collected Poems of William Carlos Williams, 1909–1939*. Vol. 1. New Directions, 1986.

"These." Williams, William Carlos. *The Collected Poems of William Carlos Williams, 1909–1939*. Vol. 1. New Directions, 1986.

"The Seafarer." Pound, Ezra. *Selected Poems*. New Directions, 1957.

"The Silver Plough-Boy." Stevens, Wallace. *The Collected Poems*. Random House, 1990.

"The Soup." Soto, Gary. *The Tale of Sunlight*. Univ. of Pittsburgh Press, 1978.

"The Teaching Poet." Roethke, Theodore. *On the Poet and His Craft*. Univ. of Washington Press, 1965.

The Third Mind. Burroughs, William, and Brion Gysin. Viking, 1978.

"The Uncanny." Freud, Sigmund. *On Creativity and the Unconscious*. Harper & Row, 1958.

"The Waking." Roethke, Theodore. *The Collected Poems of Theodore Roethke*. Anchor Press, 1986.

"The War of Vaslav Nijinsky." Bidart, Frank. *The Sacrifice*. Vintage, 1983.

The Waste Land. Eliot, T. S. Harcourt Brace & Jovanovich, 1962.

"The Whipping." Hayden, Robert. *Collected Poems*. Liveright, 1985.

"The Widow." Southey, Robert. *Poems, 1797*. Woodstock Books, 1989.

"The Widow's Lament in Springtime." Williams, William Carlos. *Selected Poems*. New Directions, 1963.

"The Woodpile." Frost, Robert. *Complete Poems*. Holt, Rinehart & Winston, 1962.

"The Woman at the Washington Zoo." Jarrell, Randall. *The Complete Poems*. Farrar, Straus & Giroux, 1975.

"The Wrench." Hillman, Brenda. *White Dress*. Wesleyan, 1985.

"Thinking of the Lost World." Jarrell, Randall. *The Complete Poems*. Farrar, Straus & Giroux, 1975.

31 Letters and 13 Dreams. Hugo, Richard. Norton, 1977.

"This Is Just to Say." Williams, William Carlos. *The Collected Poems of William Carlos Williams, 1909–1939*. Vol. 1. New Directions, 1986.

Thomas, Dylan. "Do Not Go Gentle into That Good Night." *The Collected Poems of Dylan Thomas*. New Directions, 1971.

"To Go to Lvov." Zagajewski, Adam. *Tremor*. Farrar, Straus & Giroux, 1985.

"To His Coy Mistress." Marvell, Andrew. *Complete Poems*. Ed. Elizabeth S. Donno. Penguin, 1977.

"To Make a Poem." Turner, Alberta. *To Make a Poem*. Longman, 1982.

"Trouble." Simpson, Louis. *In the Room We Share*. Paragon House, 1990.

T. S. Eliot, The Waste Land: A Facsimile and Transcript of the Original Drafts Including the Annotations of Ezra Pound. Ed. Valerie Eliot. Harcourt Brace & Jovanovitch, 1971.

Turner, Alberta. "To Make a Poem." *To Make a Poem*. Longman, 1982.

Valéry, Paul. "Literature." *Selected Writings*. New Directions, 1964.

"Victor." Auden, W. H. *Collected Poems*. Random House, 1976.

"Villanelle: Late Summer." Hacker, Marilyn. *Separations*. Knopf, 1976.

Violi, Paul. "Index." *Splurge*. SUN, 1981.

Virgil. *Georgics*. Tr. Robert Wells. Carcanet New Press, 1982.

"Visit." Ammons, A. R. *The Selected Poems*. Norton, 1977.

Wakowski, Diane. "Overweight Poem." *Emerald Ice: Selected Poems*. Black Sparrow, 1988.

———. "Snowy Winter in East Lansing." *The Rings of Saturn*. Black Sparrow, 1987.

"Walking to Sleep." Wilbur, Richard. *New and Collected Poems.* Harcourt Brace & Jovanovitch, 1988.

"Wanting a Mummy." McPherson, Sandra. *Radiation.* Ecco Press, 1973.

Watts, Isaac. "The Day of Judgment." *The Poetical Works of Isaac Watts and Henry Kirke White.* Houghton Mifflin, 1864.

Western Wind: An Introduction to Poetry. Nims, J. F. Random House, 1983.

"What Is Poetry." Ashbery, John. *Selected Poems.* Penguin, 1985.

"What My Father Told Me." Laux, Dorianne. *Awake.* BOA Editions, 1990.

"White." Strand, Mark. *Selected Poems.* Atheneum, 1980.

Whitman, Walt. "One's-self I Sing." *Leaves of Grass.* Bantam, 1983.

"Why Log Truck Drivers Rise Earlier than Students of Zen." Snyder, Gary. *Turtle Island.* New Directions, 1974.

"Widow's Winter." Knott, Bill. *Selected and Collected Poems.* SUN, 1977.

Wilbur, Richard. "Junk." *"Advice to a Prophet" and Other Poems.* Harcourt, Brace & World, 1961.

———. "The Lilacs." *Walking to Sleep, New Poems and Translations.* Harcourt, Brace & World, 1969.

———. "Walking to Sleep." *New and Collected Poems.* Harcourt Brace & Jovanovitch, 1988.

"Wildflowers." Howard, Richard. *Two-Part Inventions.* Atheneum, 1974.

Willard, Nancy. "Saint Pumpkin." *Household Tales of Moon and Water.* Harcourt Brace & Jovanovitch, 1982.

Williams, C. K. "Blades." *Poems 1963–83.* Farrar, Straus & Giroux, 1988.

———. "Combat." *Tar.* Vintage. 1983.

Williams, William Carlos. "Danse Russe." *The Collected Poems of William Carlos Williams, 1909–1939.* Vol. 1. New Directions, 1986.

———. "Iris." *The Collected Poems,* 1986.

———. "Poem." *The Collected Poems,* 1986.

———. "The Red Wheelbarrow." *The Collected Poems,* 1986.

———. "These." *The Collected Poems,* 1986.

———. "The Widow's Lament in Springtime." *The Collected Poems,* 1986.

———. "This Is Just to Say." *The Collected Poems,* 1986.

Wittgenstein, Ludwig. *Philosophical Investigations.* Tr. G.E.M. Anscombe. Oxford, 1968.

Wood, Susan. "Hollow." *Campo Santo.* Louisiana State Univ. Press, 1991.

Wordsworth, Dorothy. *Journals of Dorothy Wordsworth, Vol. 1.* Macmillan, 1941.

Wordsworth, William. "Expostulation and Reply." *Poetical Works of Wordsworth.* Houghton Mifflin, 1982.

Wright, Charles. "Yellow." *Selected Early Poems.* Wesleyan Univ. Press, 1982.

Wright, James. "A Blessing." *Above the River.* Wesleyan Univ. Press, 1990.

————. "Erinna to Sappho." *Above the River.* Wesleyan Univ. Press, 1990.

————. "Lying in a Hammock at William Duffy's Farm in Pine Island, Minnesota." *Above the River.* Wesleyan Univ. Press, 1990.

Yeats, W. B. "A Dialogue of Self and Soul." *The Collected Poems of W. B. Yeats.* Macmillan, 1962.

————. "Among School Children." *The Collected Poems of W. B. Yeats.* Macmillan, 1962.

"Yellow." Wright, Charles. *Selected Early Poems.* Wesleyan Univ. Press, 1982.

Zagajewski, Adam. "To Go to Lvov." *Tremor.* Farrar, Straus & Giroux, 1985.

Zukofsky, Louis and Celia. *Catullus.* Cape Golliard, 1969.

CONTRIBUTORS' NOTES

THE EDITORS

ROBIN BEHN teaches in the MFA Program in Writing at The University of Alabama. Her book *Paper Bird* (Texas Tech. Univ. Press, 1988) won the Associated Writing Programs Award Series in Poetry. Her next book of poems will be published by HarperCollins in 1993.

CHASE TWICHELL is the author of three books of poetry: *Perdido* (Farrar, Straus & Giroux, 1991), *The Odds* (Pittsburgh, 1986), and *Northern Spy* (Pittsburgh, 1981). She teaches in the Creative Writing Program at Princeton University.

THE CONTRIBUTORS

PAMELA ALEXANDER's books of poems are *Commonwealth of Wings* (Wesleyan Univ. Press, 1991) and *Navigable Waterways* (Yale Univ. Press, 1985). She has been a Bunting Fellow and Visiting Faculty member at the University of Iowa, and now teaches at M.I.T.

AGHA SHAHID ALI teaches at Hamilton College. His books include *The Half-Inch Himalayas* (Wesleyan Univ. Press), *A Walk Through the Yellow Pages* (Sun Gemini Press), and *A Nostalgist's Map of America* (Norton). He is also the author of *The Rebel's Silhouette*, translations from the Urdu poet Faiz Ahmed Faiz, published by Peregrine Smith.

MAGGIE ANDERSON is on the faculty at Kent State University. Her books of poems are *A Space Filled with Moving* (Univ. of Pittsburgh Press, 1992), *Cold Comfort* (Univ. of Pittsburgh Press, 1986), and *Years That Answer* (Harper &

Row, 1980). An edited volume, the selected poems of West Virginia poet Louise McNeill, appeared from Pittsburgh in 1991.

JUDITH BAUMEL is Assistant Professor at Adelphi University, where she is Director of the Creative Writing Program. Her book *The Weight of Numbers* won the Walt Whitman Award from the Academy of American Poets and was published by Wesleyan Univ. Press in 1988.

ROBIN BECKER teaches creative writing at the Massachusetts Institute of Technology and serves as the poetry editor for *The Women's Review of Books*. Her books of poetry are *Giacometti's Dog* (Univ. of Pittsburgh Press, 1990), *Backtalk* (Alice James Books, 1982), and *Personal Effects* (Alice James Books, 1979).

CHARLES BERNSTEIN's books of poems include *The Sophist* (Sun & Moon), *The Absent Father in Dumbo* (Zasterle), *A Poetics* (Harvard University Press), and *Rough Trades* (Sun & Moon). He is David Gray Professor of Poetry and Letters at SUNY-Buffalo.

T. ALAN BROUGHTON, the author of four novels and four volumes of poetry, is Professor of English and co-director of the Writers' Workshop Program at the University of Vermont. His most recent book of poems is *Preparing to be Happy* (Carnegie-Mellon Univ. Press).

SHARON BRYAN's books are *Salt Air* and *Objects of Affection*, both from Wesleyan Univ. Press. She teaches at Memphis State University and edits the literary magazine *River City*.

CHRISTOPHER BUCKLEY teaches at West Chester University in Pennsylvania. His fifth book of poems, *Blue Autumn*, appeared from Copper Beech Press in 1990. He edited *On the Poetry of Philip Levine: Stranger to Nothing* (Univ. of Michigan Press, 1990).

CHRISTOPHER DAVIS won the Associated Writing Programs Award Series in Poetry prize for *The Tyrant of the Past and the Slave of the Future* (Texas Tech Univ. Press, 1989). He teaches at the University of North Carolina at Charlotte.

DEBORAH DIGGES's first book, *Vesper Sparrows*, won the Delmore Schwartz Memorial Poetry Prize in 1988. Her second collection, *Late in the Millennium*, and a memoir, *Fugitive Spring*, were published by Knopf. She teaches at Tufts University.

STUART DISCHELL teaches English and Creative Writing at Boston University. He is the author of *Animate Earth* (Jeanne Duval Editions, 1988) and *Good Hope Road* (Viking Penguin, 1992).

RITA DOVE's books of poetry include *The Yellow House on the Corner, Museum, Thomas and Beulah* (for which she received the 1987 Pulitzer Prize), and, most recently, *Grace Notes* (Norton, 1989). A collection of short stories, *Fifth Sunday,* appeared in 1985, and a novel, *Through the Ivory Gate,* is forthcoming from Pantheon. She teaches at the University of Virginia.

STEPHEN DUNN, the author of eight collections of poetry, teaches at Stockton State College in Pomona, New Jersey. His most recent volumes are *Landscape at the End of the Century* (Norton, 1991), *Between Angels* (Norton, 1989), and *Local Time* (Morrow, 1986).

LYNN EMANUEL is Associate Professor at the University of Pittsburgh. Her first book, *Hotel Fiesta,* was published by the University of Georgia Press. Her second book, *The Dig,* won the National Poetry Series Award and was published by the University of Illinois Press.

ROLAND FLINT's most recent books of poems are *Stubborn* (Univ. of Illinois Press, 1990) and *Pigeon* (North Carolina Wesleyan College Press, 1991). He is on the faculty of Georgetown University.

STUART FRIEBERT is Professor of Creative Writing at Oberlin College where he directs the Writing Program and co-edits *Field.* He has published a dozen collections of poems and poems in translation, and edited several texts. His recent books are Marin Sorescu's *Selected Poems* (translations), *The Longman Anthology of Contemporary American Poetry* (co-edited with David Young), and *Step by Step,* a new collection of poems, from BkMk Press/University of Missouri.

CHRISTOPHER GILBERT teaches psychology and works as a consultant and psychotherapist. His recent publications are *Across the Mutual Landscape* and *Into the Into,* both from Graywolf Press.

DANA GIOIA is a businessman in New York. He has published two collections of poetry, *Daily Horoscope* (Graywolf Press, 1986) and *The Gods of Winter* (Graywolf Press, 1991). Writing frequently on contemporary poetry, he has published essays and reviews in *The Atlantic, The New Yorker, The Nation,* and *The Hudson Review.*

DANIEL HALPERN teaches in the graduate writing program at Columbia University and is editor of *Antaeus* and The Ecco Press. His recent books are *Foreign Neon, Tango,* and *Seasonal Rights,* and an edited volume, *The Art of the Tale: An International Anthology of Short Stories.*

EDWARD HIRSCH teaches at the University of Houston. His books of poetry are *The Night Parade, Wild Gratitude,* and *For the Sleepwalkers,* all from Knopf.

GARRETT HONGO, Director of Creative Writing at the University of Oregon, has published two books of poems, *The River of Heaven* (Knopf, 1988) for which he received the Lamont Prize, and *Yellow Light* (Wesleyan Univ. Press, 1982).

ANDREW HUDGINS's books of poetry are *The Never-Ending, After the Lost War,* and *Saints and Strangers,* all from Houghton Mifflin. A former Hodder fellow at Princeton University, he is Associate Professor at the University of Cincinnati.

RICHARD JACKSON is U.C. Foundation Professor of English at the University of Tennessee-Chattanooga, and also teaches at Vermont College and The Bread Loaf Writers' Conference. The author of several books of poems (*Worlds Apart* and *Alive All Day*) as well as criticism and interviews (*Dismantling Time in Contemporary Poetry* and *Acts of Mind*), he has been a Fulbright Exchange Poet to Yugoslavia and serves as editor of *The Poetry Miscellany.*

LINNEA JOHNSON teaches at Muhlenberg College in Allentown, Pennsylvania. Her book *The Chicago Home* won the Beatrice Hawley Prize and was published by Alice James Books.

DONALD JUSTICE has taught at a number of universities, including Syracuse, California (Irvine), Iowa, and the University of Florida, where he now teaches. His most recent book is *A Donald Justice Reader* (University Press of New England, 1991).

JAY KLOKKER is Instructor of Adult Basic Education at New York City Technical College. He has also taught at Boston University and through U. Mass.–Boston's Continuing Education Program.

MAXINE KUMIN is a poet and farmer in Warner, New Hampshire. A former poetry consultant to the Library of Congress, her most recent books are *Nurture,* poetry from Viking Penguin, and *In Deep,* essays from Beacon Press.

ANN LAUTERBACH is the author of three volumes of poetry, *Clamor* (Viking, 1991), *Before Recollection* (Princeton Univ. Press, 1987), and *Many Times, But Then* (Univ. of Texas Press, 1979). She teaches at The City College in New York and is a contributing editor of *Conjunctions* magazine.

SYDNEY LEA, founder of *New England Review,* has taught at Dartmouth, Yale, and Middlebury College, and is currently an instructor in the MFA Program at Vermont College. His most recent books are *The Blainville Testament: Stories and Meditations* (Story Line Press, 1991), *Prayer for the Little City* (Scribners, 1990; Collier, 1991), and a volume of fiction, *A Place in Mind* (Scribners, 1989).

THOMAS LUX is on the writing faculty at Sarah Lawrence College. His most recent book of poems is *The Drowned River* (Houghton Mifflin).

J. D. MCCLATCHY, who has taught at Princeton, Yale, and UCLA, has written three books of poems, *The Rest of the Way* (Knopf, 1990), *Stars Principal* (1986), and *Scenes from Another Life* (1981). He has edited several books, including *The Vintage Book of Contemporary American Poetry* (1990), and is the author of a collection of critical essays, *White Paper* (1989). He is currently the editor of *The Yale Review.*

JAMES MCKEAN's book *Headlong* won the Great Lakes Colleges New Writers Award for poetry and was published by the University of Utah Poetry Series in 1987. He teaches at Mount Mercy College in Cedar Rapids, Iowa.

JACKSON MAC LOW is a writer of poems, performance pieces, essays, and plays, as well as a composer, visual artist, and multimedia performance artist. Most recent of his twenty-five books are *Words nd Ends from Ez* (1989) and *Representative Works: 1938–1985* (1986). He has taught at Mannes College of Music, New York University, SUNY-Albany, SUNY-Binghamton, and Temple University.

LYNNE MCMAHON is Associate Professor of English at the University of Missouri. Her second book of poems, *Devolution of the Nude,* was published by Godine in 1992.

SANDRA MCPHERSON's forthcoming book, *The God of Indeterminacy,* will be published by the University of Illinois Press. *Streamers* (Ecco Press, 1988) is the most recent of her five collections of poetry. She teaches at the University of California at Davis.

CLEOPATRA MATHIS, Director of Creative Writing at Dartmouth College, has published three volumes of poems, *The Center for Cold Weather* (1990), *The Bottom Land* (1983), and *Aerial View of Louisiana* (1980).

WILLIAM MATTHEWS teaches at City College in New York. His most recent books are *Blues if You Want* (poems from Houghton Mifflin) and *Curiosities* (essays from University of Michigan Press).

ROGER MITCHELL is Professor of English and Director of the creative writing program at Indiana University. His recent volumes of poetry include *Adirondack* (BkMk Press, 1988) and *A Clear Space on a Cold Day* (Cleveland State Univ. Press, 1986). A volume of nonfiction, *Clear Pond: The Reconstruction of a Life*, appeared in 1991 from Syracuse University Press.

SUSAN MITCHELL's volumes of poems are *The Water Inside the Water* (Wesleyan, 1983) and *Rapture* (HarperCollins, 1992). She teaches in the English Department at Florida Atlantic University and in the MFA Program of Vermont College.

CAROL MUSKE is Professor of English at the University of Southern California. Her most recent books are a volume of poetry, *Applause* (Univ. of Pittsburgh Press, 1989), and a novel, *Dear Digby* (as Carol Muske-Dukes) (Viking, 1989). Her fifth book of poems, *Red Trousseau*, and a second novel, *Saving St. Germ*, will both be published by Viking Penguin in 1992.

JACK MYERS's recent books of poems are *Blindsided* (Godine, 1992) and *As Long As You're Happy* (Graywolf Press, 1986). He has coedited *New American Poets of the 90's* (Godine) and *A Profile of American Poetry in the 20th Century* (Southern Illinois University Press, 1991). Myers is Professor of English at Southern Methodist University.

ALICIA OSTRIKER is the author of seven volumes of poetry, most recently *Green Age* (1989) and *The Imaginary Lover* (1986). As a critic she is the author of *Stealing the Language: The Emergence of Women's Poetry in America* (1986). She teaches at Rutgers University.

MOLLY PEACOCK's volumes of poetry are *Take Heart* (Random House, 1989), *Raw Heaven* (Random House, 1984), and *And Live Apart* (Missouri, 1980). She is president of the Poetry Society of America and works in New York City as a learning specialist.

MICHAEL PETTIT has published two collections of poetry, *Cardinal Points* (Univ. of Iowa Press, 1988) and *American Light* (Univ. of Georgia Press, 1984). He teaches at Mount Holyoke College and directs the Mount Holyoke Writers' Conference.

STANLEY PLUMLY's *Boy on the Step* (Ecco, 1989) is the most recent of his six volumes of poems. He is Professor of English at the University of Maryland.

THOMAS RABBITT has published three volumes of poetry, *The Abandoned Country* (Carnegie-Mellon Univ. Press, 1988), *The Booth Interstate* (Knopf), and *Exile* (Univ. of Pittsburgh Press). He teaches in the MFA program at The University of Alabama.

KENNETH ROSEN founded and directed the Stonecoast Writers' Conference for ten years. He currently teaches writing in the Warren Wilson MFA program, and is Professor of English at the University of Southern Maine. His books are *The Hebrew Lion* (Ascensius Press, 1989), *Black Leaves* (New Rivers, 1980), and *Whole Horse* (Braziller, 1973).

DAVID ST. JOHN is the author of three collections of poetry, *Hush* (1976), *The Shore* (1980), and *No Heaven* (1985), as well as three limited editions, *The Olive Grove* (1980), *The Orange Piano* (1987), and *Terraces of Rain: An Italian Sketchbook* (1991). St. John is Poetry Editor of the *Antioch Review* and Professor of English at The University of Southern California.

JIM SIMMERMAN is Director of Creative Writing at Northern Arizona University. His books are *Once Out of Nature* (Galileo, 1989) and *Home* (Dragon Gate, 1983).

SUSAN SNIVELY teaches writing at Amherst College and Smith College. She is the author of two volumes of poetry, *Voices in the House* (Univ. of Alabama Press, 1988) and *From this Distance* (Alice James Books, 1981).

MARCIA SOUTHWICK is Associate Professor of English at the University of Nebraska, Lincoln. Her books are *The Night Won't Save Anyone* (Univ. of Georgia Press), and *Why the River Disappears* (Carnegie-Mellon Univ. Press).

ELIZABETH SPIRES is writer-in-residence at Goucher College and Adjunct Associate Professor in the Writing Seminars at Johns Hopkins University. Her books of poems are *Annonciade* (Viking Penguin, 1989), *Swan's Island* (Holt, 1985), and *Globe* (Wesleyan Univ. Press, 1981).

MAURA STANTON is a poet and fiction writer who teaches at Indiana University. Her books of poems are *Tales of the Supernatural* (Godine, 1988), *Cries of Swimmers* (Utah, 1984), and *Snow on Snow*, for which she received the Yale Series of Younger Poets Award in 1974. Her recent collection of fiction is *The Country I Come From* (Milkweed Editions, 1988).

MARY SWANDER teaches at Iowa State University. Her books of poems are *Driving the Body Back* (Knopf, 1986) and *Succession* (Univ. of Georgia Press, 1979). A playwright and nonfiction writer as well as a poet, she has recently collaborated with Jane Staw on *Parsnips in the Snow: Talks with Midwestern Gardeners* (Univ. of Iowa Press, 1990).

KAREN SWENSON's most recent book is *A Sense of Direction* (The Smith Press, 1989). A freelance journalist as well as a poet, she travels in Asia for two months of each year.

RICHARD TILLINGHAST has taught at Berkeley, Sewanee, and Harvard, and is currently Professor of English at the University of Michigan. His three volumes of poetry, all from Wesleyan, are *Our Flag Was Still There*, *The Knife and Other Poems*, and *Sleep Watch*. A new volume is forthcoming from Godine.

ALBERTA TURNER, Professor Emerita at Cleveland State University, is widely published as a poet and editor. Her most recent books are a volume of poems, *A Belfry of Knees* (Univ. of Alabama Press, 1983); an anthology, *45 Contemporary Poems* (Longman, 1985); and a textbook, *Responses to Poetry* (Longman, 1990).

LESLIE ULLMAN's collections of poems are *Dreams by No One's Daughter* (Univ. of Pittsburgh Press, 1987) and *Natural Histories* (Yale Univ. Press, 1979). She directs the creative writing program at the University of Texas–El Paso, and also teaches in the Vermont College MFA Program.

LEE UPTON, who teaches at Lafayette College, has published two volumes of poems, *No Mercy* (Atlantic Monthly Press, 1989), which was a winner of the National Poetry Series, and *The Invention of Kindness* (Univ. of Alabama Press, 1984). A critical study, *Jean Garrigue: A Poetics of Plenitude*, was published by Fairleigh Dickinson University Press in 1991.

ANNE WALDMAN is Director of the Department of Writing and Poetics at The Naropa Institute in Boulder, Colorado. Her recent books are *Helping the*

Dreamer: New and Selected Poems 1966–1988 and *Skin Meat Bones,* both from Coffee House Press. She has also produced two videotapes, *Eyes in All Heads* and *Live at Naropa,* from Phoebus Productions in Boulder.

MICHAEL WATERS teaches at Salisbury State University in Maryland. He is the author of five books of poetry, including *Bountiful* (1992), *The Burden Lifters* (1989), and *Anniversary of the Air* (1985), all from Carnegie-Mellon Univ. Press.

ROGER WEINGARTEN directs and teaches in the MFA Program in Writing at Vermont College. Among his books of poems are *Infant Bonds of Joy* (Godine, 1990), *Ethan Benjamin Boldt* (Story Line Press, 1987), and *Shadow Shadow* (Godine, 1986). He and Jack Myers edited *New American Poets of the '90's* (Godine, 1991).

THEODORE WEISS is Professor Emeritus of English and Creative Writing at Princeton University, and is editor and publisher with Renee Weiss of *The Quarterly Review of Literature.* His recent books are *From Princeton One Autumn Afternoon: Collected Poems,* and *A Sum of Destruction.*

DAVID WOJAHN's collections of poems are *Mystery Train* (Univ. of Pittsburgh Press, 1990), *Glassworks* (Univ. of Pittsburgh Press, 1987), and *Icehouse Lights,* the 1982 Yale Series of Younger Poets Selection. He teaches at Indiana University and is on the adjunct faculty of Vermont College.

INDEX

Index is arranged by author and title of exercise.

COPYRIGHT ACKNOWLEDGMENTS

"Childhood is the Kingdom Where Nobody Dies" by Edna St. Vincent Millay. From *Collected Poems*, Harper & Row. Copyright © 1934, 1962 by Edna St. Vincent Millay and Norma Millay Ellis. Reprinted by permission of Elizabeth Barnett, literary executor.

"The Cut and Shuffle Poem" and "The Fill-in-the-Blanks or Definition Poem." From *The Longman Dictionary of Poetic Terms* by Jack Myers and Michael Simms. Copyright © 1985. By Longman Publishing Group. Reprinted by permission of Longman Publishing Group.

"Dusting." Reprinted from Rita Dove: *Thomas and Beulah*. By permission of Carnegie Mellon University Press © 1986. By Rita Dove.

"Elegy for My Father, #2: Answers." Reprinted with permission of Atheneum Publishers, an imprint of Macmillan Publishing Company, from *The Story of Our Lives* by Mark Strand. Copyright © 1972, 1973 by Mark Strand.

"1142." Reprinted by permission of the publishers and the Trustees of Amherst College from *The Poems of Emily Dickinson*, Thomas H. Johnson, ed., Cambridge, Mass.: The Belknap Press of Harvard University Press, Copyright 1951, © 1955, 1979, 1983 by the President and Fellows of Harvard College.

"Finnish Rhapsody." From *April Galleons* by John Ashbery. Copyright © 1984, 1985, 1986, 1987, by John Ashbery. Reprinted by permission of the publisher, Viking Penguin, a division of Penguin Books USA Inc.

"Ghazals." From *Rhyme's Reason* by John Hollander. Copyright © 1989 by John Hollander. Reprinted by permission of Yale University Press.

"How Science Saved People from Holes." From *The Intuitive Journey and Other Works* by Russell Edson. Published by Harper & Row. Copyright © 1976 by Russell Edson. Reprinted by permission of Russell Edson.

"Index." From *Splurge* by Paul Violi. Published by SUN Press. Copyright © 1981 by Paul Violi. Reprinted by permission of Paul Violi.